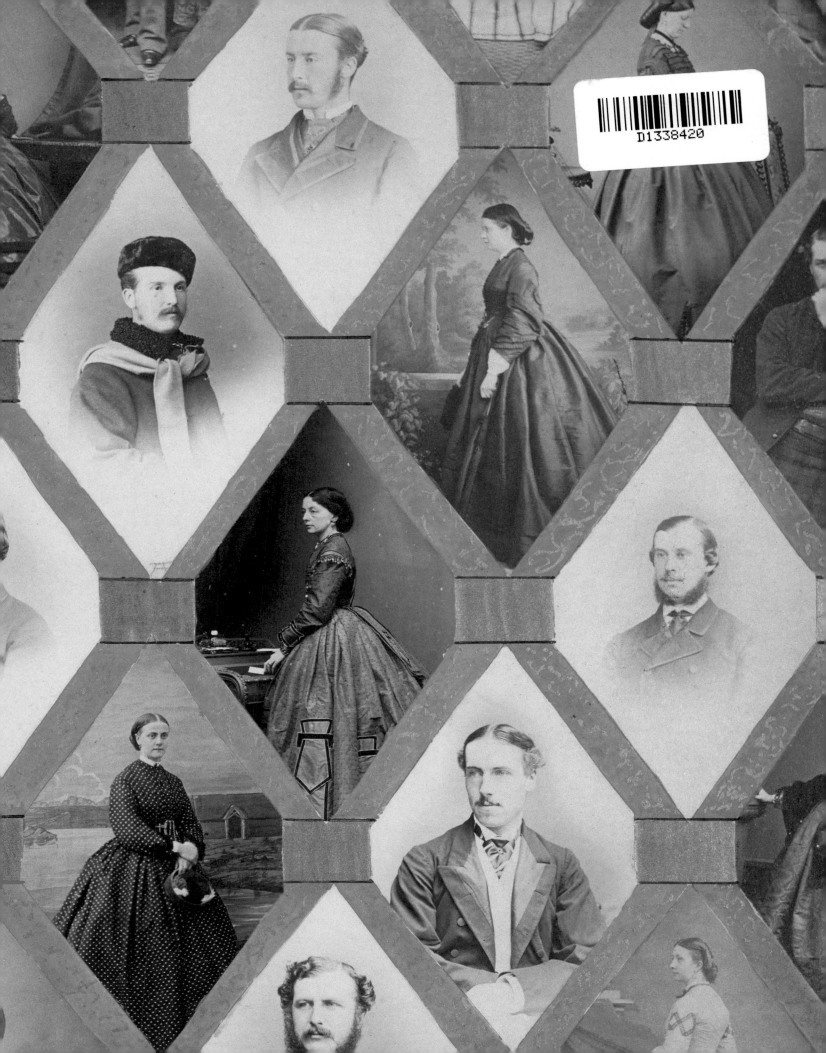

DEVELOPING THE PICTURE
QUEEN ALEXANDRA AND THE ART OF PHOTOGRAPHY

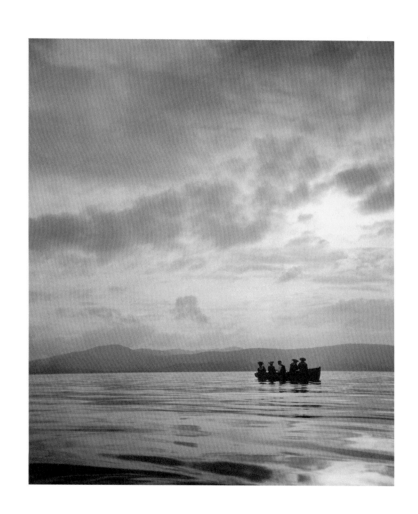

old Mother dear
1898

DEVELOPING THE PICTURE
QUEEN ALEXANDRA AND THE ART OF ✣ PHOTOGRAPHY ✣

FRANCES DIMOND

Royal Collection Publications

Published by
Royal Collection Enterprises Ltd
St James's Palace, London SW1A 1JR

For a complete catalogue of current publications,
please write to the address above, or visit our website
on www.royal.gov.uk

ISBN 1 902163 79 6

British Library Cataloguing in Publication Data:
A catalogue record for this book is available from
the British Library.

Designed by Mick Keates
Produced by Book Production Consultants plc,
Cambridge
Printed and bound by EBS, Verona, Italy

FRONT COVER:
Unknown photographer, *Alexandra, Princess of Wales,
with her camera*, c.1889–90
Albumen print, 12.1 × 4.8cm (4⅘ × 1⁹⁄₁₀″)
RPC 03/0121/7i

BACK COVER:
Queen Alexandra, 'Lieut. Watson and my cat', 1905
Printing-out paper, 12 × 9.5cm (4⁷⁄₁₀ × 3⁷⁄₁₀″)
RPC 03/0070/41h

ENDPAPERS:
Alexandra, Princess of Wales (photographers unknown),
A geometric design with photographs, late 1860s
Watercolour and albumen prints,
26.5 × 33.4cm (10⁷⁄₁₆ × 13³⁄₁₆″)
RCIN 2300104

From the Princess of Wales's Collage Album, combining
cut-out photographs and her own painted decorations.
She compiled the album c.1866–9. This design shows a
lattice pattern enclosing portraits of friends and
acquaintances.

HALF-TITLE:
Queen Alexandra, *A small boat at sea*, early 1900s
Toned bromide, 30.2 × 23.9cm (11¹⁵⁄₁₆ × 9⁷⁄₁₆″)
RPC 03/0188/13

FRONTISPIECE:
Alice Hughes, 'Old Mother-dear', 1898
Platinum print, 28.7 × 21.2cm (11⅜ × 8⅜″)
RPC 01/0235/189

The Princess was known as 'Mother-dear' by her
children. Alice Hughes, daughter of the portrait
painter Edward Hughes, photographed her on a
number of occasions. In her memoirs, published in
1923 and dedicated to Queen Alexandra, Miss Hughes
remembered how she and her father had gone to
Buckingham Palace on Coronation Day 1902, to sketch
and photograph the Queen.

CONTENTS

ACKNOWLEDGEMENTS

The life and achievements of Queen Alexandra have been a source of interest to me for many years and it has been a pleasure and a privilege to write this book. My greatest thanks are to Her Majesty The Queen for graciously allowing me to consult and use material in the Royal Archives, Royal Collection and elsewhere. I am also immensely grateful to my colleagues, past and present, in the Royal Household, for their help, advice and support.

The assistance of a number of other people and organisations has been greatly appreciated and, among them, the following have been especially helpful:

The staff of the National Art Library, Victoria and Albert Museum; the Bodleian Library, Oxford; the British Library; and the British Library Newspaper Library.

Luke McKernan, British Universities Film and Video Council; Tim Padfield, Copyright Officer, The National Archive; Jan Faull and colleagues, the British Film Institute's National Film and Television Archive; Chris Roberts, Kodak Ltd Archive; Colin Harding, National Museum of Photography, Film and Television; Mark Haworth-Booth, Department of Photographs, Victoria and Albert Museum; Terence Pepper, Clare Freestone and Juliet Simpson, National Portrait Gallery; Charles Noble, Devonshire Collections, Chatsworth; Max Donnelly, The Fine Art Society; Roger Sims, Manx National Heritage; Michael Smallman, Queen's University Library, Belfast; Gráinne MacLochlainn, the National Photographic Archive, National Library of Ireland; Grant Romer and Kathy Connor, International Museum of Photography, George Eastman House; Julie Fryd Johansen and Ulla Kiertzner, Det Kongelige Bibliotek, Copenhagen, Denmark; Roufina Samsonova, Gatchina Palace, Russia; Gerda Petri, Christian VIII's Palace, Amalienborg, Denmark, and the late Mikael Petri; Tove Thage, Irene Falnov and colleagues, Frederiksborg Castle, Denmark.

Roger Taylor, Anna Lerche von Lowzow, Giles Hudson, Gwen Yarker, Lt-Commander C.H. Knollys, Carolyn Bloore, The Earl and Countess of Rosebery, Richard Brown, David Webb, Robert Pullen; Stewart Binns and Adrian Wood, Trans World International; Mick Keates, Elisabeth Ingles and Book Production Consultants.

Finally, I should like to thank my mother for her encouragement, advice and patience.

INTRODUCTION

Queen Alexandra's interest in photography was well known during her lifetime, and copies of *Queen Alexandra's Christmas Gift Book* still survive today. However, her involvement with the art has never been examined in any great detail. Several full-length biographies of the Queen have been written over the past century, but such books generally cover the main facts of her life without allotting space to investigate her interests in depth. In some accounts the Queen has fared badly; while her beauty and kindness are conceded by everyone, her intellectual capacity is consistently and unfairly played down. One reason for this was remarked by Lord Esher, who commented that 'Her cleverness has always been underrated, partly because of her deafness; in point of fact she says more original things and has more unexpected ideas than any other member of the family.'[1] Her deafness was indeed part of the problem; another factor was that, after her death, by her own wish many of her private papers were destroyed, thus removing a certain amount of evidence about her interests and occupations.

The survival of Queen Alexandra's photograph albums, whether by accident or design, therefore means that a shaft of light can be cast into a shadowy corner. Most of the albums are kept in the Royal Photograph Collection at Windsor, and while they may not represent her entire photographic output, their contents are significant and varied enough to give a strong impression of what the medium of photography meant to her and to show her own unique way of using it. Ostensibly they reveal that she was an enthusiastic and talented photographer, but this is only a part of their worth. The special historical value of these albums lies in the fact that they appear to be the only remaining personal diaries compiled by the Queen herself. They contain details about events which may not be recorded elsewhere and give a vivid impression of the Queen's character, her artistic abilities and her enjoyment of descriptive writing.

Alexandra had always shown artistic promise. In her youth she was taught painting and drawing but her family, unlike that of her future husband, does not appear to have patronised photography seriously and she may not have had the opportunity to see photographs of a wide variety of subjects until after her marriage in 1863. The Prince of Wales, on the other hand, had been intrigued by photography as a boy; he had learnt how to use a camera and had begun a collection which continued to grow for most of his life. It is very likely that his wife was influenced by this and, to some extent, took an interest in photography for his sake. Queen Victoria had noted, in a letter of 8 November 1862 to her eldest daughter, that 'Alix… has such a deep and serious character, and is truly and laudably anxious to improve herself…. She wishes to be of real use to Bertie.' Alexandra made use of photographs in a number of creative projects and compiled albums in which collages of cut-out photographs were embellished by her own watercolour painting. Later, when she had learnt how to practise photography herself, she compiled albums of

Robert Bingham (1825–70), *Alexandra, Princess of Wales*,
June 1864
Albumen print, 8.5 × 5.2 cm (3⅜ × 2″)
RPC 01/0176

This poised and elegant portrait of the Princess closely
resembles Franz Xaver Winterhalter's painting of her,
done in the same year; he may have used it, or another
taken at the same sitting, for reference.

her own pictures and other material, with a descriptive diary or long captions filling in the spaces. These became, in effect, illustrated books, some with the fine bindings used for other volumes in her considerable library.

Any study of Queen Alexandra's photographic career should therefore also take into account her love of painting and of books; all three pastimes were interwoven. Her albums contained paintings as well as photographs; she also designed her own book-plate and, of course, published her own book, using her own photographs and descriptions.

In the context of the Royal Photograph Collection, the Queen's albums are unique. Unlike her daughter Princess Victoria, her daughter-in-law Queen Mary, or her sister-in-law, the Duchess of Connaught, whose albums also form part of the Collection, she did not arrange them as a continuous chronology of events. Instead, she concentrated on special projects. She travelled abroad frequently and extensively, and her love of travel inspired a large number of her albums. Others had a different impetus, such as the one recording the history of horses and mares at the Sandringham Stud, or the one combining photographic collages with decorative painting.

The Queen's involvement with photography also reveals perhaps unexpected elements in her relationship with her husband. Photography was a shared interest; it could even be said to have brought them together in the first place. They commissioned and collected work by many photographers and took an interest in, and encouraged, new developments such as stereoscopic photography and films. On one occasion, the Prince of Wales provided his wife with the necessary funds when a bill from W. & D. Downey was due, and on another he gave her a book of photographs of India. She in her turn presented him with the first copy of *Queen Alexandra's Christmas Gift Book* and included a number of snapshots of him in her albums.

The Queen regarded her albums as very much her personal property; on receiving her prints back from Kodak, she would allow no one else to touch them, but would select and paste them into the albums herself. She was clearly proud of them and, indeed, perhaps that is why they have survived. However, she very rarely mentions her own photography in letters. This may have been from modesty, or because it was such a regular occupation that it did not need comment. She did once refer to one of her photographs 'which I think is excellent'[2] in a way which may have been meant in fun, but it seems that she rated her endeavours with camera and brush at a very modest level. This may partly have been because it was 'not done' for ladies to boast of their achievements; it may also have been the case that adverse comments about her intelligence, however unjustified, had had their effect. The Princess was quoted as saying of herself that 'she is not amusing, she knows and she fears she bores you' in 1866 when confessing that she would like to be able to spend more time on her own with Queen Victoria.[3] As Princess of Wales she had not always been allowed to do as she chose; as Queen, she determined to have her own way, and the King, although inclined to keep public duties to himself,[4] gave her full credit for her own achievements, such as her *Christmas Gift Book*.

The immediacy of the snapshot suited Queen Alexandra's personality; impulsive and sometimes impatient, she often found it irksome to pose for long sittings with artists or photographers. On one occasion, after waiting for a cameraman to take a group picture, she turned

Queen Louise of Denmark,
Floral painting: primroses and auriculas,
date unknown
Oil, diameter 22.5cm (8⅛")
Amalienborg, Copenhagen

This painting, influenced by the work
of the flower painter I.L. Jensen, displays
considerable skill and understanding of
forms and techniques.

Prince Christian's guardian, Frederick VI, had died in 1839, being succeeded by his first cousin, Christian VIII, who died in 1848 and was succeeded by his son Frederick VII. But the new King, who was almost 40 years old on his accession, was childless and it became imperative to nominate an heir to the throne. Prince Christian's brother-in-law, Prince Frederick of Hesse-Cassel, had the best claim, but after discussion and negotiation he transferred this claim to his sister, Princess Louise, who then transferred it to her husband. Christian was recognised by the Great Powers of Britain, France and Russia as heir to the Danish throne in 1852 and this was ratified in Denmark by the passing of the Law of Succession in 1853.

As heir, Prince Christian's title changed to Prince of Denmark, he became a member of the King's Council, was given an allowance of 80,000 rigsdaler and was able to live at Bernstorff Palace, a pleasant country house in extensive grounds on the outskirts of Copenhagen.[2] Here his children enjoyed going for walks, riding, playing with their dogs and other outdoor activities. They were also open to certain literary and artistic influences; Princess Christian was a talented artist and Princess Alexandra inherited this skill as well as a lifelong love of books, perhaps inspired by her parents' library, which included many fine bindings.[3] She and her siblings, Prince Frederick, Prince William, Princess Dagmar, Princess Thyra and Prince Valdemar, were strictly and religiously brought up, but in a secure and loving atmosphere. Both parents cared deeply for their children and Princess Christian, intelligent, astute and ambitious for her family and for Denmark, recognised how important it was that they should become better known, not only to strengthen their own position in Denmark, but to improve Denmark's status with regard to the rest

of Europe. She seems to have realised that photography could be used to further both these aims and, when the time came, to bring her beautiful daughters to the attention of eligible foreign princes.

The earliest known photograph of Princess Alexandra, showing her with her sisters, Princess Dagmar and Princess Thyra, and a pony, was taken by the firm of Kirchhoff & Henschel in 1856, when she was in her twelfth year. Sixty of her school exercise books, dating from 1854 to 1862,[4] survive and they reveal that at the age of 12, besides Danish she was already learning French and German, as well as English, which she had spoken since early childhood with her English nurses. She had no pretensions to extraordinary academic ability; her father, who regarded his own intellectual powers as mediocre, once commented that she was 'not brilliant'.[5] However, this opinion, honestly expressed, was unduly pessimistic. Alexandra was eager to learn and pursued her interests with tenacity and enthusiasm, as she would continue to do throughout her life. She studied music and drawing from an early age, first with her mother and then with a

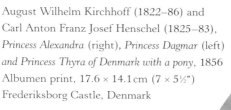

August Wilhelm Kirchhoff (1822–86) and
Carl Anton Franz Josef Henschel (1825–83),
Princess Alexandra (right)*, Princess Dagmar* (left)
and Princess Thyra of Denmark with a pony, 1856
Albumen print, 17.6 × 14.1 cm (7 × 5½")
Frederiksborg Castle, Denmark

The earliest known photograph of
Princess Alexandra and her sisters.

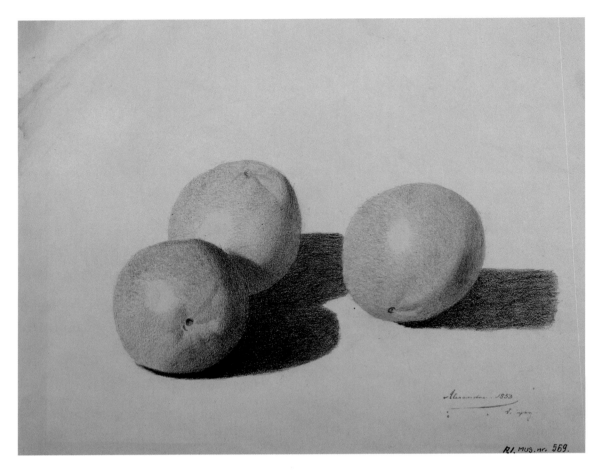

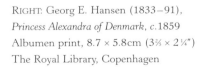

ABOVE: Princess Alexandra of Denmark,
Still life: fruit, 1853
Watercolour over pencil, 23.9 × 29.5cm (9³⁄₁₀ × 11½″)
Amalienborg, Copenhagen

Signed and dated 1853, this group is remarkably
impressive for a child of eight.

RIGHT: Georg E. Hansen (1833–91),
Princess Alexandra of Denmark, c.1859
Albumen print, 8.7 × 5.8cm (3⅖ × 2¼″)
The Royal Library, Copenhagen

An early photograph of Princess Alexandra,
taken in the year before her confirmation.

Monsieur Siboni[6] and the artist Heinrich Buntzen (1803–92), Professor at the Royal Academy in Copenhagen, who was also Princess Christian's art master. Alexandra showed great promise in both these activities. Her German teacher was a Pastor Theobald; she learnt history and geography from Professor Petersen and English from Froken Mathilde Knudsen.[7] To the last, in particular, Alexandra showed great affection and loyalty, keeping in touch with her for many years and visiting her when returning to Denmark for holidays. One of her youthful English exercises contains the sentence 'at last perseverance was crowned with success' – an early reference to a favourite precept of the Queen in later life that there was 'nothing like perseverance'. Another exercise, written in 1858, relates the story of 'Madcap Harry', a 'young prince of Wales' who 'had played wild pranks in his youth and this gave his poor father a great deal of pain and trouble. He had a good friend, an old fat fellow called Sir John Falstaff [who] spent all his time in eating and drinking.'[8] The story confirms Alexandra's interest in Shakespeare, but it also hints at another trait in her disposition. Devoted to her brothers and, later, her sons, the Princess always had a certain sympathy for mischievous boys.[9]

Princess Alexandra's other occupations included sewing,[10] and her interest in pretty clothes made her, in due course, one of the best-dressed women of her time and a leader of fashion. She enjoyed reading and gardening but was also adept at riding, gymnastics, deportment and dancing; she is said to have invented some fancy dances in her youth.[11] She became a traveller for the first time as a small child, when she was taken to a gathering at Rumpenheim, near Frankfurt, the home of her mother's family, the princes of Hesse-Cassel.[12]

The influence of these elements in her upbringing was to be continuous; her affections and predilections were constant. Her strong and abiding religious faith impressed Pastor Paulli, the minister who prepared her for confirmation.[13] But although her character had this serious aspect, Alexandra was of a cheerful and optimistic nature, delighting in fun and jokes and with a fine sense of the ridiculous.

Her confirmation on 20 October 1860, when she was nearly sixteen, heralded her entry into the adult world. Although she had been photographed with her sisters in 1856 and with other members of her family in 1859, few pictures showed her on her own. Now, as an adult, she had more portraits taken, her mother being aware that the time was approaching when a husband should be sought. At the same time Queen Victoria and Prince Albert were looking for a wife for their eldest son, Albert Edward, Prince of Wales. They had received reports of a number of young princesses; far down the list, and included reluctantly because of her Danish connections, was Princess Alexandra. She, whose family had been regarded as too German in Denmark, was paradoxically seen as not German enough by the Queen and Prince, whose eldest daughter had recently married the son of the heir to the Prussian throne.[14] But in October 1860, at Windsor Castle, they met Countess Walburga Paget, the young wife of the British Minister in Copenhagen. Sitting next to the Prince Consort at dinner, the Countess was brave enough to introduce the subject of the Prince of Wales's future marriage. She mentioned that her husband had often seen Alexandra 'and thought her the most charming, pretty and delightful young Princess it was possible to imagine'.[15]

Erwin Hanfstaengl, *Princess Alexandra of Denmark* (centre) *with
her brothers, Prince Frederick* (standing, centre) *and Prince William,
and sisters, Princess Dagmar* (left) *and Princess Thyra, c.1859*
Ambrotype, 11.6 × 8.8 cm (4 ½ × 3 ⅖″)
Frederiksborg Castle, Denmark

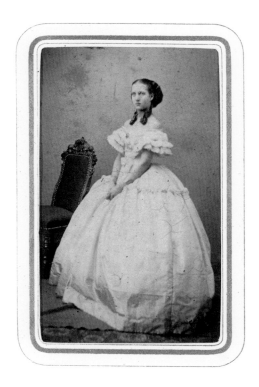

E. Lange (active *c*.1854–60s),
Princess Alexandra of Denmark, 1860
Albumen print, 8.3 × 4.8cm (3¼ × 1⅞″)
RPC 01/0184/3a

This was one of the photographs that brought
the Princess to the notice of Queen Victoria and
Prince Albert as a possible wife for their son.

Unknown photographer, *Princess Alexandra
of Denmark*, Neu Strelitz, 3 June 1861
Albumen print, 8.3 × 4.8cm (3¼ × 1⅞″)
RPC 01/0184/5a

Queen Victoria wrote on the back of this
photograph that it had been 'so much admired
by my beloved Angel'; Prince Albert had
declared, on seeing the first photograph of
the Princess, that 'from that Photograph I wd.
marry her at once'.[16]

Georg E. Hansen, *Princess Alexandra of Denmark*,
July 1862
Albumen print, 8.3 × 4.8cm (3¼ × 1⅞")
RPC 01/0184/8a

On the back of a copy of this photograph the
Princess wrote, 'An Bertie von Alix. d. 10ten
Sep. 1862. My lips cannot tell you half as much
as my heart feels for you, my beloved Bertie.'

Ghémar Frères, *An engagement portrait of Albert
Edward, Prince of Wales, and Princess Alexandra
of Denmark*, September 1862
Albumen print, 8.3 × 4.8cm (3¼ × 1⅞")
RPC 01/0184/11b

As a result of this conversation, Queen Victoria and Prince Albert appear to have asked their eldest daughter, Victoria, Princess Frederick William of Prussia, to collect more information about the Danish Princess, and on 7 December Princess Frederick William sent them a photograph, by which they were immediately captivated. She then sent another, equally charming, but at this stage it was thought unwise to let the Prince of Wales see it, lest he should fall in love with the sitter before his parents had finally persuaded themselves that the match was acceptable. Several stories were told about the circumstances in which he did eventually see this portrait of his future wife. One had the Prince of Wales, in company with some friends, being shown a photograph of the fiancée of one of them. The Prince was admiring the hand-coloured portrait of the beautiful girl when the other young man, in some confusion, realised that he had by mistake given the Prince a picture of Princess Alexandra, which his fiancée had been colouring. The Prince laughingly refused to give back the photograph, saying that he would keep it for himself. A few days later he saw a miniature of Alexandra at the home of their mutual great-aunt, the Duchess of Cambridge, and became even more anxious to make her acquaintance.[17]

Whatever the case, discreet enquiries on the part of Victoria and Albert led to Alexandra and the Prince being introduced to one another after a carefully staged 'accidental' meeting on 24 September 1861 at Speyer Cathedral in Germany, which the Prince was visiting with his sister and brother-in-law, and the Princess was visiting with her family. 'The reverse of indifference on both sides soon became quite unmistakable'[18] and the two parties travelled together to Heidelberg, where they 'happened' to be staying at the same hotel. Before saying goodbye, the young couple exchanged signed photographs. But three months later, on 14 December, the Prince Consort died at Windsor, and the Prince of Wales and Princess Alexandra were not to meet again until the autumn of 1862, at Laeken in Belgium, where, on 9 September, they became engaged.

In November 1862 Alexandra travelled with her father to England to stay with Queen Victoria 'on approval', the prospect of which caused her considerable apprehension.[19] The Queen, however, was delighted by the lovely young girl who showed such sympathy to her in her recent bereavement, and commented that Alexandra had 'plenty of sense and intelligence, and is, though very cheerful and merry, a serious solid character not at all despising enjoyments and amusements but loving her home and quiet – all much more'.[20] This combination of qualities was part of the Princess's charm; many years later, Lord Esher would write of Queen Alexandra that it was the mixture of 'ragging and real feeling' which was so attractive about her.[21]

On 7 March 1863, Alexandra and her family landed at Gravesend, to be met by the Prince of Wales and an admiring crowd of well-wishers, and on 10 March the young couple were married in St George's Chapel, Windsor Castle. It may be fanciful to say that, without photography, Alexandra might not have become Queen of Great Britain, but it is certainly true that the art of photography had given evidence in her favour at a crucial moment. In addition, the marriage of the Prince and Princess of Wales gave the impetus for the expansion of royal wedding photography.

When the Princess Royal had married Prince Frederick William of Prussia in 1858, the only photographs taken showed the bride, with and without her parents, the bridesmaids, three of the bride's sisters, her wedding lace, and the cake. At her sister Alice's wedding in 1862, a subdued

occasion which took place while the royal family was still coming to terms with the Prince Consort's death, the only photographs appear to have been of the bride and her wedding lace. Until 1863 there were no photographs of royal bridal couples, or of royal family wedding parties.

However, the dynastic and personal significance of the marriage of the heir to the throne provided a good reason for more generous documentation; the royal family was also more accustomed to being recorded in this way, and photographic techniques had improved. The first pictures celebrating Edward and Alexandra's marriage appear to have been a series of at least sixteen versions of groups taken on 9 March, the day before the wedding. These show the bride and groom with members of their immediate families, with the exception of Queen Victoria, who was not present. It is likely that these photographs were later used as reference material by the artist Henry Nelson O'Neil (1817–80), who was commissioned to 'record' the arrival of Princess Alexandra at Gravesend. By the time work on his painting was under way, the wedding was over and the Danish royal guests no longer available for sittings. However, as O'Neil later remembered, 'the Prince and Princess lent me admirable photographs' as reference material.[22]

Other photographs were taken of the interior of St George's Chapel and of the rooms in the temporary structure built next to it for the use of the royal family and others during the ceremony. A series showing the bridal pair in their wedding clothes, alone and together, was taken after the event. This may have been because Queen Victoria's emotional tension at her eldest daughter's marriage in January 1858 had been so great that the single image showing her with her husband and daughter on the actual wedding day was blurred by her inability to stop trembling. It may have been decided that it would be better if the photographs were taken well after the Prince and Princess of Wales's wedding, when emotions had subsided. The photograph showing them in their carriage as it drove away from the Quadrangle at Windsor Castle on the way to their honeymoon at Osborne House was, however, taken on the wedding day itself.[23]

The wedding photographers were Vernon Heath (1819–95) and John Jabez Edwin Mayall (1810–1901). Mayall, whose work was well known to the royal family and who had taken photographs of them since 1855, was responsible for the studio portraits. Vernon Heath, who gave photography lessons to Queen Victoria's second son Prince Alfred[24] and who had taken the last photographs of the Prince Consort, in July 1861,[25] took the remaining pictures. In his memoirs, published in 1892, Heath described how he was initially consulted about the possibility of photographing the Prince of Wales's wedding ceremony in the chapel and how he conducted experiments on site until he felt able to report that, given a fine day, success might be achieved. With the help of the Castle officials he was given a position in front of the organ loft and his assistants were allotted a side chapel below.[26]

Everything now depended on the weather, which, as luck would have it, was good. Heath arrived at his place early and the plan was that photographic plates would be passed to him throughout the ceremony by means of a wooden trough, which formed a communicating channel between the organ loft and the side chapel. He would keep exposing the plates and returning them below, without waiting for any special opportunities, 'taking, therefore, my chance as to the results'. At the end of the ceremony there was a long wait while the assistants developed the

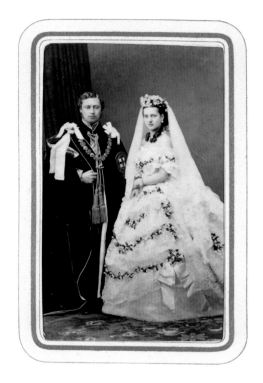

J.J.E. Mayall (1810–1901),
Princess Alexandra of Denmark with a book,
Windsor Castle, November 1862
Albumen print, 8.3 × 4.8cm (3¼ × 1⅞″)
RPC 01/0184/21b

One of several photographs taken while
Princess Alexandra was staying with
Queen Victoria for 'vetting' before her
marriage.

J.J.E. Mayall (1810–1901),
The Prince and Princess of Wales in wedding clothes,
photographed on 18 March 1863
Albumen print, 8.3 × 4.8cm (3¼ × 1⅞″)
RPC 01/0184/25a

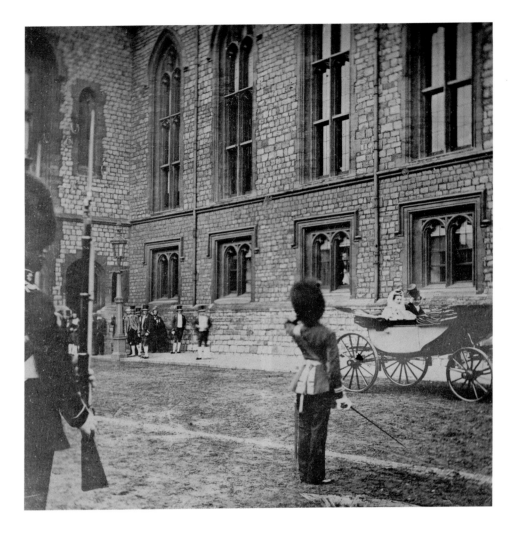

Vernon Heath (1819–95),
*Departure of the Prince and Princess
of Wales from Windsor Castle*, 1863
Albumen print,
14.4 × 13.5cm (5¹¹⁄₁₆ × 5⁵⁄₁₆″)
RA.F&V/Weddings/1863.EVII:press
cuttings volume, p.63 (photograph)

The royal couple leaving for their
honeymoon at Osborne House,
10 March 1863.

plates. Queen Victoria sent a message to find out what was happening, and eventually Heath was able to report that 'though the success was not considerable; under the circumstances it was quite as great as I could have hoped for'.[27] Heath finally submitted three or four negatives for the Queen's inspection (as was then the custom, the negatives were printed up at Windsor Castle). They included an 'especially good' one taken when the bride and groom were kneeling at the altar.[28] In the afternoon of 10 March, Heath took the photograph of the young couple leaving for their honeymoon.[29]

Heath was not the only person in the chapel who had been instructed to record the wedding. William Powell Frith (1819–1909) had been commissioned by Queen Victoria to paint the ceremony. He was used to working partly from photographs, and as the Princess of Wales was too occupied to give him a sufficient number of sittings, it was suggested that she should have her photograph taken, in the requisite pose, to provide reference material. The photographer chosen to carry this out was again Vernon Heath.[30]

The Princess duly came to Heath's studio, but the session 'was far from successful, negative after negative being spoilt'. Disheartened, Heath went to fetch another plate and returned to the studio to find the Princess, looking weary, leaning on a pillar (one of the studio accessories), with her head supported by her arm. Heath was so struck by the pose that, although it was not what Frith had specified, he asked the Princess to remain as she was while he took a photograph. After that the session went better and he obtained a picture suitable for Frith's purpose. However, Heath kept the one of the pose which had impressed him so much, as he had another purpose in mind for it.[31]

1 Information from Tove Thage.

2 When Frederick VII died on 15 November 1863, Alexandra's father became King as Christian IX. This was eight months after her marriage, on 10 March.

3 Jørgen Hein and Gerda Petri, trans. Marianne Nerving and Paulette Møller, *The Royal Danish Collection. Christian VIII's Palace, Amalienborg*, Copenhagen 1999, p.12

4 Private collection

5 RA.VIC/QVJ/1862: 3 Sep.

6 Presumably the son of Giuseppe Siboni (1780–1839), who founded the Royal Conservatory in Copenhagen in 1821 and was director of singing at the Royal Opera.

7 Mrs C.N. Williamson, *Queen Alexandra, the Nation's Pride*, London 1902, p.17

8 Private collection

9 In her autobiography Baroness de Stoeckl, a friend of the royal family, describes how during World War I Queen Alexandra's carriage was about to drive through the gates leading to the arch at Constitution Hill in London, when a small boy on a bicycle, 'whistling at the top of his voice', forestalled it by slipping past in front of the horses, waving cheerfully as he disappeared in the direction of Belgrave Square. The Queen was highly amused, and when the police, who had failed to stop him, sent abject apologies the next day, she said, 'Nonsense. Why shouldn't the boy have passed? I would, if I had been he' (Baroness de Stoeckl, *Not All Vanity*, ed. George Kinnaird, London 1950, p.161).

10 Williamson, *op. cit.*, pp.14, 18, 19, 20

11 *ibid.*, p.19

12 James Pope-Hennessy, *Queen Mary*, London 1960, p.53

13 Williamson, *op. cit.*, p.25

14 Queen Victoria's dislike of Denmark is said to have stemmed from the ill-fated marriage of her great-aunt, Princess Caroline Matilda, to the mentally ill King Christian VII. The question of the duchies of Slesvig (the Danish version of the name) and Holstein exacerbated this. Slesvig was ancient Danish territory; Holstein, linked to it since 1481, was more German in sympathy, and in the 1840s Slesvig seemed about to change allegiance. The war that followed ended with a victory for Denmark and the duchies were confirmed as Danish. However, German, and particularly Prussian, interference continued. The Danes reacted by incorporating Slesvig fully into Denmark, thus breaking the terms of the peace treaty, which had specified that the two duchies should not be separated. The act ratifying this move, signed in November 1863 by the new king, Christian IX, precipitated a crisis: the German Duke of Augustenburg proclaimed himself Duke of Schleswig-Holstein, supported by the new Prussian minister of state, Otto von Bismarck. On 1 February 1864 the combined Austro-Prussian army marched north; Denmark was forced to surrender the two duchies. Two years later Prussia turned on Austria and seized them for herself. (Palle Lauring, *A History of Denmark*, Copenhagen 1999, Chapters 10 and 11.)

15 Georgina Battiscombe, *Queen Alexandra*, London 1969, p.19

16 RA.VIC/Z 13/49

17 Other versions had the Prince of Wales being shown a photograph of the Princess while staying with an Italian prince for a few days' sport at his shooting box, or being shown it by chance, by a gentleman wishing to interest him in photography. Elizabeth Villiers, *Queen Alexandra the Well-Beloved*, London 1925, pp.40–42

18 Battiscombe, *op. cit.*, p.27

19 Philip Magnus, *King Edward VII*, London 1964, p.60

20 *Dearest Mama: Private Correspondence of Queen Victoria and the Crown Princess of Prussia, 1861–1864,* ed. Roger Fulford, London 1968, p.131

21 Battiscombe, *op. cit.,* p.248

22 National Portrait Gallery, NPG 5487. O'Neil put himself at the edge of the painting as one of 'the important persons' but was chided by the Prince and Princess, who said that he should not have 'stuck himself in the corner'.

23 In a letter to Princess Frederick William on 18 March 1863, Queen Victoria commented on her son's and daughter-in-law's return from honeymoon and mentioned that 'they have been photographed together this morning in their wedding dresses! Later they will be done with me'. Fulford, *op. cit.,* p.182. As in the case of the Princess Royal's wedding, the cake was also photographed, on an unrecorded date. The couple, in what seem to be their 'going away' clothes, posed with Queen Victoria and a marble bust of the Prince Consort, and with other members of the royal family, on or after 18 March.

24 Vernon Heath, *Recollections,* London 1892, p.52

25 *ibid.,* pp.111–15

26 *ibid.,* pp.114–15

27 *ibid.,* pp.145–6

28 This has not subsequently been found.

29 Heath, *op. cit.,* pp.146–7

30 *ibid.,* pp.147–8. See Jeremy Maas, *The Prince of Wales's Wedding. The Story of a Picture,* London 1977

31 *ibid.,* pp.148–9

CHAPTER 2
THE FIRST ALBUMS

Princess Alexandra had married into a family that was fascinated by photography. Queen Victoria and Prince Albert, serious patrons and collectors of the medium, had been intrigued by its possibilities since 1840, when they were first shown some daguerreotypes. A daguerreotype of the Queen, with the Princess Royal, was made in about 1845 and portraits of Prince Albert were taken in 1842 and 1848. In the latter year the first photograph in *Portraits of Royal Children* (a series of volumes that eventually extended from 1848 to 1899) was taken, and by the 1850s a number of photographers[1] were recording the life and appearance of the royal family. Thus by 1856, when Alexandra probably had her first picture taken, her future husband, the Prince of Wales, was thoroughly accustomed to the process and was being encouraged by his parents to take an interest in it.

Born in 1841, two years after the beginning of the photographic era and therefore unable to remember a time when photography did not exist, the Prince of Wales took a different attitude to it from that of his parents. For him, the ability to make pictures with a camera would not have appeared particularly extraordinary. In the 1850s he began to visit photographic exhibitions, including a display at the Polytechnic Institution on 10 May 1855, where he saw what Queen Victoria described as 'a rather long though pretty illustration of the Voyages of Sinbad, the Sailor, by photos'.[2] On 7 June 1856 he and his tutor, Mr Gibbs, visited the 18-year-old Maharajah Duleep Singh at his guardian's house in Roehampton and, according to the Prince's diary, 'he photographed me twice & I did him once'.[3] This was perhaps the first photograph that the Prince ever took. The Maharajah had been taught how to take photographs by Dr Ernst Becker, Prince Albert's German librarian, who was also a skilled photographer. The Prince of Wales probably used the Maharajah's camera on 7 June but, having already seen a number of works by other people and having become a subscriber to Roger Fenton's *Crimean War* series, he now decided to purchase a camera for himself. Thus on 18 June 1857, the 15-year-old Prince wrote that 'in the afternoon I went to Horne & Thornethwaite's and ordered myself a Photo. Apparatus as I am going to learn to Photo'. The equipment arrived and on 23 June 'I photographed for the first time'. There is no mention of the person who taught him to do this, but it is likely to have been Dr Becker. There are three other references to his having taken photographs, on 24 and 29 June and on 4 July.

Four photographs by the Prince, of Viscount Valletort and the Reverend Charles Tarver, are preserved in one of Queen Victoria's albums, and an invoice indicates that eleven positives were printed for the Prince of Wales in July 1857 by the Photographic Institution at 168 New Bond Street, London, for eleven shillings.[4] These may have been his own work. According to monetary values at the time the cost was fairly high and, as it would have been paid out of the Prince's

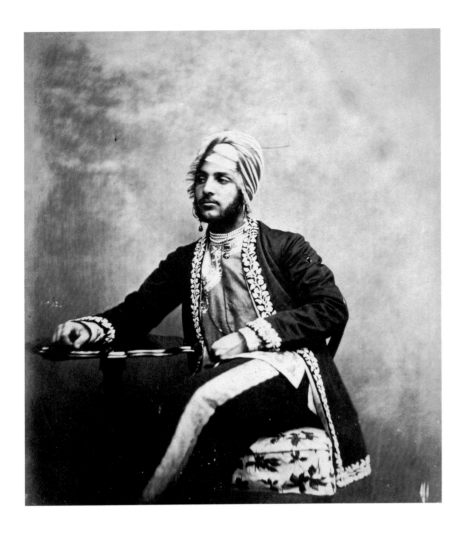

Albert Edward, Prince of Wales,
Maharajah Duleep Singh, Roehampton,
7 June 1856
Print on salted paper,
19.3 × 16.2cm (7⅝ × 6⅜")
RPC 03/0055/26

Maharajah Duleep Singh of Lahore (1838–93)
was deposed as a boy by the British East India
Company when they annexed the Punjab in
1849. They gave him a pension and appointed
as his guardian Dr John Login, who had a
house in Roehampton. The Maharajah settled
in England, meeting Queen Victoria in July
1854 and staying with the royal family at
Osborne House. His friendship with them
lasted for the rest of his life.

personal allowance, this may be one reason why his attempts at photography appear to have come
to an end. No further references to it have been found. Another factor may have been that his
younger brother, Prince Alfred, took up photography too and set about producing considerable
numbers of prints. Did the Prince of Wales, as elder brother, make a dignified withdrawal from the
potential contest?

Whatever the case, the Prince still remained interested enough in photography to begin a
collection of prints. They included portraits, but these were not a primary concern, as they were
for Queen Victoria. The Prince of Wales was much more gregarious and more widely travelled than
his parents, and his interest was in collecting travel and topographical photography.

This interest began early in his life when in 1862 he took the photographer Francis Bedford
(1816–94) with him to record monuments and notable sights during his tour of the Near East
(see opposite). (Bedford had already produced photographs of Coburg and Gotha for Queen
Victoria to give to her husband as birthday presents in 1857 and 1858.) The tour of 1862 resulted
in a collection of at least 180 prints, and the Prince of Wales also possessed images of the Near
East by other photographers, such as Maxime du Camp (1822–94).

By the time of his marriage in 1863 the Prince of Wales had collected about 1,000 photographs, and Princess Alexandra might well have been prompted by her husband's interest to learn more about the medium. Her wedding presents certainly led to the enlargement of her own photography collection. The jewellery that she received was photographed by the London Stereoscopic and Photographic Company; one piece, given by her eight bridesmaids, was a bracelet containing their portrait photographs. Another present, a book of forty albumen print copies of drawings of views, gardens, buildings and interiors, given and perhaps executed by her cousin Adelheid, Duchess of Nassau, showed how art and photography could be used in conjunction.

At Easter 1863, shortly after their wedding, the Prince and Princess of Wales moved into their

Francis Bedford (1816–94), *Excavated temple at the base
of the Sphinx, Ghizeh*, 4 March 1862
Albumen print, 24.4 × 29.5cm (9⅗ × 11⅗″)
RCIN 2700865

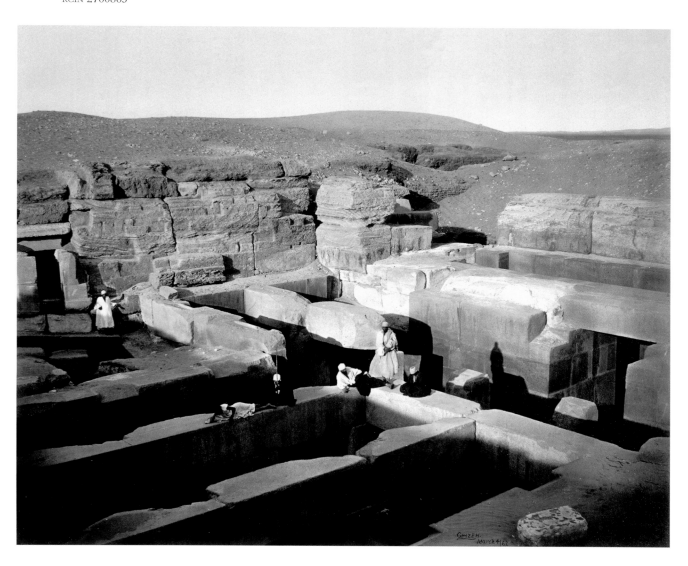

new residence, Sandringham Hall (now Sandringham House) in Norfolk. It was to be their country home for the rest of their lives. The Prince liked entertaining on a large scale but, although Alexandra enjoyed offering hospitality, she regarded Sandringham as a family home, especially after her five children were born, between 1864 and 1869. It also became the centre of a wider community; housing was built locally by the Prince for his staff and tenants. Many of the staff stayed for decades and became more like friends than servants. One was Frederick Ralph, Usher of the Servants' Hall from 1863 to 1902, who also ran a successful photographic business in the neighbouring village of Dersingham.

On 7 January 1864 the photographer Vernon Heath was summoned to Frogmore House, Windsor, to record a game of ice hockey, to be played by the Prince of Wales and his friends on Virginia Water at the southern end of Windsor Great Park.[5] But the cold was so intense that it froze the collodion (a gluey solution used on the photographic plates) and photography was impossible. The Prince, said Heath, 'made light of our disappointment and told me to go and get a pair of skates'.

The Princess of Wales, who was expecting her first child, had been brought to Virginia Water to watch the game. She left early, followed later by the Prince and, at dusk, by Heath and the rest of the party. On returning to Frogmore to collect his apparatus, Heath was astounded to learn that the royal baby had already been born, two months earlier than expected.[6]

Heath now remembered the photograph which he had taken of the Princess the previous summer, with her head resting on her arm. While working on another commission he had photographed a 'Mrs Noble's baby' in a cot. By combining the two negatives, Heath produced a print apparently showing the Princess of Wales standing by a cot and looking down at the child in it. On the day of the christening of Prince Albert Victor of Wales, Heath took one of the 'combined prints' to Marlborough House, where it was shown to, and praised by, the Prince of Wales. Heath then ventured to ask whether he might, when convenient, photograph the new Prince and insert him into the cot in place of Mrs Noble's baby.[7]

This amused the Prince, who commented, 'Better leave it as it is; why, at that age, one child is so like another that there can be no necessity for the change.' Heath acquiesced, but privately 'held to my project', and in April 1864, at Sandringham, he was able to carry it out. Summoned to Sandringham to photograph the house and grounds for an album of views for Queen Victoria's birthday, Heath also took a group of the Prince and Princess with their son in the conservatory, and 'ventured to remind His Royal Highness of my desire to substitute his child for Mrs Noble's child in the photograph he had seen'. The Princess was happy to comply and held her son in the position required, so that Heath got his wish. The resulting combination print was so successful that it, and the conservatory group, were eventually engraved by Holl and published as 'Dedicated by command to Her Majesty'.[8]

The visit to Sandringham afforded Heath further opportunities for photography, including a picnic party at Hunstanton and the Prince of Wales's magnificent but ferocious Indian mastiffs. Heath was so pleased with this latter picture that he sent a copy to the celebrated animal painter Sir Edwin Landseer (1802–73). The photograph was later published and proved a great success.[9]

Engraving by William Holl (1807–71)
after a photograph by Vernon Heath (1819–95),
published on 28 November 1864
by Moore, McQueen & Co. in London
and François Delarue in Paris,
The Prince and Princess of Wales with their
eldest son, Prince Albert Victor, April 1864
Engraving, 21.6 × 17.7cm (8½ × 7″)
RCIN 606275

This group is based on a photograph
taken in the conservatory at
Sandringham. The infant Prince
is wearing a sash decorated with
Danish flags.

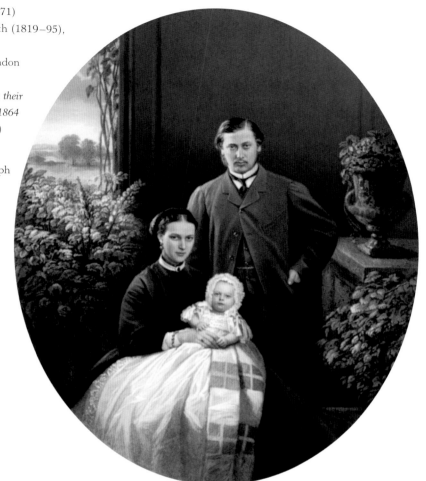

In the early years of their marriage the Prince and Princess of Wales sat for numerous photographers.[10] A sample year, 1865, demonstrates this. On 1 April, 'Alix & I with Eddy were photographed by Mr Window in our Conservatory.' On 13 April, at Sandringham: 'After luncheon we & the whole party were photographed (in a group) by Mr Pridgeon, a Lynn photographer, & the result was satisfactory.' On 8 July, at Windsor, 'Our whole morning was spent with Mr Saunders, the Eton photographer, who took Alix and me & the children in the Conservatory.'[11] (This was the day after the christening of Prince George of Wales, the couple's second son, later to become King George V, in the Private Chapel at Windsor Castle.) They also included photographic exhibitions in their joint visits to art galleries.[12]

Having studied art with her mother and Professor Buntzen in Denmark, Alexandra had her first drawing lessons in England from William Leighton Leitch (1804–83). Much of her early work was in monochrome tones, using either pencil drawing or pencil and wash. She thus became practised at translating the multiple colours of objects and views into shades of grey or brown – a discipline directly related to the understanding of how monochrome photography would convey

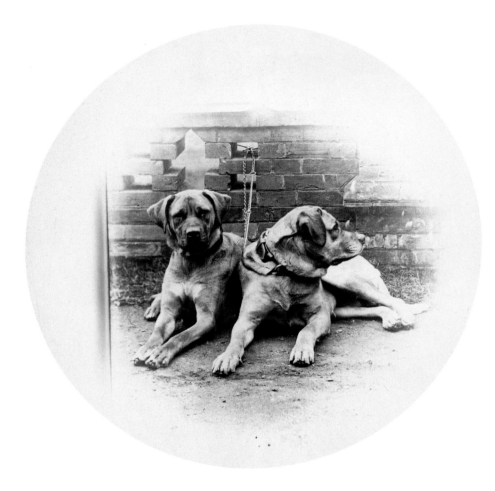

Vernon Heath (1819–95),
The Prince of Wales's Indian mastiffs,
April 1864
Albumen print,
19 × 19cm (7½ × 7½")
RCIN 2102251

This was taken for the album of views which was to be presented to Queen Victoria for her 45th birthday. The dogs' restlessness made them impossible to photograph. Heath eventually had an inspiration, telling the dogs' keeper to hide behind one of the columns on the terrace, but to take care that the animals should not see him. At a given signal, the keeper was to whistle as though calling the dogs. The result was 'magical! Forward came the ears of both dogs – one looked ahead, the other turned his head in the direction of his left shoulder, the massive paws of each were stretched in front, and then off came the cap of my lens.'

Jabez Hughes (1819–84),
*Queen Victoria and her daughter Alice,
Princess Louis of Hesse* (left), *with the
Princess of Wales, July 1864*
Albumen print,
5.3 × 7.8cm (2⅟₁₆ × 3⅟₁₆")
RPC 01/0176/15d

The Princess of Wales's smiling face enlivens this otherwise rather serious group.

multicoloured real life. But she enjoyed the use of colour as well, as is graphically demonstrated in three albums that she compiled in the 1860s after coming to England.

One of these is a small volume of *carte-de-visite* portraits of heads of state, *Monarchs of the World*, covering not only Europe but also Turkey, Egypt, China, Japan, America and Madagascar (see below). Information about the sitters is given in decorative lettering and each page has, at the top, a golden emblem with the name of the relevant country written on it in red. At the beginning of the book is an *Index of Reigning and other Powers*, in which the illuminated lettering is surrounded by a gold background decorated with delicate leaf designs in red, blue and green. The album, which has a double 'A' monogram on the front cover, can be identified as the Princess's property, and the embellishments are typical of her work.

The other two albums resemble one another closely; one is kept in the Danish Royal Collection at Frederiksborg Castle in Denmark, while the other is part of the Royal Photograph Collection at Windsor. The album at Frederiksborg was originally bought, with blank pages, from the London firm of Howell & James and it has a metal cartouche on the front cover bearing the name 'Louisa'. This might indicate some connection with the Princess of Wales's mother

King Christian IX and Queen Louise of Denmark, c.1864–6
Albumen print; painted decorations.
Page size: 13.6 × 20.4cm (5⅜ × 8″)
RPC 01/0116/9

The Princess of Wales's parents, photographed by
Georg E. Hansen (the King) and E. Lange (the Queen).

Attributed to Alexandra, Princess of Wales,
Index of Reigning and other Powers, *c.*1864–6
Watercolour and gold,
Top: Left title page 13.6 × 20.5cm (5⅜ × 8 1/16″);
Above: Right title page13.5 × 20.3cm (5⅜ × 8″)
RPC 01/0116/frontispiece

The title pages of this album are decorated
and illuminated in a style typical of the work of
the Princess, to whom it belonged.

Alexandra, Princess of Wales,
*An unfinished page, c.*1867
Albumen print, watercolour, pencil,
29 × 21.7cm (11⅖ × 8½")
Frederiksborg Castle, Denmark

A page showing a photograph of Queen
Olga of the Hellenes (1851–1926), which
Princess Alexandra planned to decorate with
painted foliage. It is possible to see how
the Princess created these pages, because
several of the designs remain unfinished.
In some of them she started with the
painting; for example, a geometrical lattice
pattern of diamond shapes, already
painted, never received the photographs
that were intended for each space.
In others, she put the photograph on the
page first, as here. Grand Duchess Olga
Constantinovna of Russia married King
George I of the Hellenes (who, born
Prince William of Denmark, was elected
to the Greek throne in 1863) in 1867, and
work on the album probably ceased not
long afterwards. It may have been a holiday
occupation in Denmark, left behind when
the Princess returned to England.

(now Queen Louise since her husband's accession to the Danish throne in 1863). However, the contents of the album bear a strong resemblance to the work of the Princess. The first page has a photograph of Sandringham with the date 1866, and the succeeding sixteen pages have a series of unique designs made up of cut-out photographs with painted borders and decorations. The Prince and Princess of Wales are shown with their two little sons in a trellis and floral design, while Prince Alfred (who had made his career in the Royal Navy) appears in a blue and gold frame with ropes. The Princess's father, King Christian IX, is shown in a patriotic design with Danish flags; and a pink half-egg shape, with leaves, contains smaller eggs with photographs of babies emerging from them. Another page has carefully drawn envelopes scattered over its surface, containing half-revealed *cartes-de-visite*.

In February 1867, a few days before the birth of her eldest daughter, Princess Louise, Alexandra complained of feeling unwell; her malady rapidly developed into a severe attack of rheumatic fever. Her baby was born on 20 February, but she continued to suffer excruciating pain and fever for many weeks afterwards, with no real improvement until 20 April. The Princess was

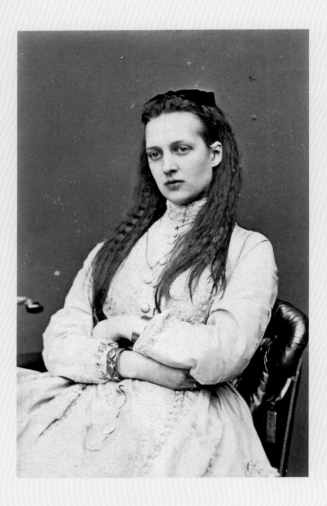

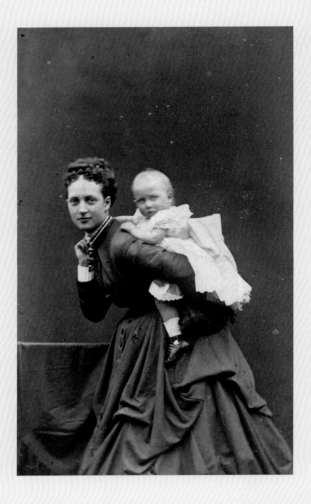

J. Russell & Sons, *The Princess of Wales*, summer 1867
Albumen print, 8.5 × 5.3 cm (3³⁄₁₆ × 2½″)
RPC 01/0177/13c

The Princess during her convalescence from rheumatic fever.

W. & D. Downey, *The Princess of Wales and Princess Louise*,
September 1868
Albumen print, 9.2 × 5.6 cm (3⅝ × 2³⁄₁₆″)
RPC 01/0238/2l

The Princess with her daughter in an informal pose
designed to show that she had recovered from her illness.

not able to walk again until the summer; her right knee remained stiff for some time, and, although gradually responding to treatment, was troublesome for the rest of her life. Another unfortunate result of the illness was that the hereditary form of deafness, otosclerosis, from which Alexandra and her mother both suffered (and which until then had in Alexandra's case been slight), began to worsen.

A photograph taken in 1868 by the firm of W. & D. Downey showed the Princess carrying her daughter on her back. Such an informal pose was unusual, especially for a member of the royal family, and the picture was enormously popular when it was made available for sale to the public. It demonstrated that the Princess of Wales had made a good recovery after her long illness, but, although she bore her problems lightly, she had been left with certain difficulties. Her lame leg meant that her enjoyment of active pursuits was spoilt; nevertheless she did her best to regain her ability to dance and developed a graceful, gliding walk to disguise her limp. She was also able to resume riding by using a specially adapted side-saddle, which allowed her to bend the knee of her left leg rather than her right. She had always been very determined and her innate belief in perseverance must have helped her to overcome her problems. By the beginning of the twentieth century film footage shows that, normally, her limp was hardly noticeable. Her deafness was a much more serious disadvantage: it hampered her enjoyment of music and was a great drawback in the discharge of her social duties. Neither was it comfortable for her to be in a crowd of exuberant relatives, since loud noises caused her physical pain.[13] When listening to familiar voices or those at a certain pitch, she could hear better, but she was now prone to misunderstand much of what was said to her, often causing others to underestimate her intelligence.

Her disabilities also had a profound effect on the way Princess Alexandra regarded suffering in others. As her niece Marie, Grand Duchess George of Russia, remembered, 'she felt everyone's sufferings, worries or anxieties acutely, just as if they were her own'.[14] This played a part in the Princess's increasing interest in nursing, medical practice and the development of new treatments for disease.

Difficulties in hearing and in movement at this time may have encouraged Alexandra to spend longer on artistic projects. The Frederiksborg album remained unfinished, but she had already started another, now at Windsor, which she completed, with a title page and twenty-nine different designs. There is no doubt as to her authorship, since the album contains a slip of paper with a note in Queen Mary's hand stating that it was 'Painted by Queen Alexandra'. The album was probably started in 1866 (this date appears in one of the designs), and apparently finished before the first photograph of her youngest daughter.[15] From the end of 1868 to the spring of 1869, the Prince and Princess of Wales were away on a tour of Europe and the Near East, and one of the designs in the album shows a certain Orientalist influence. The book may therefore have been completed after their return in May 1869, while the Princess was awaiting the birth of Princess Maud, or shortly afterwards.

This delightful album, while closely resembling its Frederiksborg counterpart (for instance, there is another design using photographs in envelopes), displays increased skill and maturity in execution.

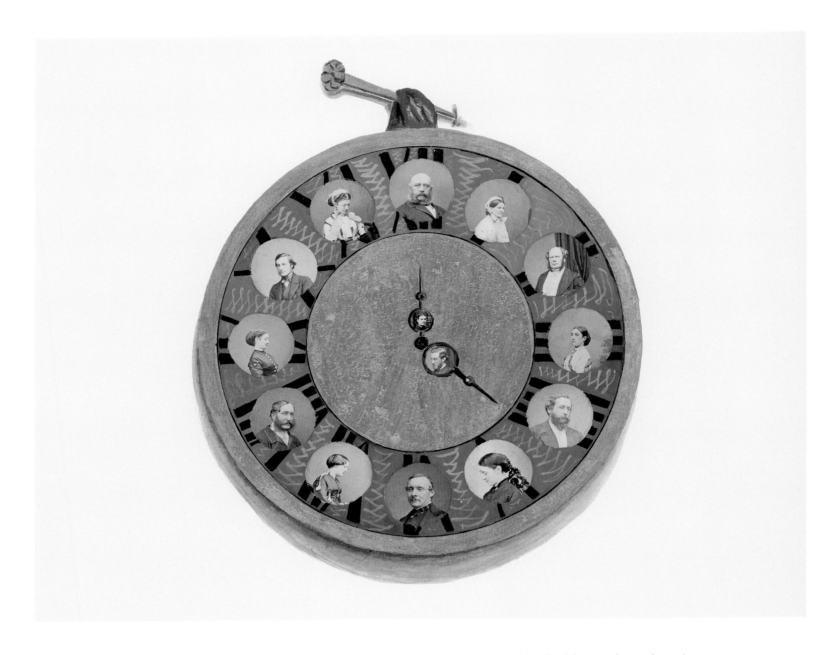

Alexandra, Princess of Wales (photographers unknown),
A design with a clock face, late 1860s
Watercolour and albumen prints,
page size 26.5 × 33.5cm (10⁷⁄₁₆ × 13³⁄₁₆″)
RCIN 2300103

This and the following illustrations are from the album
compiled and painted by the Princess of Wales between
1866 and 1869. George, Duke of Cambridge, is at the top.

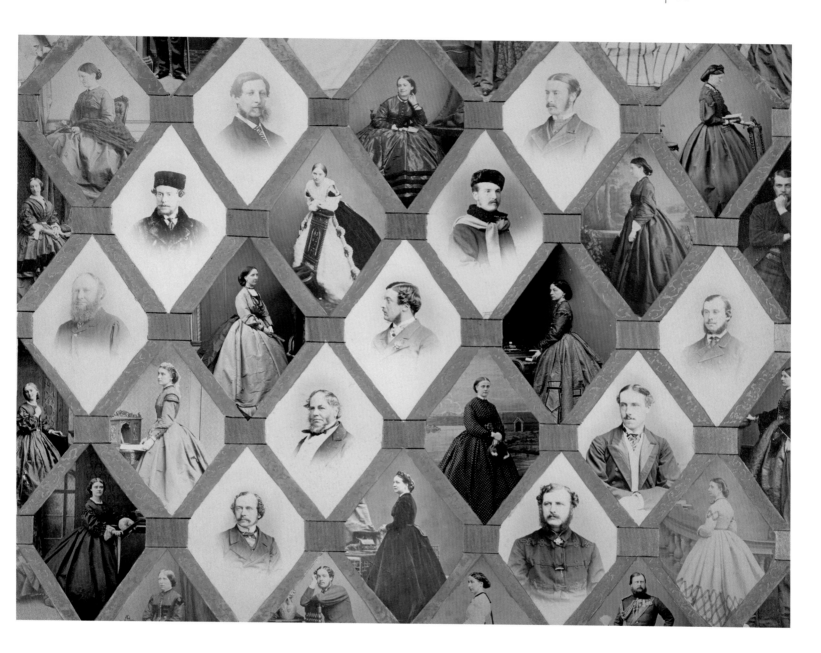

Alexandra, Princess of Wales (photographers unknown),
A geometric design with photographs, late 1860s
Watercolour and albumen prints,
26.5 × 33.4 cm (10⁷⁄₁₆ × 13³⁄₁₆″)
RCIN 2300104

Prince Edward of Saxe-Weimar is in the right-hand triangle
at the bottom edge; Major Christopher Teesdale is in the
second diamond from the right, just above and to the left
of Prince Edward; the gentleman in the Russian-style hat
and scarf, second complete diamond from the right,
second row down, is possibly Sir Arthur Ellis.

Alexandra, Princess of Wales (photographers unknown),
*A design with flowers, using photographs of the Princess of
Wales's children*, late 1860s
Watercolour and albumen prints,
page size 26.5 × 33.3cm (10 ⁷⁄₁₆ × 13 ⅛″)
RCIN 2300116

The date can be calculated from the photographs of the
Princess's children that were used: they include Prince
Albert Victor, Prince George, Princess Louise and Princess
Victoria but not the youngest surviving child, Princess
Maud, who was born in November 1869 and apparently
not photographed until 1870.

Alexandra, Princess of Wales (photographers unknown),
A design with photographs in twig frames, late 1860s
Watercolour and albumen prints,
page size 26.5 × 33.5 cm (10⁷⁄₁₆ × 13³⁄₁₆″)
RCIN 2300108

Shown in the oval at bottom left are Prince Edward of
Saxe-Weimar and his morganatic wife Countess Dornburg.

1 They included William Kilburn, Roger Fenton, William Bambridge, Colonel the Hon. Dudley De Ros, Dr Ernst Becker, Leonida Caldesi, George Washington Wilson, J.J.E. Mayall, T.R. Williams and Antoine Claudet.

2 RA.VIC/QVJ/1855: 10 May

3 RA.VIC/EVIID/1856: 7 June

4 RA.VIC/Add A 5/500/586. Eleven shillings was equivalent to 55p – worth approximately £25 at today's value.

5 Vernon Heath, *Recollections*, London 1892, p.150

6 *ibid.*, pp.151–2

7 *ibid.*, p.152

8 *ibid.*, pp.153–5. The photograph of the Princess with the baby, as described by Heath, has not been found; the nearest approximation to it is RCIN 606309.

9 *ibid.*, pp.155–9

10 See page 181 for a list of photographers employed by them. By this time the Prince had become President of the Amateur Photographic Association.

11 Extracts from RA.VIC/EVIID/1865: 1, 13 Apr.; 8 July

12 For example, they attended an exhibition of photography on 30 October 1873: RA.VIC/EVIID/1873: 30 Oct.

13 Marie, Grand Duchess George, *A Romanov Diary. The Autobiography of Her Imperial and Royal Highness Grand Duchess George*, New York 1988, p.166

14 *ibid.*, p.165

CHAPTER 3
TRAVELS AND INSPIRATIONS

The tour of 1868–9 had taken the Prince and Princess of Wales to Paris, Copenhagen, Berlin and Vienna, before they set off for Egypt, Constantinople and the Crimea, travelling back home by way of Athens, Corfu and Paris. This holiday – her first trip outside Europe – was a particularly memorable one for Alexandra. She loved travelling and sightseeing and, best of all, the holiday was undertaken in company with her husband, who was able to show her the places he had visited in 1862. The visit to Egypt in particular provided her with memories of a time of great happiness, spent in an exotic and romantic setting, which would inspire her many years later. Although undertaken partly for the sake of the Princess's health, it also gave the Prince an opportunity to see the battlefields of the Crimean War (1853–6), fulfilling a long-held ambition.

Albert Edward, Prince of Wales, who had been about 12 at the outbreak of the Crimean War, was, like most other boys, deeply impressed by military matters. The Crimean War was the first armed conflict to be documented by photography, the two best-known British photographers involved being James Robertson (active 1850s) and Roger Fenton (1819–69). When Robertson's views of the Crimea went on show in February 1856, the Prince was taken to see them; he also made two visits to The Gallery in Pall Mall, on 21 February and 28 June 1856, to see Fenton's pictures of the campaign.[1] Fenton, whose work was already well known to the royal family, had undertaken his Crimean project under the patronage of Queen Victoria and Prince Albert, and the Prince of Wales was evidently so impressed that, aged 14, he had become a subscriber to Fenton's Crimean series – probably the youngest person in a list that included his parents, the French Emperor and many others.

With his marriage to Princess Alexandra and the births of their children over the next decade, the Prince of Wales now had his own establishment, his own social circle and, through his wife's family, many new relatives. In 1866 the Princess of Wales's sister, Princess Dagmar, had married the Tsarevich Alexander of Russia, and in 1867 their brother, Prince William, by then elected to the throne of Greece, married the Grand Duchess Olga Constantinovna. These two marriages created the climate for friendlier relations with the Russian Imperial Family than had existed during the 1850s, and thus allowed greater possibilities for visiting the Crimea. Further ties would follow in 1874 when Prince Alfred married the Tsar's daughter, Grand Duchess Marie Alexandrovna.

The Prince and Princess of Wales, with their party, started their journey up the Nile on 6 February 1869, travelling in a fleet of barges and *dahabiahs* (Nile steamers). Then followed visits to the ruins of ancient Egypt as well as to more modern edifices, such as a sugar factory. On one occasion they went on an expedition to Karnak by moonlight, celebrating by drinking champagne and watching a display of fireworks among the ruined temples. Alexandra was intrigued to visit

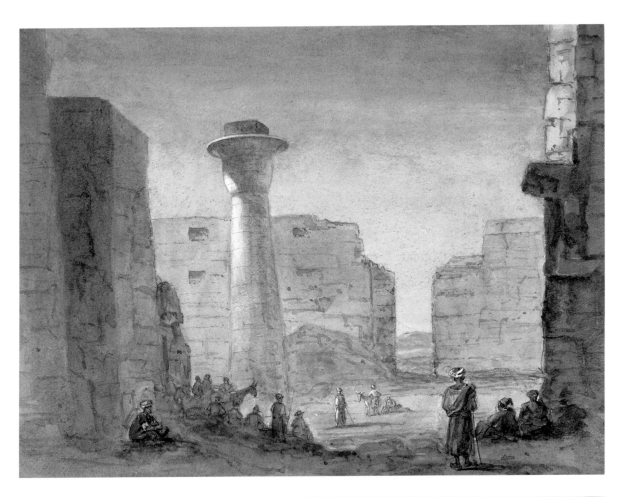

Alexandra, Princess of Wales, *The temple of Karnak*,
16 February 1869
Watercolour, 24.7 × 30.7 cm (9 ⁷⁄₁₀ × 12 ¹⁄₁₀″)
RL.K 136

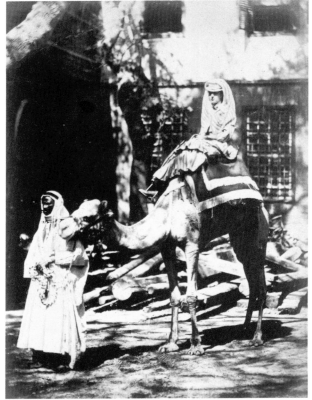

Unknown photographer, *Alexandra,*
Princess of Wales riding a camel, February 1869
Albumen print, 13.3 × 9.7 cm (5 ¼ × 3 ¹³⁄₁₆″)
RPC 01/0177/45

Roger Fenton (1819–69), *Omar Pasha*, 1855
Albumen print, 17.5 × 14.1cm (6 ⁹⁄₁₀ × 5½″)
RCIN 2500341

Writing to his mother from Constantinople
on 4 April, the Prince mentioned having met
a former Crimean War hero: 'I made the
acquaintance of Omar Pasha (about whom you
and dear Papa used always to laugh at me in
former days) & he is very agreeable to talk to –
& is a very fine looking old man. He commands
all the Troops in Turkey, but there is the
"Seraskier" or Commander in Chief & also
Minister of War over him.'[2]

the harem of the Khedive; she was photographed riding on a camel, and revelled in a way of life
so different from the rather restricted conditions at the court of Queen Victoria.

After leaving Egypt, the royal couple and their guests travelled on to Constantinople, where
they were entertained by the Sultan, and where the Prince and Princess enjoyed shopping
incognito in the bazaars. Then followed the visit to the Crimean battlefields.

The royal party arrived at Sevastopol in HMS *Ariadne* on 13 April. The Prince's first
impression was of shock at the state of the town. Fascinated as he was by seeing all the landmarks
of which he had heard so much in his youth, the Prince's overriding feeling, 'after having spent
one of the most interesting days that I can remember', was of sadness at the waste of life –
'for what? for a political object'.[3]

The Crimea was a favourite holiday resort for the Russian Imperial Family and nobility, and
the Prince and Princess of Wales visited several of their palaces and villas. The Prince was deeply
touched by the kindness and hospitality of the Russians on this Crimean excursion. Not only were
he and his wife able to stay overnight at the Livadia Palace by invitation of the Tsar, but every help
was given by the authorities on what could have been a difficult and embarrassing visit to the
scenes of Russia's defeat only fourteen years earlier. The success of the visit must also have owed

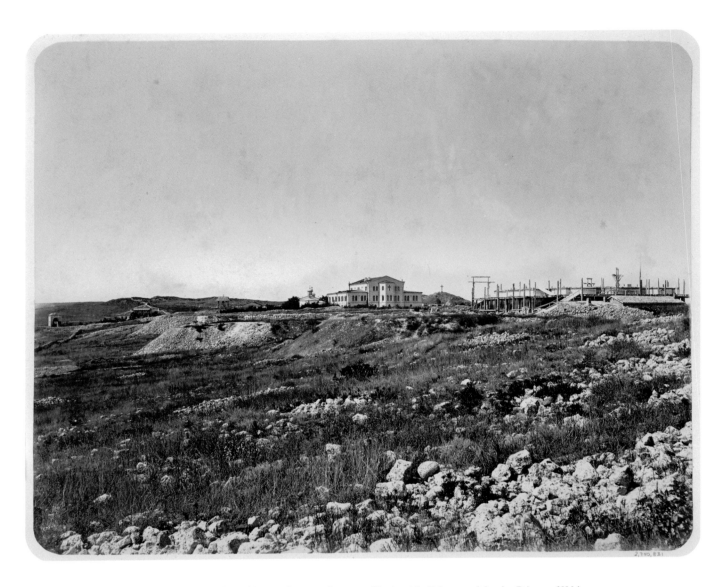

Unknown photographer, *Site of the old town, Sevastopol*,
1869
Albumen print, 25.5 × 38.2 cm (10⅓ × 15³⁄₁₀″)
RCIN 2700831/56

During his Crimean visit, the Prince of Wales was
profoundly affected by the sight of the ruined town:
'It is too sad to see the havoc & devastation that has
taken place. Nothing but bare walls, riddled with shot
& shell meet your view at every turn – & it only brings
the horrors of war too vividly before you.'

much to the Prince's own tact and friendly feelings towards his host country. When he was invited
to attend the wedding of his sister-in-law, Princess Dagmar, to the Tsarevich Alexander, the Prince
of Wales had told Lord Derby that he would be 'only too happy to be the means in any way of
promoting the *entente cordiale* between Russia and our own country' and that 'besides the pleasure
of being at Dagmar's marriage, it would interest me beyond everything to see Russia'.[4] This feeling
was sustained after the Crimean visit, and during the rest of the century the Prince of Wales
sought a better understanding with Russia – an aim in which he was not always supported by
Queen Victoria or by British public opinion. It culminated in the friendly agreement between
Britain and Russia, signed in 1907, and the meetings, in 1908 and 1909, of the two royal families,

by this time even more closely related through the marriage in 1894 of King Edward's niece, Princess Alix of Hesse, to Queen Alexandra's nephew, the future Tsar Nicholas II.

The early 1870s were to be sad and difficult times for the Prince and Princess of Wales. On 6 April 1871 their youngest child, Alexander John Charles Albert, was born, but lived for only one day. Both parents were deeply upset by this loss and, writing of the tragic event eleven years later to her son George, the Princess of Wales regretted that 'Nothing remains on earth to remind us of him but his little grave.'[5] Later in the same year, 1871, the Prince of Wales himself fell seriously ill with typhoid fever and for a time his life hung in the balance, his wife keeping devoted vigil at his bedside.[6]

Perhaps because she was preoccupied with her growing family, the Princess appears not to have compiled any albums during the 1870s. A series of photographs recording the Prince and his family from 1848 onwards also came to an end in 1873. However, Alexandra did possess a number of wooden fans decorated with painted designs and cut-out family photographs that appear very similar to her earlier albums, and some at least may be her own work.[7]

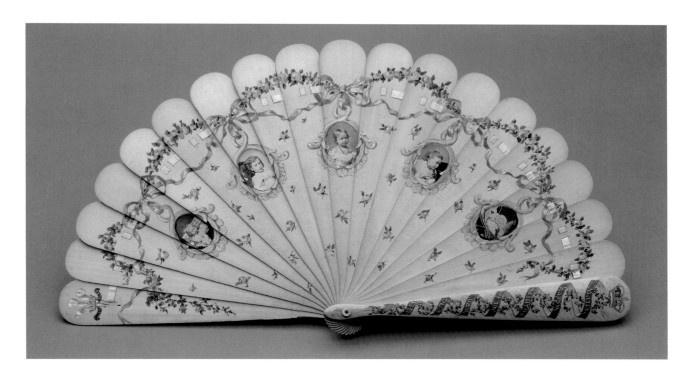

Fan presented to the Princess of Wales on her birthday,
1 December 1871
Maple brisé fan painted in watercolour, bodycolour and gold, guard length 23.2 cm (9″); albumen prints
RCIN 25193

The fan is decorated with photographs of the Princess's children: *(left to right)* Princess Victoria, Prince Albert Victor, Princess Louise, Prince George and Princess Maud. The prints have been attributed to W. & D. Downey and Hills & Saunders. The artist may have been the Princess of Wales's sister-in-law, Alice, Princess Louis of Hesse, who was staying at Sandringham at this time and who produced similar work elsewhere.[8]

Oliver Montagu's influence on the Princess may have had an effect which has not been recognised before. During the Russian visit he compiled an album containing photographs, newspaper cuttings, menus, programmes, and a diary written by himself, describing not so much the wedding but the parties and excursions that took place in celebration of it. He may have shown the album to Alexandra, and at some point it entered royal possession. Its contents were to have a bearing on the way the Princess organised her own albums.

Having enjoyed the Egyptian and Crimean journey so much, Alexandra looked forward eagerly to the prospect of accompanying her husband on future tours. Unknown to her, however, he was already planning a trip to India without her. When she discovered this she was highly indignant, protesting her determination to go. However, both Queen Victoria and the Prince of Wales were against it, and in the end she had to accept their decision. But she never forgot her disappointment, nor really forgave her husband for having deprived her of the chance to see the wonders of the Indian subcontinent.[10] Nevertheless, when the time came for the Prince of Wales to leave, both he and the Princess were miserable at parting from one another, and he remained in low spirits for several weeks afterwards. In spite of this, the tour, which lasted from 8 November 1875 until 13 March 1876, was highly successful. The Prince, with his customary tact, courage and ease of manner, was seen to symbolise the best aspects of British rule, and prepared the way for the proclamation of Queen Victoria as Empress of India later in 1876.

There seems to be no evidence that the Prince took a photographer as a member of his suite, as he had done in 1862, but according to the *British Journal of Photography*:

> The Athenaeum says that the Prince of Wales's visit to India will give birth to a novelty in the shape of 'specials'. It is said that Messrs. Bourne & Shepherd, the best known of Indian photographers, will depute the chief of their staff to accompany HRH throughout his tour through India. This 'photo-special' will be assisted by a large number of skilled native photographers, who hope in concert to produce a perfect panorama of the Royal progress.[11]

The 'perfect panorama' eventually took the form of six extremely heavy, leather-bound albums, which between them contained 446 photographs. These were mostly views, but included many portraits of Indian maharajahs and leaders. Various other subjects, such as moneychangers at Bombay and events connected with the Prince's visit, among them the progress of a juggernaut car at Madras, were depicted.

In due course the Prince and the albums returned to England, and for her Christmas present in 1876 the Princess received from her husband *Bourne & Shepherd's Royal Photographic Album of Scenes and Personages connected with H.R.H. the Prince of Wales's Tour in India, 1876*. It contained a selection of 140 photographs, including some not in the bigger series of six albums. Illustration Number 4 showed his cabin on board HMS *Serapis*, with photographs of his wife and children prominently displayed.

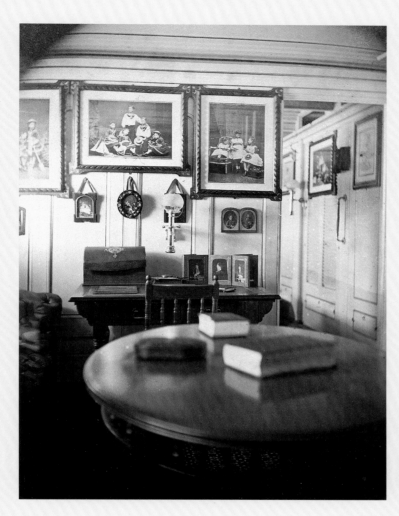

These pictures are from *Bourne & Shepherd's Royal Photographic Album of Scenes and Personages connected with H.R.H. the Prince of Wales's Tour in India, 1876*, which the Prince of Wales gave his wife for Christmas that year on his return from India.

Bourne & Shepherd,
The Prince of Wales's boudoir,
HMS *Serapis*, 1876 (No. 4)
Albumen print,
13.8 × 10.2cm (5⁷⁄₁₆ × 4")
RPC 07/0260/4

Photographs of Alexandra and their children are clearly visible on the wall of the Prince's cabin.

Bourne & Shepherd,
The Prince of Wales's Yarkund shooting pony, 1876 (No. 70)
Albumen print,
9.7 × 13.8cm (3¹³⁄₁₆ × 5½")
RPC 07/0260/70

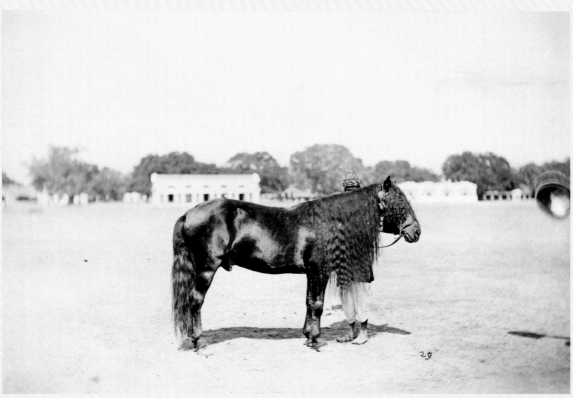

Bourne & Shepherd,
The Taj Mahal, Agra,
1876 (No. 57)
Albumen print,
10.3 × 8.5cm (4 1/16 × 3 3/8″)
RPC 07/0260/57

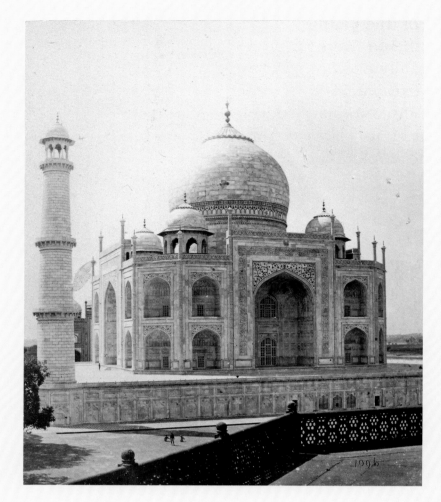

Bourne & Shepherd,
Group of Thakurs, Bikanir,
1876 (No. 81)
Albumen print,
10.2 × 13.9cm (4 × 5 1/2″)
RPC 07/0260/81

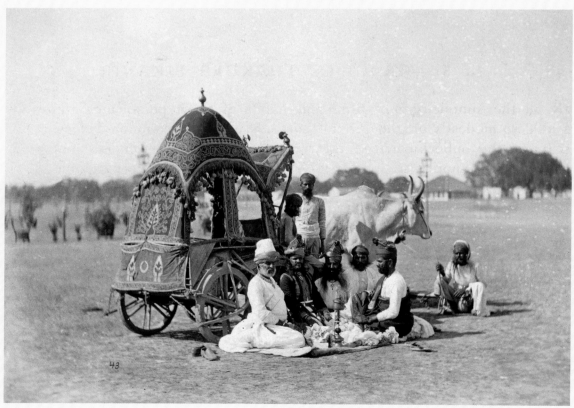

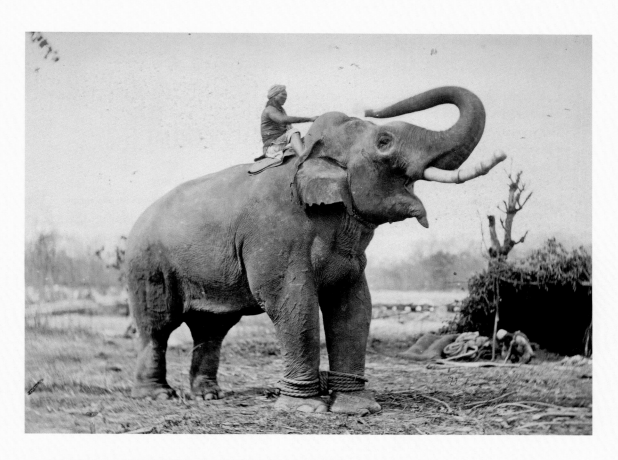

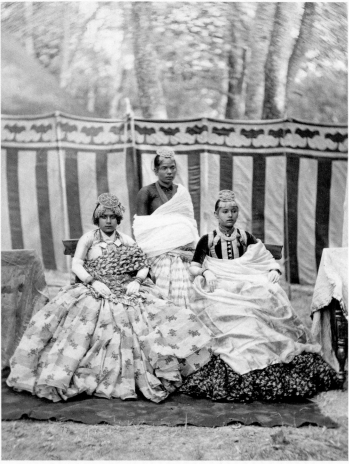

Bourne & Shepherd,
The elephant Jung Pershad,
1876 (No. 108)
Albumen print,
10.2 × 13.8cm (4 × 5⁷⁄₁₆″)
RPC 07/0260/108

Bourne & Shepherd,
Ladies of Sir Jung Bahadur's household,
1876 (No. 112)
Albumen print,
13.8 × 10.2cm (5⁷⁄₁₆ × 4″)
RPC 07/0260/112

OPPOSITE ABOVE: Alexandra, Princess of Wales,
A view with boat and tower, undated
Ink wash, 18.7 × 28cm (7⅖ × 11″)
RL.K 130

Monochrome work of this kind would have accustomed
Alexandra to the conversion of colour into tone when she
came to use black-and-white photography.

OPPOSITE BELOW: Alexandra, Princess of Wales,
Windsor Castle from the north, 1887
Watercolour, 18.2 × 27.5cm (7⅕ × 10⁹⁄₁₀″)
RL.K 457

ABOVE: Alexandra, Princess of Wales,
Cowes, 5 August 1884
Watercolour, 9.5 × 17.3cm (3¾ × 6⅘″)
RL.K 433, f.3

In this light sketch the Princess is following the rule
of the 'golden section' to govern the arrangement of this
marine-scape. Her sketchbook was made, conveniently,
with a small paint-box attached to one end.

RIGHT: Alexandra, Princess of Wales,
Queen Victoria at Balmoral, 1884–6
Watercolour, 17 × 10.3cm (6⁷⁄₁₀ × 4″)
RL.K 1308,f.9

At the base of this slightly irreverent sketch of
her mother-in-law, the Princess has written 'The
missing leaf of Life in the Highlands', referring to
the books written by Queen Victoria about her life
at Balmoral. These were: *Leaves from the Journal of
Our Life in the Highlands* (privately printed in 1865
and 1867, and published for general circulation in
1868), and *More Leaves from the Journal of A Life
in the Highlands*, published in 1883. This sketch,
which comes from a sketchbook covering the years
1884–6, was probably done from imagination.

BELOW: Alexandra, Princess of Wales,
A game of cards, 1880/81
Pencil, 12.4 × 17.9cm (4⁹⁄₁₀ × 7″)
RL.K 432,f.11

The Prince of Wales is watched by his brother,
Prince Leopold *(left)*, and two other gentlemen,
who may be Prince John of Glücksburg, an uncle
of the Princess *(right)*, and Christopher Sykes
(second from right).

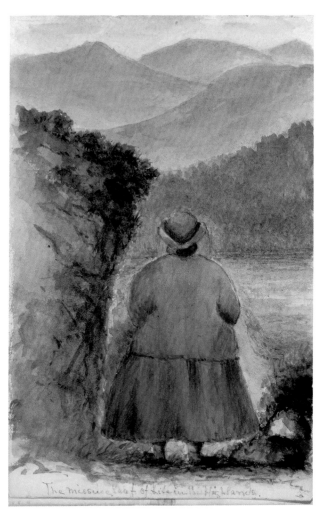

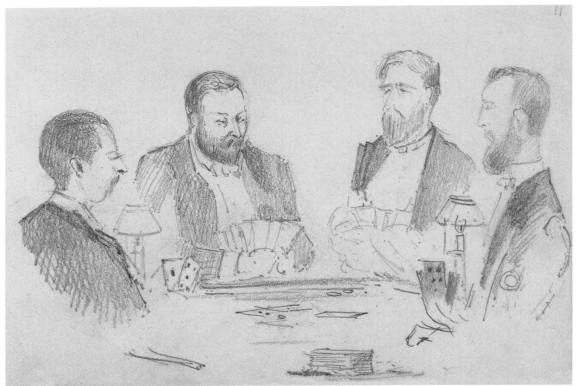

Alexandra, Princess of Wales, *View of trees*, undated
Pencil and watercolour, 23.3 × 15.3cm (9⅓ × 6″)
RL.K 161

The influence of W.L. Leitch, one of Alexandra's teachers,
is apparent in this exercise with a limited palette.

Alexandra, Princess of Wales, *Scotland,*
October 1888
Watercolour, 17.3 × 9.5cm (6⅘ × 3¾″)
RL.K 433,f.8

This sketch was made in the book with a paint-
box attached (see page 55); it can be seen, with
its lid closed, at the base of the picture.

studios in London and elsewhere. The house of Frederic (later Sir Frederic and then Lord) Leighton (1830–96) in Holland Park Road was one such destination. Leighton's views, painted during his travels in the East, and especially his Arab Hall, begun in 1877 to form a setting for his collection of blue faience tiles, would have greatly appealed to the Princess. The exotic ambience would have reminded her of Egypt and Constantinople, and she had a liking for tiles, which were used in two structures at Sandringham built for her.[10] Alexandra visited Leighton's studio at least eight times, and some twenty-six other artists entertained her in this way between 1873 and 1923.[11] She also visited the studios of her art masters. In all, in these years she paid at least eighty visits to studios, and over 280 visits to galleries and exhibitions,[12] among them Agnew's, the Fine Art Society and the Tate.[13] The one that seems to have been most frequently attended, with at least twenty-three visits between 30 May 1894 and 2 February 1919, was the Fine Art Society, then, as now, situated in New Bond Street within easy reach of Marlborough House and Buckingham Palace. There she saw the work of many artists, the majority of them watercolourists such as Mary Barton, Ella Du Cane, George S. Elgood, William Russell Flint and Laura Knight.[14]

Meanwhile, photographic technology had been evolving towards the production of cameras that could be used easily by amateurs. The invention of gelatine emulsions, introduced in the 1870s, made it possible to expose photographic plates much more rapidly than before. By 1878 ready-made plates could be bought, and within the next two years the new process had become extremely popular. Small portable cameras were soon being produced in large quantities. In 1885 the Eastman Company of Rochester, USA, introduced portable 'roll-holders' or roll-film cameras, which were lighter and more convenient than those using heavy glass plates.

Photography was now available to anyone and became particularly fashionable with artistically minded ladies. The Princess of Wales was not uninfluenced by fashion and, like her husband, was curious about modern inventions; following the introduction by George Eastman of the roll-film camera, the couple accepted one as a gift from the inventor.[15]

In a short paragraph in its 5 June 1885 issue the *Amateur Photographer* welcomed 'into the ranks of Amateur Photography the Princess of Wales'.[16] Whether this was published before or after the presentation of the camera by Eastman is not clear. Tantalisingly, there is no mention of it in her engagement diaries, and no mention of her being taught how to use a camera. Alexandra had lessons in singing, thoroughbass (musical accompaniment) and First Aid,[17] but there is nothing to say, in effect, 'Man came to teach Princess photography'. Although the diaries are incomplete, it is still most likely that this omission indicates that the tuition came from within the Household rather than from an external source. The Prince of Wales could have passed on his knowledge of photography to his wife, but the person likely to have had the most up-to-date information about the new technology was the professional photographer Frederick Ralph, who also served as Usher in the Servants' Hall at Sandringham. Ralph certainly claimed to have taught the Princess, as was reported in *Photography* in 1902, quoting from *The Westminster Gazette*:

In a small studio near the Sandringham Road, at Hunstanton, there is to be found on most days of the week during the season an old gentleman who taught Queen Alexandra how to

Alexandra, Princess of Wales (photographers unknown),
A design showing a scene with horses, riders and carriages
Watercolour, albumen print,
page size 26.5 × 34cm (10⅖ × 13⅜″)
RPC 03/0190/23

The Prince and Princess of Wales can be seen on horseback in the middle distance. Others present include Prince Alfred (standing in front of the carriage on the right, wearing a top hat), and Oliver Montagu, who can be seen in the carriage on the left.

ABOVE: No. 4 Kodak camera, formerly in the possession of Queen Alexandra. This is a box camera, to hold rollfilm of 5″ x 5″. It has an RR type lens, sector shutter and two reflecting finders. It is covered in mauve leather, with 'AA' monogram and crown in gold.
18 × 33 × 13cm (7⅟₁₆ × 13 × 5⅛″)
National Museum of Photography,
Film & Television/SSPL

LEFT: Wynne's Infallible Exposure Meter, 1893, formerly in the possession of Queen Alexandra. This is a watch-type actinometer, in a solid silver case. The back is engraved with a crowned 'A' monogram and Prince of Wales's feathers, and has a rose, thistle and shamrock decoration. It has a plush-lined leather case.
Case measures 7.5 × 9.5 × 2cm (2¹⁵⁄₁₆ × 3¾ × ¹³⁄₁₆″)
National Museum of Photography,
Film & Television/SSPL

use a camera, and who, subsequently, instructed Her Majesty in the art of developing and printing. Mr. Ralph, who was one time usher of the servants' hall at Sandringham, is now a royal pensioner as well as a photographer, and though he is getting on for seventy he is frequently called upon to take private pictures for the King and Queen. None of these special photographs are ever published, but a copy of each is carefully preserved by the Queen, who, by the way, has now a dark room at her Norfolk home.[18]

The Princess (with other members of the royal family) is said to have attended the London Stereoscopic School of Photography in Regent Street, London,[19] but no details of her involvement have yet been found. One source for the information may be a notice in the *British Journal Almanac Advertisements*. This proclaims the virtues of the Stereoscopic Company's Twin Lens 'Artist' Hand Camera (the 1894 pattern) which held twelve plates and could be 'focussed even during the transition of the object to be photographed'. It could also work at different speeds and produce time exposures, as it had 'exceptionally rapid lenses'. The camera could operate using plates or films and could be used as a hand camera as well as on a stand 'for ordinary photography', and was apparently being used by 'the Principal Officers of H.M. Army and Navy' and also 'by H.R.H. The Princess of Wales'. A drawing of Alexandra holding the camera is shown,[20] implying that she possessed one by 1894 (she had already, in 1889, acquired a No. 1 Kodak camera, introduced in that year). In due course Alexandra also used No. 2 Bulls'-Eye Kodak cameras; in addition, the Kodak Company had presented her with a No. 4 Bulls'-Eye Special Kodak model in 1892. This camera, which was covered with mauve leather, is now kept in the Kodak Museum at the National Museum of Photography, Film and Television in Bradford, with a Wynne's Exposure Meter of 1893, which also belonged to her.

No photographs by the Princess from as early as 1885 have been found. The earliest surviving photograph album associated with her is a large one bound in dark green leather. It has her monogram of 'AA' and a crown in the centre of the front cover, and the word 'Kodak', reproduced as a facsimile of her handwriting, at the top left-hand corner. It contains 240 of the typical small circular photographs made by a No. 1 Kodak camera, which probably date from 1889–90. The images, which measure 6.5cm (2½") in diameter, are printed on oblong pieces of paper set within window mounts, regularly arranged four to a page. There are no captions or other details. The subject-matter of the photographs ranges from the Princess's family and friends to horses, holidays and sea trips. The impression they give is of someone who is enjoying the use of her camera on every possible occasion. However, as her second daughter, Princess Victoria, was taking larger-format photographs in 1887, the Princess of Wales certainly had some knowledge or experience of this kind of print before she started using the No. 1 Kodak.

Princess Victoria's earliest surviving albums date from 1887–8 and from 1889–91. Nearly all her photographs record family life: the Princess of Wales at the piano or reading; views of her daughters' rooms; Princess Maud of Wales on a seesaw, with the Rector of Sandringham's wife and daughter at the other end, and groups taken on board the Royal Yacht *Osborne*, or during holidays abroad. The prints vary in size but are usually oblong; some are as much as 18cm (7")

Princess Victoria of Wales, *The Princess of Wales reading in the entrance hall at Sandringham*
Albumen print, 17.6 × 12.2cm (7 × 4¹³⁄₁₆")
RPC 03/0085/24

As elsewhere, the Princess is shown holding the book at some distance, implying that she was long-sighted; further evidence for this is her use of a magnifying glass (in preference to spectacles, which she disliked wearing) when reading newspapers in later life.

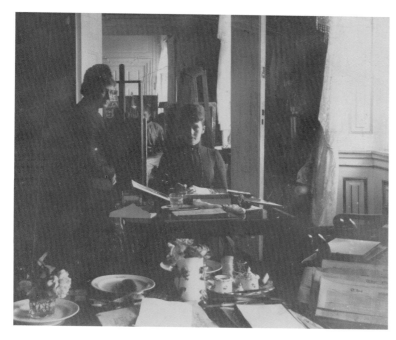

LEFT: Princess Victoria of Wales,
*Queen Louise and the Princess of Wales
at Fredensborg*, 1891
Albumen print,
approximately 11.9 × 13.1 cm (4¾ × 5⅟₁₆″)
Amalienborg, Copenhagen

Queen Louise of Denmark and her daughter
with painting materials, photographed by
Alexandra's daughter Princess Victoria.

BELOW: Princess Victoria of Wales,
*Queen Louise and the Princess of Wales
at Fredensborg*, 1891
Albumen print, 11.9 × 13.1 cm (4¾ × 5⅟₁₆″)
Frederiksborg Castle, Denmark

Queen Louise watches her daughter painting.

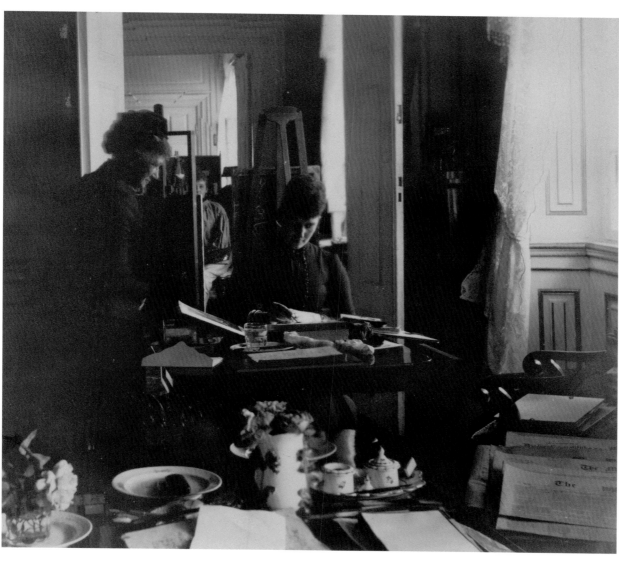

Alexandra, Princess of Wales, *Princess Victoria of Wales seated on one of the stone oriental lion-dogs at Sandringham*, c.1890
Printing-out paper, diameter 6.5cm (2⁹⁄₁₆″)
RPC 03/0063/7b

Alexandra, Princess of Wales, *A horse outside its stable*, c.1890
Printing-out paper, diameter 6.5cm (2⁹⁄₁₆″)
RPC 03/0063/8a

Alexandra, Princess of Wales, *A ship at sea*, c.1890
Printing-out paper, diameter 6.5cm (2⁹⁄₁₆″)
RPC 03/0063/19d

The Princess had a penchant for views with a central point.

Alexandra, Princess of Wales, *Albert Edward, Prince of Wales, and his brother, Arthur, Duke of Connaught, on board a yacht*, c.1890
Printing-out paper, diameter 6.5cm (2⁹⁄₁₆″)
RPC 03/0063/20a

The circular photographs on this and the following two pages come from the album described on page 61.

on their longest measurement. Mr Ralph may, of course, have taken them, or some of them, but it seems to be significant that Princess Victoria herself appears in only a few.

Whether or not the small round snapshots represented the Princess of Wales's first real steps into the realms of photography, she appears to have been delighted at her success, and decided to have a number of the images reproduced on a china tea service. This was made by Brown-Westhead, Moore & Co., of Cauldon Place, Hanley, Staffordshire, as 'Cauldon Ware', and the project was announced in the *Amateur Photographer* in a report that 'an entirely fresh shape for the china' had been designed by Mortlock's Ltd, one of the principal London china dealers. The originality of the style of the service and the use of photographs in this way were noted and the Princess's 'native wit' was credited with the idea.[21] The china was sold to the Princess by Mortlock's from their Pottery Galleries in Oxford Street and Orchard Street, London, in 1891.[22]

The tea service itself has terracotta-coloured pictures on a cream background, and was originally supplied with eighty-five pieces.[23] The service has a very personal kind of charm and must have delighted its owner. The use of pictures, generally paintings, of palaces, houses and other views on china was, however, not uncommon; a dessert service painted with views of Danish

Alexandra, Princess of Wales, *A meal at Sunningdale Park*, c.1890
Printing-out paper, diameter 6.5cm (2⁹⁄₁₆″)
RPC 03/0063/13a

Maria, Lady Ailesbury *(standing, background)*, Princess Victoria of Wales *(seated)*, and the Hon. Julie Stonor *(far right)*. Sunningdale Park was let during Ascot week of 1889 and 1890 to the Prince of Wales and his family.

Alexandra, Princess of Wales, *A view of land and sea*, c.1890
Printing-out paper, diameter 6.5cm (2⁹⁄₁₆″)
RPC 03/0063/37c

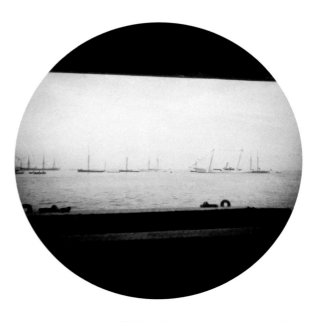

Alexandra, Princess of Wales, *Princess Victoria* (left)
*and Princess Maud of Wales on a yacht, c.*1890
Printing-out paper, diameter 6.5cm (2%″)
RPC 03/0063/44a

Alexandra, Princess of Wales, *Sea view from the yacht, c.*1890
Printing-out paper, diameter 6.5cm (2%″)
RPC 03/0063/45d

A strong geometrical design in dark and light.

Alexandra, Princess of Wales, *Queen Victoria at Abergeldie
with her granddaughter, Princess Louise, Duchess of Fife,*
probably 9 October 1890
Printing-out paper, diameter 6.5cm (2%″)
RPC 03/0063/53a

Abergeldie Castle, originally leased by the royal family in
1848, was used as the Scottish residence of the Prince and
Princess of Wales and their family when Queen Victoria
was at Balmoral.

Alexandra, Princess of Wales, *Queen Victoria at Abergeldie,*
probably 9 October 1890
Printing-out paper, diameter 6.5cm (2%″)
RPC 03/0063/53c

This image has the Queen's head as its centre, while her
figure becomes a segment of the circle and her pointing
stick is reminiscent of the hand of a clock.

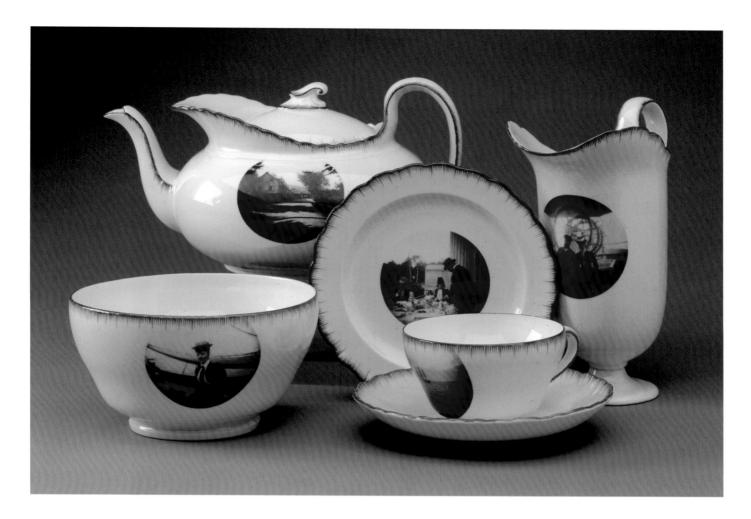

ABOVE: Alexandra, Princess of Wales, *Early work*
Negatives: 6.7cm (2¹¹⁄₁₆″) square
Prints: printing-out paper, diameter 6.7cm (2⅜″)
Box: 12 × 25.5 × 19cm (4¾ × 10 × 7½″)
RCIN 2300010

ABOVE: China by Brown-Westhead, Moore & Company,
photographs by Alexandra, Princess of Wales,
A selection of pieces from the Princess of Wales's tea service
Teacup (RCIN 53058.19.a):
5.6 × 10.4 × 8.6cm (2⅕ × 4¹⁄₁₀ × 3⅖″)
Saucer (RCIN 53058.19.b):
2.5 × 14 × 14cm (1 × 5½ × 5½″)
Plate (RCIN 53059.1):
1.6 × 14.5 × 14.5cm (½ × 5⁷⁄₁₀ × 5⁷⁄₁₀″)
Teapot (RCIN 53066.2):
12 × 21.6 × 13.3cm (4¾ × 8½ × 5¼″)
Sugar basin (RCIN 53063.1):
7.1 × 13.3 × 13.3cm (2⅘ × 5⅕ × 5⅕″)
Milk jug (RCIN 53060.1):
17 × 14.2 × 8.8cm (6⁷⁄₁₀ × 5⁵⁄₁₉ × 3½″)

These are some of the photographs and negatives used
to decorate the tea service made for the Princess in
'Cauldon Ware' and supplied by Mortlock's of Oxford
Street, with their original box. The box is made of wood
covered in sheepskin, and has gold tooling and a metal
handle on the lid.

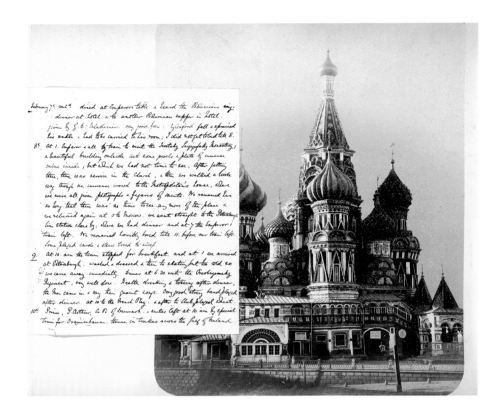

Unknown photographer, *The Cathedral of St. Basil, Moscow*, 1874
Albumen print,
page size 33.7 × 48.8 cm (13¹⁵⁄₁₆ × 19¼")
RPC 04/0004/39

In this page from Montagu's album, the diary is glued to the edge of the page, but can be lifted up to reveal the whole photograph. Other pages bear ephemera such as menus, music programmes and newspaper cuttings. These components are almost identical to those used by the Princess of Wales in her own albums from 1893 onwards.

Be that as it may, Alexandra, with her daughters Princess Victoria and Princess Maud and their suite, set off on a short cruise in Norway, a country unfamiliar to them, on the Royal Yacht *Osborne* on 16 August 1893. From the descriptions that she later wrote in the album, the Princess reveals her enjoyment of the unusual circumstances which she encountered, as well as her sense of humour.

On one occasion, while in the vicinity of the Hardanger Fjord, the party landed and walked over to a farmhouse 'where there was a nice old woman with her daughter. We were much amused at seeing the Milk Maid feeding her cows with <u>herrings</u>, which they seemed to relish greatly!'[26] After lunch one day, the Princess and her party drove round the outskirts of the town. She rode in 'a small "gig" – with a prancing black horse – a regular stepper – which went like the wind downhill as hard as it cld. tear. I took my trusty Captain with me – & behind us we had a very amusing & sharp Norwegian boy – he seemed very bitter against the Swedes & a great politician. We passed so many lunatic Asylums that at last I began to fear that he took us for some of the escaped inmates & was going to leave us in one.'

Next morning Alexandra, not usually an early riser, surprised herself and everyone else by being on deck at 7 am on 'a heavenly day & I cannot express how enjoyable & beautiful it all was'. Encouraged by this experience, she rose at 6 am on 25 August in order to make a sketch out of the window of her cabin. As it was very cold, 'I wrapped myself up in a shawl & my old sealskin cloak (the very same old thing I wore on my <u>arrival</u> in England [in] <u>63</u> when I landed at Gravesend before my marriage!)'.

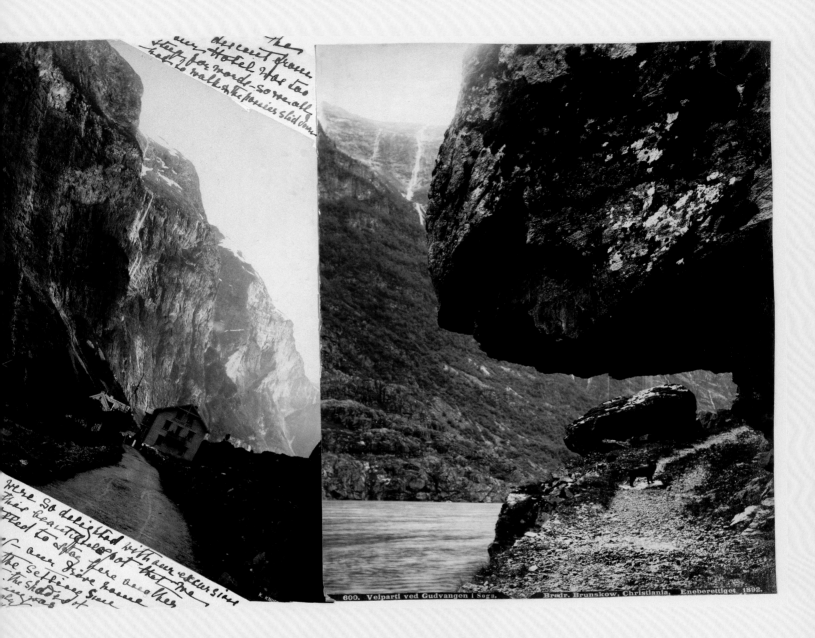

600. Veiparti ved Gudvangen i Sogn. Brødr. Brunskow, Christiania. Eneberettiget 1892.

PAGES 71–4: Alexandra, Princess of Wales,
The Norwegian cruise, 1893
Page sizes: 28.1 × 38.7cm (11⅛ × 15¼")
Albumen prints; printing-out paper (snapshots)
RPC 03/0064/18, 03/0064/23, 03/0064/27, 03/0064/32

A selection of four pages (that overleaf reproduced at just under actual size) from the album commemorating the cruise, showing how the Princess arranged photographs, paintings and script. Princess Alexandra's album, like Oliver Montagu's, contained commercial photographs and other printed material. But to these she added personal touches in the form of her own descriptions, sketches and photographs. There is more than a hint that she enjoyed descriptive writing.

The rest of the day
after coffee we spent
quietly on deck,
basking in the
sun — reading
writing & did
all the photographs
on the next
page — We
reached Bergen
at 4.30. The Consul
came on board
& brought us our
... letters & papers
from England — & we
do had early dinner, rather tired

... after breakfast we
more through all the
... concerned up to
... with interest to
... the ... which
the man — which
... once a year!
... man was very nervous
but did his part
very well —

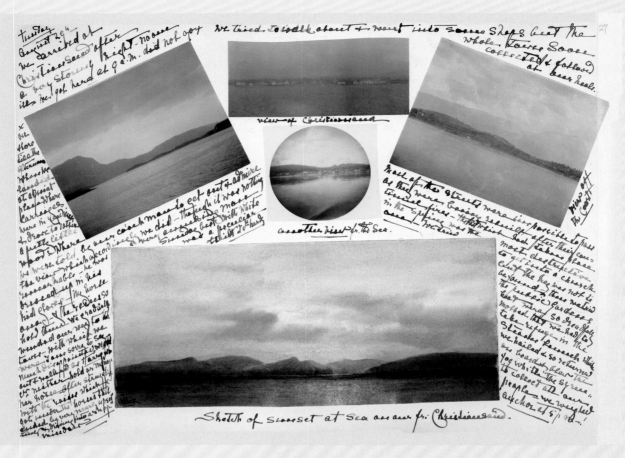

view of Christiansund

another view fr. the Sea.

Sketch of sunset at sea as seen fr. Christiansund.

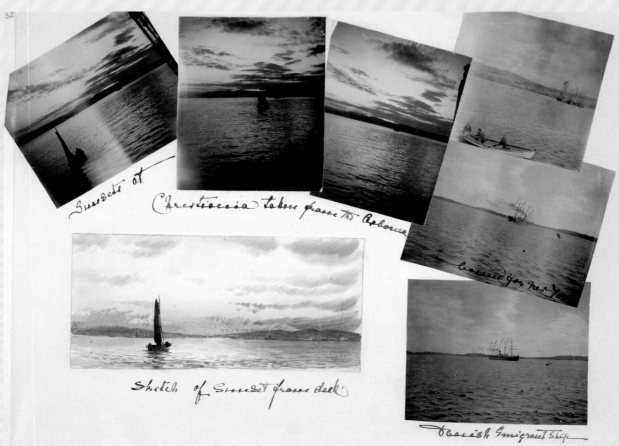

Sunsets at Christiania taken from the Osborne

Sketch of Sunset from deck

Norwegian Emigrant Ship

With evident enjoyment, the Princess next described an excursion made by Princess Maud and another member of the party, Captain Holford, in order to get some coffee for their tired companions from a hotel at the top of a steep hill:

We got so hot & thirsty from our walk that we asked Maud & Capt. Holford to fetch us lazy creatures some coffee at the Hotel – which they did after two hours absence, having had many difficulties – first to get up that awful hill, then to get the coffee ready – & finally to get down the hill! They tried to drive it down in the carriole but that was hopeless as it all spilt, so poor Captain Holford actually carried it all the way in his arm – while [Maud] carried the sugar & cream. They were unmercifully laughed at & chaffed all the way down by some people talking Danish – who said that only English people would dream of doing such things – but [at] which Maud suddenly turned round & faced them like a young bull dog & astonished them much by saying in Danish 'You had better take care as we understand every word you say' – so this shut them up quickly. At last they arrived, much exhausted & half the coffee spilt, but very much delighted with their success in getting it down at all. The worst of all was that the proprietor of the Hotel had insisted on our having his best silver pot & spoons – which made it all the heavier to carry – because he said the Emperor of Germany on his visit to the Hotel had used them – so we must be equally honoured!

On the following day, however, there was a less amusing occurrence:

We climbed up a very steep hill – peeped into one of the huts, where a girl was busily washing up & at that moment scrubbing the stone floor on all fours – while a great strong lout of a boy was stretched out full length chaffing her, on a bed – he, the beast, was evidently resting from the exertion of slaughtering a most beautiful goat – which I discovered outside <u>beheaded</u> – its poor eyes looked so sad & pathetic – that it gave me quite a turn – & I cannot get them out of my head, they haunt me still.

Alexandra's humour was sometimes turned on herself. On returning to Bergen, they went for a drive in very windy weather, 'which blew my hat all awry, of which however I was in blissful ignorance until I got into the boat & the people cheered – I tried to bow with great dignity!! when I saw Captain Holford & the men in fits of suppressed laughter at the object they beheld in me, as the more I bowed the more crooked got my hat, until I fear at last I must have looked perfectly screwed.' She was also deeply moved by the majestic Norwegian scenery: 'There was a most glorious moon – which had a most curious effect of solemnity & unspeakable grandeur – behind those huge mountains which seem to tower up to the very heavens in the stilly night! & inspired one with almost a feeling of awe! They seemed so far above man & so near to Heaven! – & all the dear ones gone before.'

Such a memorable holiday should properly end on an exciting note. After visiting a sanatorium

(by which she was favourably impressed) at the summit of a hill, the Princess was driving back down again in a small carriage. Realising that the steepness of the hill might cause difficulties:

I took extra precautions by trying to go gently down at first – fearing that my beautiful trotter might be too much for me at such a rapid pace down that very long & steep hill! but unfortunately the result was just the reverse – suddenly my gallant steed stumbled & do what I could he was unable to recover himself – & disappeared altogether under the carriage & for some time I saw nothing but its tail sticking straight up & we driving on all the same – till I very nearly lost my balance & felt myself going over the horse – the Captain quietly imagining that I intended to get out, as he saw me slowly rising from my seat. All I cd. do was to shout to the coachman to get off – but this was no easy matter, as each time the poor man put one foot out, the other was caught by the seat shutting up – owing to the carriage being tilted up so far – but at last he succeeded & our poor horse got up – but alas, his knees were a terrible sight, both of them cut to the bone & the blood pouring down – while his head [was] white with dust – too unlucky! as with all my driving I never had such an accident in all my life before – it was indeed a lucky escape that we did not break shafts & all & roll down the hill. I was ashamed to meet anybody, as they all stared at my poor horse's broken knees – so I made our man in his smart livery get off several times to sponge them. This is how our last drive ended, in lovely Norway, which we quitted with the greatest regret.

Alexandra, Princess of Wales;
photogravure by Annan & Sons, Glasgow,
Wellington Barracks, before 1897
5.4 × 2.2cm (2⅛ × 4¹³⁄₁₆")
RCIN 1230733/II

Several of Alexandra's photographs,
including this one, were illustrated
in the *Special Souvenir* catalogue of
the Kodak Exhibition held at the
New Gallery, Regent Street,
27 October – 16 November 1897.

Alexandra, Princess of Wales,
Prince Edward of York, Bernstorff, 1898
Printing-out paper,
12.5 × 9.8cm (4¹⁵⁄₁₆ × 3⅞″)
RPC 03/0066/3c

The Princess took this snapshot
of her grandson (later King Edward VIII)
during a visit to Denmark to celebrate
Queen Louise's 81st birthday.

The Princess of Wales dealt almost exclusively with the Eastman Photographic Materials Company (Kodak Ltd), and in October and November 1897 she allowed six of her prints to be shown in a Kodak exhibition at the New Gallery in Regent Street.[27] Her two elder daughters, Princess Louise (now Duchess of Fife) and Princess Victoria, also took part, as did Beatrice, Princess Henry of Battenberg, and the Duchess of York.[28] The royal section of the Kodak exhibition amounted to about forty-five photographs and photogravures, displayed at one end of the gallery.[29]

On 11 March 1899, accompanied by her daughters, Princess Victoria and Princess Maud (who in 1896 had married her cousin Prince Charles of Denmark) and their suite, the Princess of Wales set sail for Paris on the first stage of a Mediterranean cruise which was to last until 22 May. The album that the Princess compiled in memory of this cruise includes many more of her own

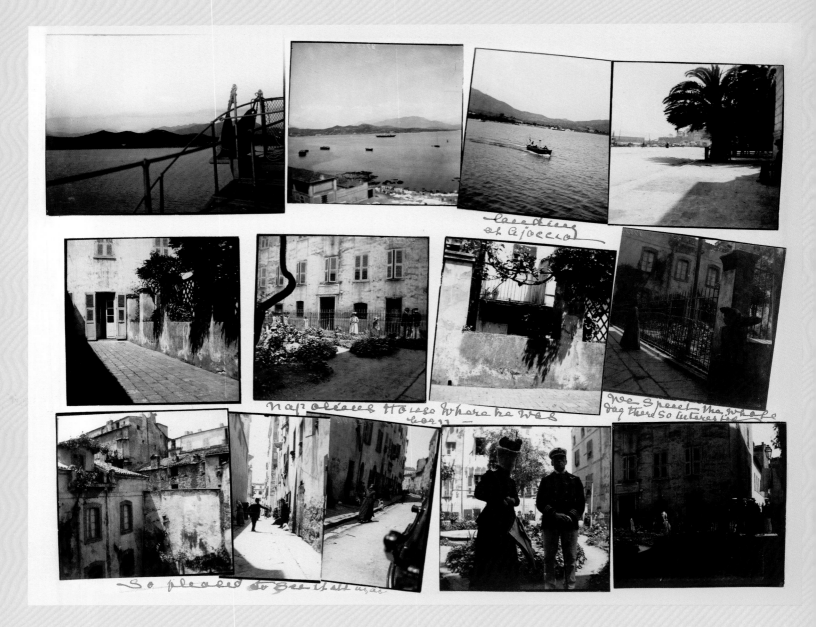

ABOVE: Alexandra, Princess of Wales,
A page of photographs taken at Ajaccio, the birthplace
of Napoleon Bonaparte, 1899
Printing-out paper,
page size: 30.4 × 38.5cm (12 × 15⁵⁄₁₆″)
RPC 03/0065/67

The Princess greatly admired Napoleon and
visited Ajaccio several times.

OPPOSITE: William H. Grove & Boulton,
The Napoleon Room at Marlborough House, 1912
Carbon, 23.4 × 28.6cm (9¼ × 11¼″)
RCIN 2102002

Some of Alexandra's collection of souvenirs and
commemorative items relating to Napoleon can be
seen here. She also possessed at least sixty books
about Napoleon and his circle.

photographs than the Norwegian album and shows more confidence in her abilities as a photographer. Once again, she used captions and written descriptions to accompany the snapshots.[30]

This holiday gave Alexandra the chance to visit two sites associated with Napoleon: his house at San Martino on Elba, where he had lived in exile for nearly a year, and his birthplace at Ajaccio in Corsica: 'We spent the whole day there, so interesting.' In Italy she and her companions met the Duke of Cambridge at the station in Rome, but while he was being 'received grandly by our Ambassador', they 'sneaked off' by cab and 'drove straight to Professor Corrodi's Studio,[31] who came with us to the Vatican where we saw the beautiful Sistine Chapel galleries of painting and sculpture'. Excitement of a different kind followed on 30 March, when 'we all from the ship … went up Mount Vesuvius… it took us four hours – & was most exciting & interesting…. We were nearly choked by the sulphur smoke & the noise was terrific.'

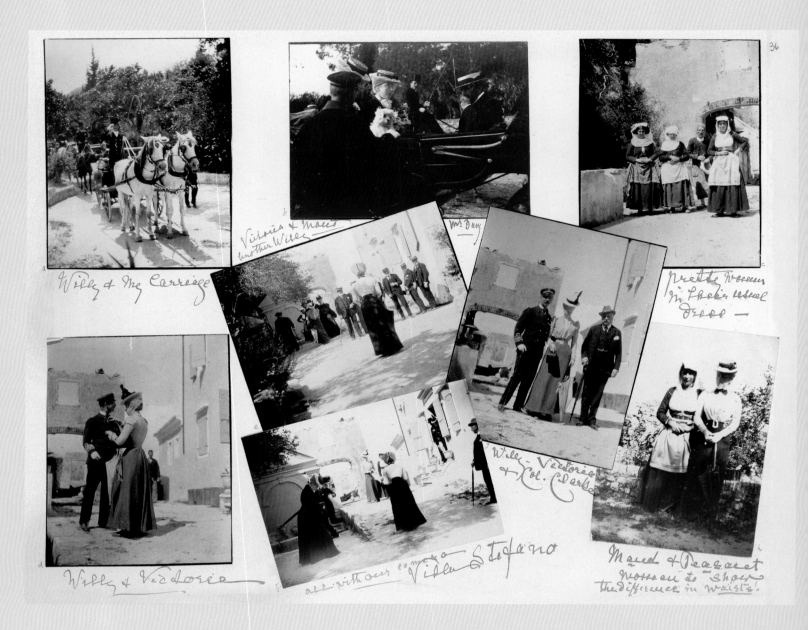

ABOVE: Alexandra, Princess of Wales,
A page of photographs taken at Villa Stefano, Corfu, 1899
Printing-out paper, page size: 30.4 × 38.5cm (12 × 15⅛")
RPC 03/0065/36

OPPOSITE TOP LEFT: Alexandra, Princess of Wales,
'The Peasants in their smart national dress for their Saints' Day',
Greece, 1899
Printing-out paper, 12.3 × 9.5cm (4¹⁵⁄₁₆ × 3¹³⁄₁₆")
RPC 03/0065/34b

The Princess has caught the eye of a small boy
in the crowd.

OPPOSITE TOP RIGHT: Alexandra, Princess of Wales,
A peasant woman at Villa Achilleion, Corfu, 1899
Printing-out paper, 12.3 × 9.5cm (4¹⁵⁄₁₆ × 3¹³⁄₁₆")
RPC 03/0065/37a

The setting is reminiscent of the neo-classical paintings
of Lord Leighton and Sir Lawrence Alma-Tadema.

OPPOSITE BELOW: Alexandra, Princess of Wales,
Group of peasants on the road, Crete, 1899
Printing-out paper, 9.4 × 12cm (3¾ × 4⅞")
RPC 03/0065/43h

The Princess saw these women on the road to the
Palace of Mustapha Pasha; she was always intrigued
by national costume.

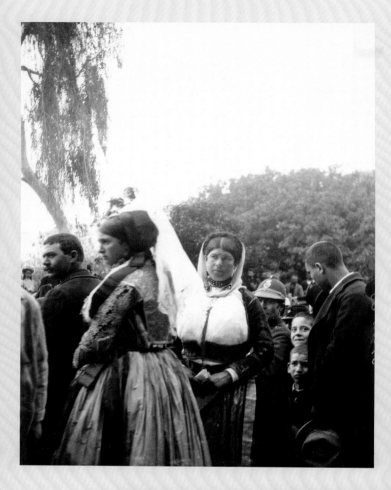

Alexandra, Princess of Wales, *The view from the Princess's window in the Palace at Athens*, 1899
Printing-out paper, 9.7 × 12.5cm (3¹³⁄₁₆ × 4¹⁵⁄₁₆″)
RPC 03/0065/47b

Alexandra, Princess of Wales, *King George I and Queen Olga of the Hellenes*, 1899
Printing-out paper, 11 × 9.8cm (4⅜ × 3⅞″)
RPC 03/0065/49a

Alexandra particularly liked strong contrast and was fond of photographing silhouettes. Here she has used the figures of her brother and sister-in-law to produce a study in dark and light.[32]

LEFT: Alexandra, Princess of Wales,
Tunis, 1899
Printing-out paper,
9.4 × 12.5cm (3¹¹⁄₁₆ × 4¹⁵⁄₁₆″)
RPC 03/0065/57e

BELOW: Alexandra, Princess of Wales,
View through railings, Tunis, 1899
Printing-out paper,
9.6 × 12.3cm (3¾ × 4⅞″)
RPC 03/0065/59a

ABOVE: Alexandra, Princess of Wales, *'My neighbours on board their small yacht, enjoying their Sunday afternoon just under my window'*, 1899
Printing-out paper,
8.4 × 12.4cm (3⅜ × 4⅞")
RPC 03/0065/69d

This boat was moored next to the Royal Yacht at Marseilles.

LEFT: Alexandra, Princess of Wales, *'Carlos being washed'*, 1899
Printing-out paper,
9.6 × 12.3cm (3¾ × 4⅞")
RPC 03/0065/53d

Ernest Davies, a member of the crew of the Royal Yacht, is undertaking extra duties, washing Princess Maud's dog.

Part-way through the holiday, the Princess, with Miss Charlotte Knollys and General Clarke, made a detour to Copenhagen by way of Frankfurt, in order to attend the christening of her great-nephew, the future King Frederick IX. Returning to Venice on 16 April, they spent 'five lovely days going in Gondolas visiting St. Marco – St. Maria Salute – St. Giovanna & St. Paolo – La Donna dei Miraculi – finished up every day with drinking excellent Chocolate on the Piazza surrounded by Pigeons who sat on our heads and shoulders.' After leaving Venice ('I always feel a pang at leaving this poetical place') the royal party travelled to Corfu, where they were met by the Princess's brother, King George I of the Hellenes, and later saw a grand religious procession in honour of St Spiraeias. The peasants were wearing their national costume, which was much admired by the Princess of Wales.

Alexandra and her party finally arrived at Athens on 2 May, where they spent several days with her brother and sister-in-law before leaving on 7 May for Patras ('lovely place – but on shore like hot steam bath'). They landed at Zanthe on 9 May, where she 'bought some poor little pigeons which I saved from being killed for food – & let them fly further on'. After this, they stopped at Messina and then Tunis, where they met the British Consul, Mr Johnstone, and his wife. The Princess kept a photograph of them in her album, next to one of the Consul's pet monkey, who had 'travelled with them on honeymoon'. She was also intrigued to visit the Bey of Tunis at his palace:

> We found him seated on a throne surrounded by all his attendants – a very civil old man but we had to speak to him by an Interpreter, which was a very embarrassing undertaking, all sitting in a circle round the room. At last I suggested to be allowed to see the Harem – which he jumped at & opened a small side door. Here we found all his wives – & very ugly vulgar French cheap furniture in endless rooms – with a <u>couch</u> or <u>bed</u> in each – which I hope they liked. The Ladies had long sort of Turkish trousers on & long hanging garments, with their hair loose – decorated with flowers. The Ladies were kind and showed us everything.

In 1900 the Princess of Wales's imagination was caught by an event with which her husband had been concerned – the Exposition Universelle in Paris. The Prince had presided at meetings, held at Marlborough House, of the executive committee of the Royal Commission for the Paris Exhibition,[33] and used his influence to obtain loans for display in the British Pavilion. The exhibition was opened by the French President, Emile Loubet, on 14 April 1900, and when the Princess of Wales visited Paris in October, she devoted four days to it.[34]

What was on show would have had a great appeal to her. It included not only the largest international exhibition of contemporary art that had ever been held, with thousands of paintings and sculptures from all over the world, but also an historic survey of art in France and a retrospective exhibition of French art from 1800 to 1889. Among the less usual items was a display of chronophotography by Etienne-Jules Marey, who had developed a way of recording different stages of the movements of men and birds on a single plate, as well as Georges Méliès's films

Cinderella, *Red Riding Hood* and *Bluebeard*.[35] Examples of Röntgen rays were shown, and the Kinora Viewer, invented by Auguste and Louis Lumière and, by 1900, being manufactured by L. Gaumont & Cie, was on display.[36]

On 22 January 1901 Queen Victoria died at Osborne House, in the presence of many members of her family. The Princess of Wales held her hand as she breathed her last. This was a fitting end to their relationship; in spite of occasional differences, Alexandra had always loved her mother-in-law, and the feeling had been fully reciprocated. Now the Princess (who refused to be called Queen until after the funeral) brought her creative instincts to bear on the provision of a memorial to her mother-in-law, designing a panel to be cast in bronze and mounted at the head of the Queen's bed.[37]

Following his mother's death, the Prince of Wales succeeded to the throne as King Edward VII at the age of 59. He was to be crowned on 26 June 1902, but shortly before this he was taken suddenly and dangerously ill with perityphlitis (a condition akin to appendicitis).[38] An operation saved his life, but the Coronation, which finally took place on 9 August, was shortened so as not to tire him too much. This may also be the reason why few full-length formal photographs of him,

Queen Alexandra, *A view from Buckingham Palace, looking down the Mall*, c.1902
Printing-out paper, 7.6 × 10.1 cm (3 × 4")
RPC 03/0067/5e

Queen Alexandra's fondness for central focal points in her work is clear here. This view pre-dates the installation of the Queen Victoria Memorial outside Buckingham Palace at the west end of the Mall.

Queen Alexandra/Alfred Nutt (designer)/
Ion Pace (sculptor?)/the Gunthorp foundry,
Memorial plaque to Queen Victoria, 1903
Bronze, 220 × 175.2cm (86⅝ × 68¾″)
RCIN 34161

This plaque is in Queen Victoria's bedroom at
Osborne House. A report of 7 November 1903
in the *Sphere*, a popular magazine of the time,
headed 'Designed by a Queen for a Queen',
described how the memorial had recently been
put in place. The panel 'has its origination in
a design made by Queen Alexandra, who has
taken the deepest interest and given personal
supervision to the work in its several stages to
completion'. The memorial took the form of
'two angels in high relief bearing away the
crown. Above is the sacred monogram with
rays and winged seraphs amid conventional
clouds; below, in faint relief, are indications
of Westminster Abbey, where her late Majesty
received her crown, and the mausoleum at
Frogmore, the Queen's last resting place on
earth. The inscription on the tablet was
suggested by Queen Alexandra.' It reads:
'Thy Saviour called thee, Beloved, now thy
work is done. Thou art weary; come rest in
thy eternal Father's Home. In loving memory
from her sorrowing children, grandchildren
and great grandchildren to their ever-beloved
Mother and Queen. Victoria. Jan. 22 1901'.

with Queen Alexandra, appear to have been taken at this time. The King may not yet have been
strong enough to stand up to long photographic sessions. On the other hand, a number of pictures
were taken by W. & D. Downey and Alice Hughes, of Alexandra in full Coronation robes, alone
and with her pages.

Before the King's illness a request had been received from Charles Urban, an entrepreneurial
film-maker, for permission to film the Coronation service inside the Abbey. Not surprisingly, this
was refused, although Urban was allowed to use a camera in the precincts and was able to film the
King and Queen on their arrival and departure. However, he commissioned a 'studio version' of
the service from the French film-maker Georges Méliès, using stage props, actors and a good deal
of imagination, which was then combined with Urban's own, genuine footage to produce a
reasonably convincing result.[39] An album entitled *Coronation Procession 1902* containing

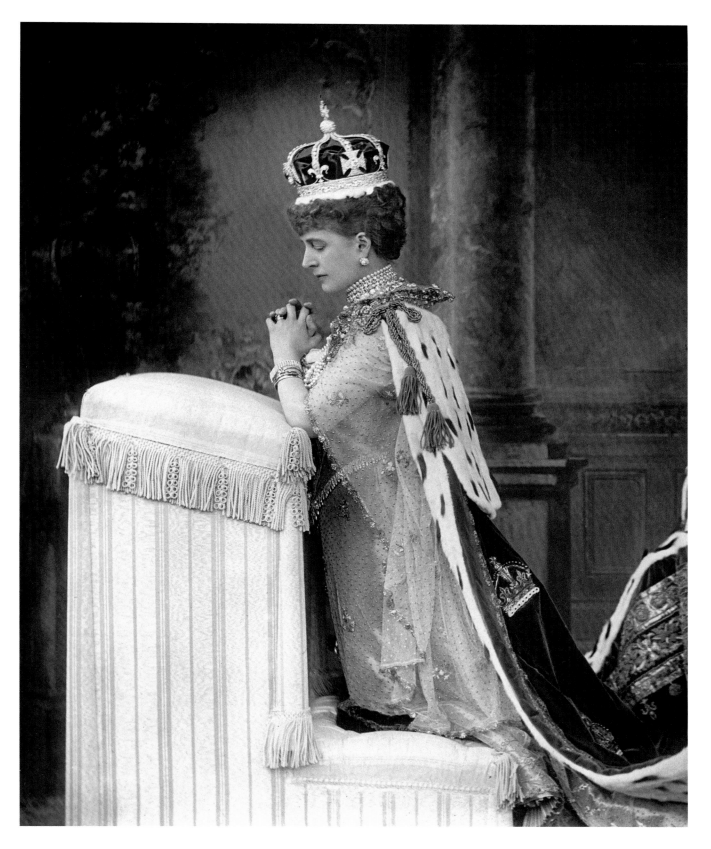

W. & D. Downey, *Queen Alexandra at the time
of the coronation*, 1902
Platinum print, 28.6 × 22.9cm (11¼ × 9″)

photographs of the procession, scenes outside the Abbey and other events, such as a review in the grounds of Buckingham Palace, is in the Royal Photograph Collection. The photographs are unattributed, but it is possible that at least some may have been by Urban or another film-maker, Cecil Hepworth.[40]

From 21 July to 1 August 1903, King Edward and Queen Alexandra paid a State Visit to Ireland in the Royal Yacht. This included Dublin, Belfast, Cork and several other places. The visit was a great success, and although Alexandra apparently did not compile her own Irish photo album, it was marked photographically by the presentation to the King, by 'some of his Irish subjects in happy remembrance of the Royal Visit of 1903', of four albums, each allotted to one of the four Provinces of Ireland: Ulster, Leinster, Munster and Connaught. The total number of photographs was 200 – fifty for each province – and they were printed in tones of black, white and grey, sepia or green.

Unknown photographer,
Doorway, Quin Abbey, 1903
Carbon print, 20.5 × 15.4cm (8¹⁄₁₀ × 6¹⁄₁₀″)
RCIN 2600140/38

Unknown photographer,
Evening on the Liffey, Carlisle Bridge, Dublin, 1903
Carbon print, 23 × 17.8cm (9¹⁄₁₀ × 7″)
RCIN 2600002/2

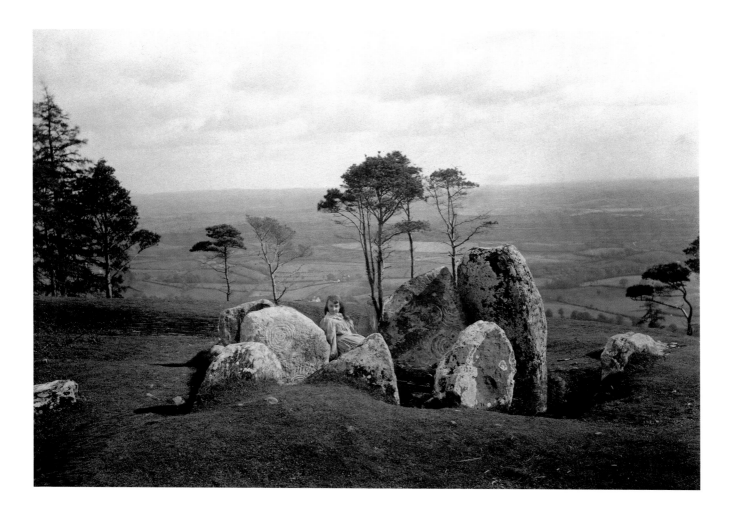

ABOVE: Unknown photographer,
Knockmany Tumulus, Co. Tyrone, 1903
Carbon print, 14.7 × 20.3cm (5¾ × 8″)
RCIN 2600074/23

LEFT: Unknown photographer,
A Waterfall, Maam Turc Mountains, 1903
Carbon print, 14.5 × 20.2cm (5¹¹⁄₁₆ × 8″)
RCIN 2600157/4

These four pictures are from the albums
presented to King Edward VII during the
Royal Visit to Ireland in 1903. The books
were bound by Hegan & M'Ferran Binders
of Belfast but, unfortunately, no mention
was made of the photographers who
produced such beautiful views. It is thought
that the albums were probably put together
by the Lawrence Studio, working with a
number of photographers, including Robert
French. Another photographer, Robert
Welch, is also thought to have contributed
to the collection.[41]

It was at about the turn of the century that Alexandra began to design a book-plate for herself (see page 95). Sir Frederick Ponsonby remembered a visit on board the Royal Yacht in 1902, when she showed him her cabin. It was 'more like a drawing room' than a cabin and was painted white and panelled with bookcases, 'with a boudoir grand piano and very comfortable armchairs'. Proudly, 'the Queen showed me … her book-plate, which she had designed herself. On it were her favourite books, her favourite music, her favourite dogs, a picture of Windsor, a picture of the Palace at Copenhagen, and a little strip of music, the first bars of her favourite song; a most elaborate book-plate, and she said she had been told it would be quite impossible to have so many different things portrayed, yet there it was.'[42]

Russell & Sons, *Queen Alexandra's painting room at Windsor Castle, c.1910*
Printing-out paper, 24.3 × 29.3cm (9⁹⁄₁₆ × 11⁹⁄₁₆″)
RCIN 2100757/20

The Queen used this room when staying at the Castle during her husband's reign. Her painting of clematis, reproduced opposite, can be seen at the end of the room, towards the left. The drawers and cupboards resemble those used in the Queen's painting room at Marlborough House (see page 150), where she lived as a widow; perhaps they were copied, or transferred there when she ceased to occupy the rooms in Windsor Castle.

ABOVE: Queen Alexandra,
Clematis, early 20th century
Watercolour, 42.6 × 56.2cm (16¾ × 22⅛")
RL.K 1409

LEFT: Unknown photographer,
*Queen Alexandra in her cabin on board
the Royal Yacht 'Victoria and Albert'*, 1905
Printing-out paper, 8.4 × 8.7cm (3³⁄₁₆ × 3⁷⁄₁₆")
RPC 03/0069/71b

Queen Alexandra's book-plate underlines her love of books and her pleasure in reading. Her collection of books and albums also demonstrates her fondness for decorative bindings. Perhaps this began in her youth at her parents' house, where, according to the recollections of King Christian IX's ADC, Colonel C.H. Rørdam, Queen Louise's library contained 'a lot of books in magnificent bindings'.[43] Over 3,000 books belonging to Alexandra are still in royal possession.[44] A paragraph from 'Our Ladies' Page' by Filomena, from the New York edition of the *Illustrated London News* in January 1907, shows that the Queen's interest was already public knowledge:

Queen Alexandra is a great lover of books, and has given numbers of them as presents. She is particularly fond of presenting Lord Tennyson's poems. She knew the great poet personally, and honoured him with much affection. When her Majesty gives a book for a present it is almost always beautifully bound specially to her order. Bookbinding is a branch of art which traditionally is patronised by royal personages One day, no doubt, Queen Alexandra's bindings, as well as the equally beautiful ones often ordered by the King, especially from the Guild of Women Book Binders, will be regarded as literary treasures descended from our century. An almost priceless treasure for a collector of the twenty-third century would be the Sandringham Visitors' Book, exquisitely bound in purple morocco, tooled with the royal coat of arms, and containing the autographs of most of the celebrated people of our era.[45]

Curiously enough, those who knew the Princess in the early years of her marriage were under the impression that books held no charm for her. 'The melancholy thing is that neither he nor the darling Princess ever care to open a book,' lamented Lady Frederick Cavendish,[46] and Queen Victoria would have agreed with her.[47] The Queen gave her daughter-in-law books on various occasions; these were frequently of poetry, such as *The Bridal Souvenir*, decorated with illuminated borders, which was given as a wedding present, or of an improving nature, such as *Moral Emblems with Aphorisms, Adages and Proverbs, of all Ages and Nations*, given in 1864. However, while the Princess certainly enjoyed the position in society which her marriage had brought her, it did not mean that the more thoughtful side of her character had changed. Her beauty, perennially youthful appearance and a certain lack of guile in her manner and conversation were misleading: such an ethereal creature was most unlikely to be intelligent as well – or so it was perceived. Queen Victoria only visited Sandringham twice (the first time being in 1871–2 during the Prince of Wales's illness and the second time in April 1889), and so had little opportunity to discover how many of her daughter-in-law's books it contained, especially as the century progressed. Some of these books were presented to the Princess; one gift received in 1878 embraced a whole library of 1,500 volumes belonging to a gentleman, George Mitchell, of Bolton Street, Piccadilly. He bequeathed 'his Library of Books (except the *Decameron* of Boccaccio) to Her Royal Highness the Princess of Wales, if she will be graciously pleased to accept the same, for the benefit of herself, or of any of her children'.[48]

It is not surprising that, by now, the Queen enjoyed reading much more than social and official functions; her deafness was causing increasing difficulties. Perhaps the largest section of her

ABOVE: *The front cover of 'Queen Alexandra's Album,*
c.1890s to early 1900s', 1893
(album bound by J.C. Vickery of Regent Street, London)
28 × 39 × 5.5cm (11 × 15½ × 2½")
RPC 03/0067/9

Helen Faudel-Phillips gave this album to the
Princess of Wales as a birthday present in 1893 or
1899, describing it as 'a book I have had made for
your "Kodak Views", & which I trust your Royal
Highness will like'.

RIGHT: Queen Alexandra/Mr Scott,
Queen Alexandra's book-plate, c.1902
11 × 8.3cm (4¹³⁄₁₆ × 3¼")
RPC 03/0070 (inside front cover)

The lines of music are the opening bars of Gounod's
Romeo and Juliet; the dogs (two Japanese spaniels
and a borzoi) were called Punchie, Billie and Alix.
The Danish palace is Kronborg Castle at Elsinore,
associated with Shakespeare's *Hamlet* (not Copenhagen
as Ponsonby thought); the other castle is certainly
Windsor. Queen Alexandra's favourite writers were
Byron, Shakespeare, Shelley and MacCarthy
(possibly the Irish poet and translator Denis Florence
MacCarthy, 1817–82); another book, entitled
John Inglesant, was by Joseph Henry Shorthouse.
Books of music, by Schumann, Rubinstein, Wagner,
Brahms and the Danish composer Niels Gade

(1817–90), are also included, together with the motto
'Faithful unto Death'. The design is bordered by oak
leaves and roses, with a small dove hovering among
them. A Danish flag is placed close to the emblem of
the Prince of Wales's feathers.

Attributed to Miss M. Lilian Simpson,
Queen Alexandra's Autograph Book, 1908–25
Three panels and a clasp in electro-silver plate,
over a binding of dark blue velvet,
24.8 × 19.6 × 7.3cm (9¹⁵⁄₁₆ × 7⅝ × 2⅞″)
RA VIC/Add W28

King Edward VII gave this book to Queen Alexandra as
a Christmas present in 1905. The design on the panels
embodies the growth of life, watched over by spirits,
with Love as the central figure. It is identical in design
to a binding in the British Library, by Miss Simpson,
which was modelled on a commission from the Council
of the Art Union of London.[49] That book was exhibited
at the Royal Academy in 1896, where the Prince of
Wales may have seen it during his visit on 2 May, when
the Princess was on holiday with her sister in the South
of France. The Prince and Princess of Wales were both
interested in bookbinding, and their daughter Princess
Victoria is said to have practised it herself. The inscription
on the silver, which can be seen in the illustration, reads:
'Art Union of London 1st January 1896'.

library was historical; it included biographies of remarkable and sometimes strong-minded ladies, such as Mary, Queen of Scots; Marguerite de Valois; Marie Antoinette; Caroline of Brunswick; Beatrice D'Este, Duchess of Milan; and Elizabeth of Bohemia. It is also possible that reading helped her to gain a knowledge of events that she had been unable to catch in conversation; she possessed many memoirs of figures whose life-span overlapped hers. Among these were a number of memoirs of German court life, and it is interesting that she was reading these up to and during the First World War. Her hatred and suspicion of Germany, or rather, of Prussia, had its origin in Prussia's defeat of Denmark in 1864 and subsequent annexation of the Danish territory of Slesvig (Schleswig) and Holstein.[50] She was fond of, and sympathised with, her sister-in-law, Victoria, Princess Royal, and her husband, who became Emperor Frederick III in 1888 before dying of throat cancer in the same year. But she found their son, Emperor William II ('Kaiser Bill'), overbearing and ridiculous.

The library also contained a small number of books relating to photography. One of these, *With Nature and a Camera*, by Richard Kearton, dealt with wildlife; others contained photographic illustrations of places, works of art and buildings. One, *London*, published in 1909, contained images by Alvin Langdon Coburn, whose photographs would receive greater public acclaim as the century progressed.[51] Coburn exhibited work at the Goupil Gallery in 1910, 1913 and 1917. Alexandra regularly frequented this gallery, but it has not yet proved possible to match the timing of her visits with that of Coburn's exhibitions. However, he shared the 1910 exhibition with Baron de Meyer, who had photographed King Edward and Queen Alexandra a few years earlier; perhaps they heard of Coburn's work from him.

The Queen also collected books on art, historic buildings and architecture. These included *Architektür von Olbrich*, published in two volumes,[52] which contained pictures of the houses built by

Lafayette, *The Princess of Wales at the Devonshire House Ball*, 1897
Toned printing-out paper,
35.4 × 25.6cm (12 ¹⁵⁄₁₆ × 10 ⅛″)
RPC 01/0235/188

The Princess in costume as Marguerite de Valois, one of her favourite historical characters. She is attended by Louvima Knollys, daughter of Sir Francis Knollys. At the Waverley Ball in 1871 the Princess had appeared as Mary, Queen of Scots, her ancestress, whose life also fascinated her.

41 Information from the National Library of Ireland.

42 Sir Frederick Ponsonby, first Lord Sysonby, *Recollections of Three Reigns*, London 1951, p.143. The design was commissioned from Messrs J. & E. Bumpus of Oxford Street in London, a bookshop regularly patronised by the Queen. It was drawn, under her supervision, by an artist named Scott, and engraved partly by John Edward Syson and partly by J.A.C. Harrison. The book-plate also bears the initials W.P.B., namely William Phillips Barrett, a New Zealander who worked for Bumpus from the early 1890s and was responsible for the book-plate orders. (Brian North Lee, *British Royal Bookplates*, Scolar Press, London 1992, p31.)

43 Jørgen Hein and Gerda Petri, trans. Marianne Nerving and Paulette Møller, *The Royal Danish Collection. Christian VIII's Palace, Amalienborg*, Copenhagen 1999, p.12

44 They are kept at Sandringham and Windsor. Many were bound in cloth, sometimes with leather spines and corners, with line decorations and lettering in gold and with her cypher, a double A and a crown, at the top left corner of the front cover. Many have her own signature, the date when they were acquired and sometimes a comment about the contents. Her surviving accounts show that she bought quantities of books from Messrs Hatchard, J. & E. Bumpus and at least thirty other suppliers (RA.VIC/Add A 21/220A-D). Many were intended as gifts.

45 *Illustrated London News* (New York edition), 19 January 1907, p.108

46 Battiscombe, *op. cit.*, p.126

47 Battiscombe, *op. cit.*, p.87

48 RL. Catalogue of the Library of George Mitchell, Esquire, RCIN 1028983.a

49 Marianne Tidman, *Women Bookbinders, 1880–1920*, London 1996, p.89

50 See Chapter 1, note 14

51 Kearton, RCIN 1134864; Coburn, RCIN 1231935

52 RCIN 1033710 and 1033711

53 The Princess had become familiar with the French language in her youth, when she was taught by her resident governess, Mademoiselle Schwiedland. Her French lessons included not only grammar and composition, but 'histoire naturelle' and 'cours d'analyse logique' as well as Swiss, ancient Roman and ancient Greek history.

54 Oscar Wilde; RCIN 1033683, with the Princess of Wales's book-plate

55 The story is repeated here by courtesy of Lt.-Commander C.H. Knollys, in whose family it is still told.

EXHIBITOR AND AUTHOR

B y the early years of the new century the fact that Queen Alexandra enjoyed photography was well known. She was often seen with a camera on public occasions and this was quickly taken up by the Press. In 1905 the *Daily Mirror* published a picture of her taking a photograph and commented that it was not the first time that this had happened: 'Not long since, she levelled a camera at part of a crowd gathered to welcome her. A correspondent with a camera promptly levelled his lens at Her Majesty, who seemed greatly amused and smiled upon him as the cameras clicked simultaneously.'[1]

By this time Alexandra and other members of the royal family had contributed to more exhibitions in London. Two of these were held in 1902, at the Kodak Galleries at 40 West Strand and 115 Oxford Street; on 1 July 1901 Queen Alexandra had granted a Royal Warrant to 'Mr George Eastman, trading as "Kodak"'. In 1904 the important Grand Kodak Exhibition included eleven of the Queen's photographs. This exhibition went on tour and was sent to the USA in 1905.[2] In August and September of the same year, the Queen gave permission for nine of her photographs to be published in three special supplements of the *Graphic*, a popular illustrated

Attributed to Sir Arthur Ellis (1837–1907), *Queen Alexandra with her camera during a holiday in Norway*, 1904
Watercolour,
23.8 × 24.6cm (9⅜ × 9⅝")
RL 28453

Major-General Sir Arthur Ellis was a distinguished soldier and royal servant. He served as Equerry to Edward VII as Prince of Wales and as King from 1868 till his death, and was also Extra Equerry to the King, and Comptroller in the Lord Chamberlain's Department from 1901. Ellis was also a talented artist who enjoyed drawing caricatures.[3]

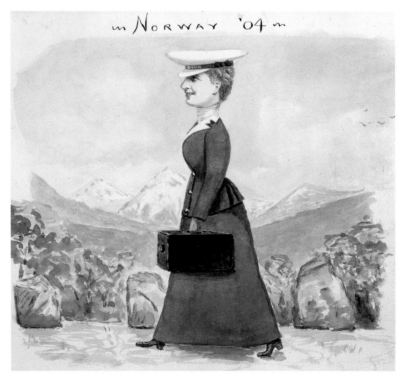

weekly magazine (see page 169). Kodak, who provided the prints, undertook to display copies of them in the windows of their dealers' shops.

In 1906 Alexandra and other members of the royal family took part in an exhibition of 'Royal Kodak Photographs' held at the Kodak Gallery at 115 Oxford Street, London W.1. Twenty-three photographs by the Queen were included; the *Amateur Photographer* commented that she 'displayed a fine appreciation of artistic effect in some of her subjects', in particular *Gathering Storm Clouds* and *H.M.S. Ganges from the Royal Yacht*.[4] The majority of the Queen's photographs in this exhibition, as on so many other occasions, were maritime studies. Her skill in recording such subjects was instinctive; her Danish blood gave her a great love of the sea. In addition, she took an interest in naval matters for the sake of her sons, both of whom, as boys, had undergone naval training, Prince George making the Royal Navy his career until he became heir to the throne.

Other members of the Queen's social circle during this period were also keen photographers. One of these, Sarah Angelina Acland, the daughter of the Prince of Wales's physician Sir Henry Acland, had first become friendly with the royal couple during a visit to Wildbad, a spa in the Black Forest, in 1869, and had kept in touch with them mainly through correspondence with the Prince's private secretary, Francis (later Viscount) Knollys, and his sister Charlotte, personal secretary to the Princess.[5] In due course Miss Acland became a Fellow of the Royal Photographic Society and regularly showed work at the Society's exhibitions between 1899 and 1909.[6] In November 1896 she had sent one of her photographs to the Prince of Wales, which he considered 'a very good one'. This may have been the portrait of Henry George Liddell, Dean of Christ Church, Oxford, taken in June 1896, which is still kept in the Royal Photograph Collection. Miss Acland later experimented with colour photography and sent some examples for Queen Victoria to see.[7]

In a letter of 12 June 1903, Charlotte Knollys commented on the 'many interesting photographs' that Miss Acland had taken in Gibraltar and how 'it must be very amusing doing them in three colours!' By 1905 it appears that Miss Acland hoped to send examples of her work to Queen Alexandra too; Miss Knollys writes in an undated letter that the Queen would be very happy to see some of her photographs 'if you could, at any time, send a small collection <u>here</u>'. These may be the images referred to in a letter of 8 June 1905, in which Miss Knollys confessed that 'both the Queen and myself made a mistake in thinking that the Photographs you wrote about were the <u>ordinary</u> ones mounted on cardboard. If you would like it you could of course send the lantern slides but I fear they would not show to advantage unless properly lighted up and this I fear would be impossible under the circumstances.' Somehow the problems were circumvented and by 12 June Miss Acland's slides had been returned to her, with the comment that 'the Queen admired them very much'.[8]

During this period King Edward VII gave his support to the publication of a catalogue of the paintings and drawings in Buckingham Palace, and a guide to Windsor Castle.[9] William Edward Gray (active early twentieth century) was employed as official photographer to record works in the royal collection and, after the King's death, continued to work for the royal family, his Royal Warrant as photographer to Queen Alexandra being renewed when she became Queen Mother.

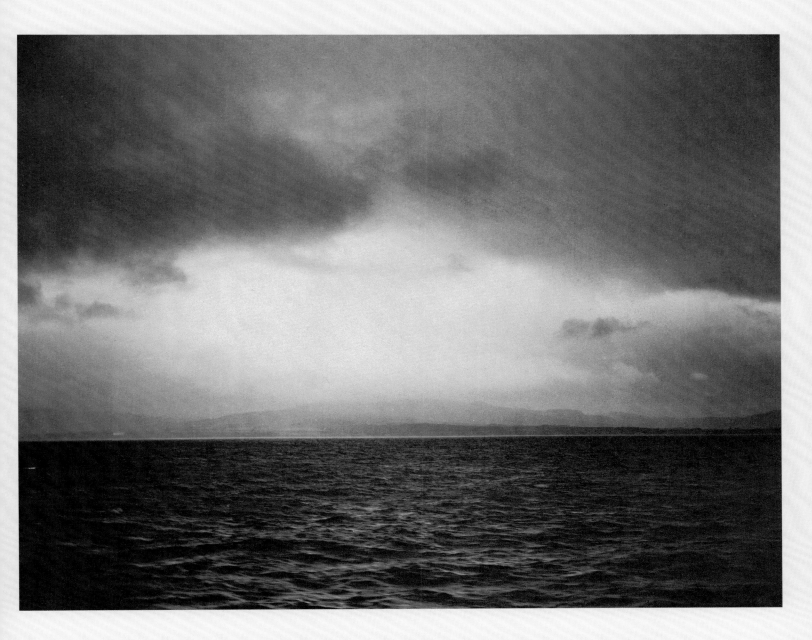

Queen Alexandra, *A view at sea*, early 1900s
Toned bromide, 23.7 × 30.2cm (9⅜ × 12″)
RPC 03/0188/10

This view recalls the photographs of Gustave Le Gray, some of which were acquired by Queen Victoria and Prince Albert.

This and the photographs on the next three pages appear to have been enlarged from smaller snapshots. Although no information is given, it is likely that the images were among those which Queen Alexandra showed at Kodak exhibitions or published in the *Graphic* in 1905.

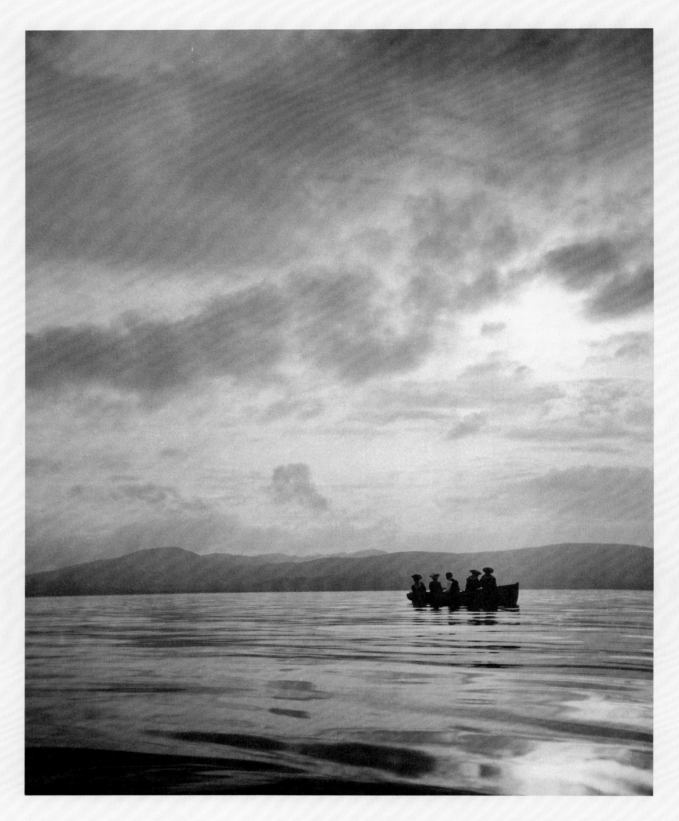

Queen Alexandra, *A small boat at sea*, early 1900s
Toned bromide, 30.2 × 23.9cm (11¹⁵⁄₁₆ × 9⁷⁄₁₆″)
RPC 03/0188/13

ABOVE: Queen Alexandra, *A view of the garden at Sandringham, with the Prince of Wales's three eldest children,* early 1900s
Toned bromide, 23.9 × 30.2cm (9⁷⁄₁₆ × 11¹⁵⁄₁₆″)
RPC 03/0189/3

RIGHT: Alexandra, Princess of Wales, *Crowds greeting King Christian IX of Denmark on his birthday,* 8 April
Toned bromide, 23.9 × 30.3cm (9⁹⁄₁₆ × 12″)
RPC 03/0189/6

This was taken from one of the four palaces at Amalienborg in Copenhagen. The King celebrated his eightieth birthday in 1898.

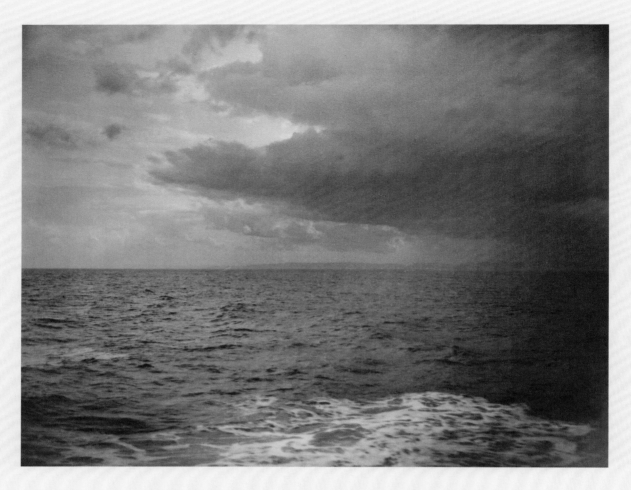

ABOVE: Queen Alexandra, *Sea view with dark clouds*, early 1900s
Toned bromide, 23.5 × 30.1cm (9¼ × 11⅞″)
RPC 03/0189/11

LEFT: Queen Alexandra, *Changing the Guard at Windsor Castle*, early 1900s
Toned bromide, 30.2 × 23.8cm (11¹⁵⁄₁₆ × 9⅜″)
RPC 03/0189/13

A familiar event, recorded in such a way that the image divides into three horizontal sections.

In the spring of 1905 the Queen took another Mediterranean holiday on board the Royal Yacht, and compiled a record of it, this time in two volumes.[10] It began inauspiciously. A State Visit to Portugal had been planned as part of the cruise, but the King was unwell, and Alexandra was obliged to leave without him. On arrival at Vigo the weather prevented any communication with the shore; the Queen commented that there was nothing to do 'but to photograph the seagulls'.

On 22 March the yacht arrived at Lisbon, where the Queen was met by King Carlos, Queen Amélie and the Dowager Queen Maria Pia. Now began several days of celebration; during 'a long and most exciting drive through the beautifully decorated & crowded streets', flowers and live doves were thrown into Queen Alexandra's carriage. At the opera, where Massenet's *Manon* was performed, the audience gave her such a reception that, from shyness, 'I nearly sank into the ground' although 'it <u>touched</u> me deeply'. The Queen and her party left on 25 March, 'never having had such an ovation and enthusiastic reception in all my life!!' After a short visit to Spain, the yacht arrived at Gibraltar, where the Queen and her companions rode to the top of the Rock, 'which I have always wished to see so much', on 'specially selected quiet ponies or donkeys'.

ABOVE: Unknown photographer,
*Queen Alexandra riding a donkey
in Gibraltar*, 1905
Printing-out paper,
7.4 × 7 cm (2⅞ × 2¾″)
RPC 03/0069/14c

LEFT: Queen Alexandra,
A view of roofs in Portugal, 1905
Printing-out paper,
12.2 × 10 cm (4¾ × 3¹⁵⁄₁₆″)
RPC 03/0069/28d

On 30 March, while still at Gibraltar, Alexandra visited the battleship *King Edward VII* – 'a splendid ship'. Sir William James described how, after touring the ship and being lowered 10 metres (30 feet) on the hydraulic lift intended for those wounded in action, the Queen 'photographed us all with her Kodak'. Then she went over to the wireless telegraph and sent a message to the King: 'I am aboard the ship named after you and send you my fondest love.'[11]

On 7 April, King Edward, 'looking much better than I expected', arrived at Marseilles, where the yacht had been moored. On arrival at Algiers just over a week later, Alexandra's first impressions were 'very gloomy & dull – pouring with <u>sleet</u> & rain & <u>horribly cold</u>'. The weather improved the next day, and the party were able to visit a mosque, the Turkish quarter of the town and the palace, where they had lunch with the Governor, General de Mustapha. At Bougie the Queen was presented with an *outarde* (a bird of the desert) and two gazelles, which were kept in a special enclosure on the deck of the Royal Yacht. The visit to Algiers lasted several more days, then, after visiting Sardinia, the yacht arrived at Corsica on 26 April, and the Queen was able once more to 'visit Napoleon's House – my third visit there'.[12]

The King and others left for England on 28 April, but Queen Alexandra set off for a private visit to her brother in Greece. While there, on 9 May, she went with her sister-in-law to a hospital of which Queen Olga was patron. With them was Nurse Fletcher, who had travelled with the royal party on the yacht to look after Princess Victoria, recovering from appendicitis. They saw 'a most terrible operation performed on a poor Woman – It was most interesting & wonderfully well & quickly done by a Greek surgeon of great skill. The poor patient however died three days after.' (Alexandra's fragile appearance was deceptive; she had considerable sang-froid and, as Princess Victoria once remarked, 'my Mother is seldom tired, although she doesn't look particularly strong'.[13])

The cruise continued, with further stops in Malta, Oran (Algeria), Gibraltar, and Algeciras. In Arosa Bay, as at the beginning of the holiday, they were plagued by gales. The Queen and some others went ashore, but during a drive into the country 'it blew a perfect hurricane – which got worse and worse – we positively saw nothing of the country as the dust was so intense – we struggled with our hats & had to tie handkerchiefs over our faces'. Arrangements were made for them to return by train, but at Arosa Bay the sea was so rough that the yacht had to remain a mile and a half offshore. The problem of conveying the Queen and her companions back to it was acute:

> <u>How</u> we ever got back to the <u>Yacht</u> that afternoon ! – The wind had got up to such a pitch that we cld. hardly walk along the Pier. Here the Captain had sent for a big covered boat (a Picket) fr. the *Aboukir* as no small launch could face the sea. Into it we all scrambled – & then lo and behold what a tossing we got…. The whole crew & poor Victoria were anxiously watching our arrival & were wondering how we shd. get on board without the boat being dashed to pieces against the ship – they poured gallons of oil on the sea – & luckily a big wave carried us high, when we four ladies leapt out & were saved, while the poor gentlemen were inundated by oil.

Safe in London, four days later, Alexandra was 'very grateful for our lovely Cruize' but added 'all is <u>well that ends well</u>'.

ABOVE: Queen Alexandra, *'Arabs mounted on their prancing steeds'*, Kerrata, Algeria, 1905
Printing-out paper, 9.5 × 12.4cm (3¾ × 4¹⁵⁄₁₆")
RPC 03/0069/58c

LEFT: Queen Alexandra, *'Bertie drives back in our little carriage by himself, fast asleep'*, 1905
Printing-out paper, 8.7 × 9cm (3⅔ × 3½")
RPC 03/0069/66k

An affectionate portrayal of her husband, recording an incident in Sardinia.

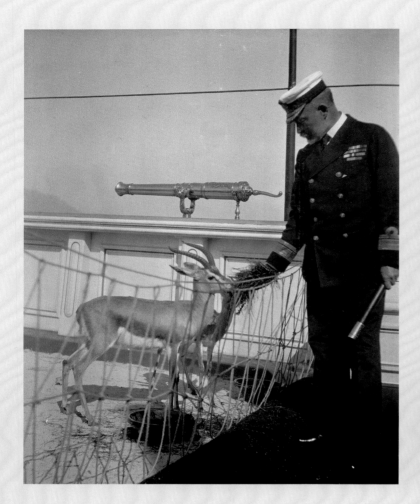

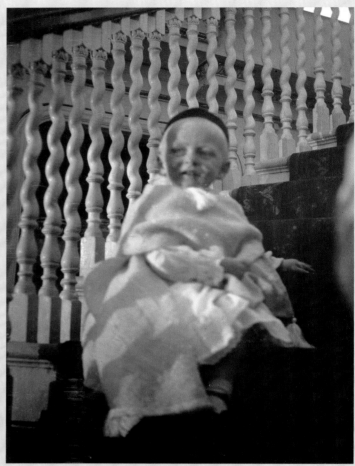

Queen Alexandra, *An officer in charge of gazelles
on the Royal Yacht*, 1905
Printing-out paper, 11.9 × 9.2cm (4¹¹⁄₁₆ × 3⅝″)
RPC 03/0069/72b

Queen Alexandra, *Prince Alexander of Denmark
on the Royal Yacht*, 1905
Printing-out paper, 12.6 × 9.2cm (4¹⁵⁄₁₆ × 3⅝″)
RPC 03/0069/68a

Alexandra often referred to her grandson as
'my little Hamlet'; later, when his father was elected
to the throne of Norway, he took the name of Olav.
In this photograph the pattern formed by the banisters
contrasts with the dark carpet on the stairs, and the
child, intentionally or not, has a distinctly pontifical
appearance.

ABOVE: Queen Alexandra, *King George I
of the Hellenes in his study, Athens*, 1905
Printing-out paper, 9.6 × 12.7 cm (3¾ × 5″)
RPC 03/0069/77b

LEFT: Queen Alexandra, *Queen Olga
of the Hellenes in her room, Athens*, 1905
Printing-out paper, 11 × 9.7 cm (4⁵⁄₁₆ × 3¹³⁄₁₆″)
RPC 03/0069/77e

OPPOSITE TOP LEFT: Queen Alexandra, *King George I
of the Hellenes and one of his grandchildren*, 1905
Printing-out paper, 11.9 × 9.8cm (4¹¹⁄₁₆ × 3⅞″)
RPC 03/0069/77g

The child was perhaps Princess Irene (born February 1904).

OPPOSITE TOP RIGHT: Queen Alexandra, *Princess Nina
of Russia and Prince Paul of Greece*, 1905
Printing-out paper, 12.1 × 9.9cm (4¾ × 3⅞″)
RPC 03/0070/4b

Two of the grandchildren of King George I of the Hellenes.

OPPOSITE BELOW: Queen Alexandra, *Queen Alexandra's
nephew, Constantine, Duke of Sparta, in the garden of his palace
at Athens*, 1905
Printing-out paper, 9.1 × 11.7cm (3⁵⁄₁₆ × 4⅝″)
RPC 03/0069/76i

ABOVE: Queen Alexandra, *Princess Victoria and gentlemen
in the garden of the Palace of San Anton, Malta*, 1905
Printing-out paper, 9.7 × 12.4cm (3¹³⁄₁₅ × 4⅞″)
RPC 03/0070/22g

A newspaper cutting of 12 May 1905, kept in this album,
notes that after lunching at the San Anton Palace, the Queen
'walked through the orange groves and the beautiful gardens
of the palace, taking photographs of the most interesting
spots'.

ABOVE: Queen Alexandra, *Girls from the School for Embroidery at Oran*, 1905
Printing-out paper, 10.2 × 9.5cm (4 × 3¾″)
RPC 03/0070/30f

Queen Alexandra had enjoyed sewing as a girl and started needlework and carving schools at Sandringham for the children of estate workers.

OPPOSITE: Queen Alexandra, *Some of the population of Oran*, 1905
Printing-out paper, 12.3 × 9.6cm (4¹³⁄₁₆ × 3¹³⁄₁₆″)
RPC 03/0070/30b

Three horizontal blocks of progressively lighter tone rise to the top of the picture, throwing emphasis on the women in their eastern dress who have caught the Queen's eye.

Queen Alexandra, *Gymnastics on board ship*, Malta, 1905
Printing-out paper, 9.7 × 12.4cm (3¾ × 4⅞")
RPC 03/0070/24i

The Queen and her brothers and sisters had been taught
gymnastics as children by their father.

Queen Alexandra, *'Lieut. Watson and my cat'*, 1905
Printing-out paper, 12 × 9.5cm (4⁷⁄₁₀ × 3⁷⁄₁₀″)
RPC 03/0070/41h

The Siamese cat had been given to the Queen by
Vice-Admiral Harry Grenfell.

ABOVE: Queen Alexandra, *Royal party at table*, Corfu, 1906
Printing-out paper, 10.1 × 12.6cm (3⅞ × 4¹⁵⁄₁₆″)
RPC 03/0070/25g

Published in *Queen Alexandra's Christmas Gift Book*, this
shows the King seated in the foreground, the Prince of
Wales wearing a white panama hat, and Miss Charlotte
Knollys seated, left. Also present are the Hon. Harry
Stonor *(in distance)* and the Hon. Seymour Fortescue
(standing to right).

LEFT: Queen Alexandra, *King Edward VII and others
climbing among the rocks*, Taormina, 1906
Printing-out paper, 8.8 × 8.5cm (3⁷⁄₁₆ × 3⅜″)
RPC 03/0071/8b

Soon afterwards, Queen Alexandra became involved with a completely different kind of book. The idea for this originated a few years earlier, when, during their cruise round the British Isles after the Coronation in 1902, the royal party had visited the Isle of Man, where they met the author Hall Caine.[14] His work was already known to Alexandra (in a letter to her son, George, Prince of Wales, she had described Hall Caine as 'a curious-looking man, the same as his books').[15] Hall Caine's eldest son, Ralph, was the managing director of the publishers Cother & Company, and either Hall Caine or his son suggested that a gift book associated with the Queen might be produced for Christmas and sold for the benefit of her Fund for the Unemployed.

Alexandra's approval of the idea may have been prompted by a volume in her possession, published in 1901, called *The May Book*. This contained a selection of verse, essays, pictures and stories, and had been compiled by a Mrs Aria to be sold in aid of Charing Cross Hospital. Its contents and purpose were strikingly similar to the Queen's book, which was to be entitled *The Queen's Carol: an Anthology of Poems, Stories, Essays, Drawings and Music by British Authors, Artists and Composers*, and was published by the *Daily Mail* in London, Manchester and Paris in 1905. Dedicated to Queen Alexandra, it embodied several of her favourite preoccupations: art, poetry, music and stories; much to her surprise and delight, sales brought in a large sum of money for the Fund.[16]

The area of interest to Alexandra which had not been covered by the *Carol* was photography. Hall Caine knew this and was also aware of public curiosity about the Queen's hobby. Some time

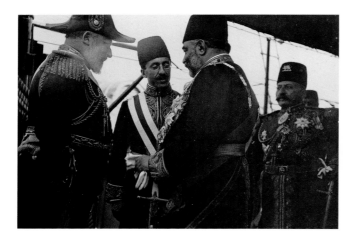

ABOVE: Queen Alexandra, *King Edward VII talking to Persian officials during the Shah of Persia's visit*, 1902
Printing-out paper, 8.6 × 12.7cm (3⅜ × 5")
RPC 03/0067/8d

RIGHT: Queen Alexandra, *Muzaffar Od-Din, Shahanshah of Persia*, 1902
Printing-out paper, 12.3 × 9.4cm (4⅞ × 3¹¹⁄₁₆")
RPC 03/0067/8f

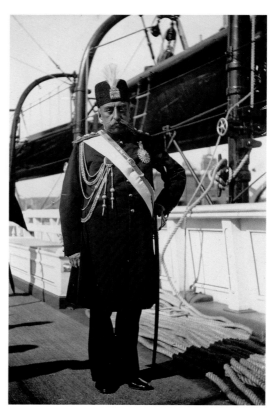

ABOVE: Queen Alexandra,
*A sunlit view with sea, ship and clouds, c.*1902
Printing-out paper,
8.6 × 12.3cm (3⁷⁄₁₆ × 4¹³⁄₁₆″)
RPC 03/0067/16e

LEFT: Queen Alexandra,
*The Forth Bridge, c.*1902
Printing-out paper,
10.2 × 12.3cm (4 × 4⅞″)
RPC 03/0067/33d

The Prince of Wales had opened the Forth
Bridge on 4 March 1890; this was probably
taken some years later.

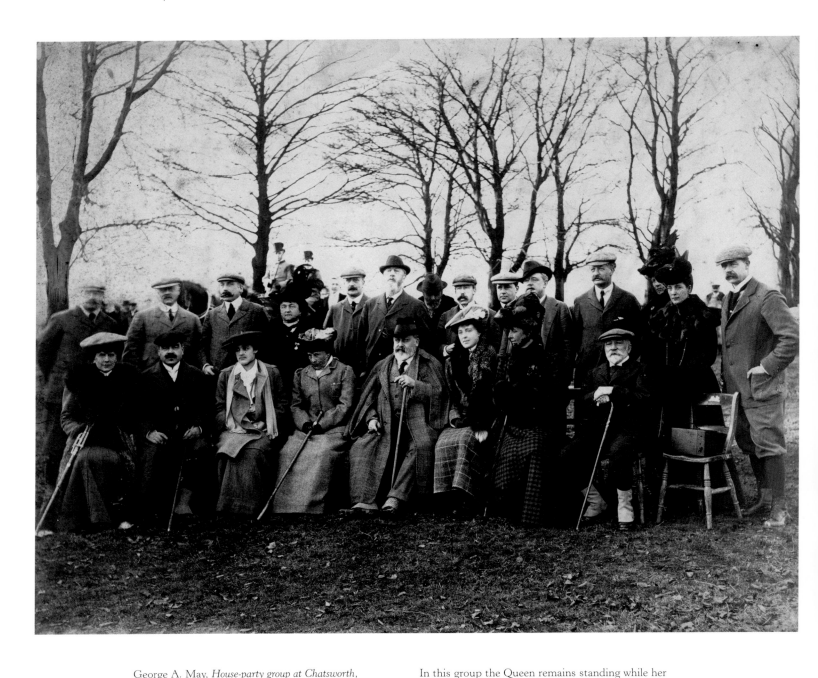

George A. May, *House-party group at Chatsworth*,
January 1906
Silver print, 20.5 × 25.4cm (8 × 10″)
Devonshire Collection, Chatsworth, Derbyshire

In this group the Queen remains standing while her
camera has a chair to itself. *Left to right, back row*:
Lord Stanley; Captain Holland; Lord Charles Montagu;
Duchess of Manchester; Lord Elcho; Duke of Devonshire;
Earl of Gosford; Earl of Mar & Kellie; Dr Bankart;
Earl de Grey; Lord Lurgan; Countess of Gosford;
Queen Alexandra and Lord Desborough.
Front row: The Hon. Mrs Keppel; Marquis de Soveral;
Miss Muriel Wilson; Duchess of Devonshire;
King Edward VII; Princess Henry of Pless; Lady de Grey;
Mr Arthur Sassoon; Queen Alexandra's camera.

early in 1907, therefore, he suggested that a royal photograph album might be published for sale in aid of the poor. Miss Knollys wrote to him on 3 July 1907 to let him know that Queen Alexandra was in favour of the idea, but as she had taken 'literally thousands of "snapshots"', which were not all of equal merit, it would take a long time to make a choice. The Queen, who was about to go to Ireland, was then much too busy to carry this out, but Miss Knollys asked Hall Caine to raise the subject again at a more propitious time. (She also returned to him a book of photographs which he had sent for Alexandra to look at, and which she had 'admired extremely'.)[17]

Evidently the Queen's enthusiasm for the project was growing, as Miss Knollys wrote to Hall Caine again on 27 November to ask if he would need negatives or prints of the Queen's snapshots for the book. This was not long before Christmas, however, and Alexandra felt that it would not be a good time to appeal to the public for money.[18]

After Christmas, the Queen was able to spend some time choosing suitable photographs and by 26 February 1908 Miss Knollys reported that she had selected 107. By now, news of the coming book may have leaked out. An article in the *Sketch* in early 1908 referred to 'that collection of pictures which for years it has been her Majesty's pleasure to take. It includes many which are decidedly humorous, many which are historic, and many which are unique. The collection is a cherished possession of the Queen's, who began photography when it first became possible for amateurs.'[19] In May 1908 Alexandra allowed three of her photographs to be published in the 'Royal Edition' (limited to 150 copies) of *The Flag: The Book of the Union Jack Club*, which was published for the Club by the *Daily Mail*. (This was as a result of a personal request to the Queen, who had accompanied King Edward when he opened the Union Jack Club on 1 July 1907.) The photographs, reproduced on separate pieces of paper, were glued on to the pages of *The Flag*, and apparently captioned by the Queen. Ralph Hall Caine was worried that the publication of the three images might pre-empt the unique impact of Queen Alexandra's own book, but Miss Knollys assured him that there was no danger of more being published before 'your father's book appears'.[20]

Meanwhile, Alexandra had compiled three more albums. One commemorated the State Visits to Denmark, Norway and Sweden, which took place from 20 April to 4 May 1908. It contained few if any of her own photographs and was mostly made up of commercial views, postcards, printed matter and souvenirs. Its interest lies in revealing something of Alexandra's ideas in the arrangement of pages and the

Alfred Schmidt, *A caricature of King Edward and Queen Alexandra from a Danish paper*, 6 April 1908
31.7 × 20.5cm (12⅞ × 8⅛")
RPC 03/0073/5b

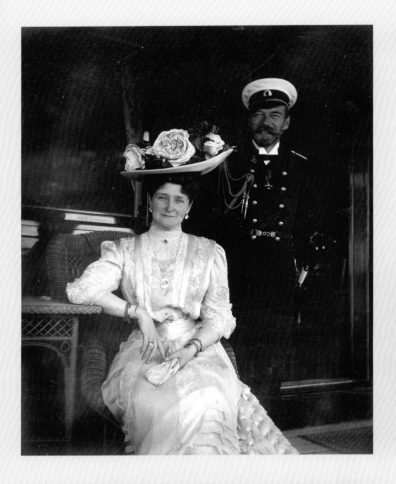

ABOVE LEFT: Queen Alexandra, *Emperor Nicholas II and Empress Alexandra Feodorovna of Russia*, 1908
Printing-out paper, 11.8 × 9.5 cm (4¹¹⁄₁₆ × 3¾″)
RPC 03/0074/11d

This cheerful picture was taken during a State Visit which was also a family reunion.

ABOVE: Queen Alexandra, *Grand Duchess Maria* (right) *and Grand Duchess Anastasia of Russia*, 1908
Printing-out paper, 11.8 × 8.7 cm (4⅝ × 3⁷⁄₁₆″)
RPC 03/0074/13c

The two younger daughters of Emperor Nicholas II.

LEFT: Queen Alexandra, *Tsarevich Alexei of Russia with a drum*, 1908
Printing-out paper, 12.2 × 9.3 cm (4¹³⁄₁₆ × 3¹¹⁄₁₆″)
RPC 03/0074/13f

This lively snapshot captures the little boy's pleasure in his toy.

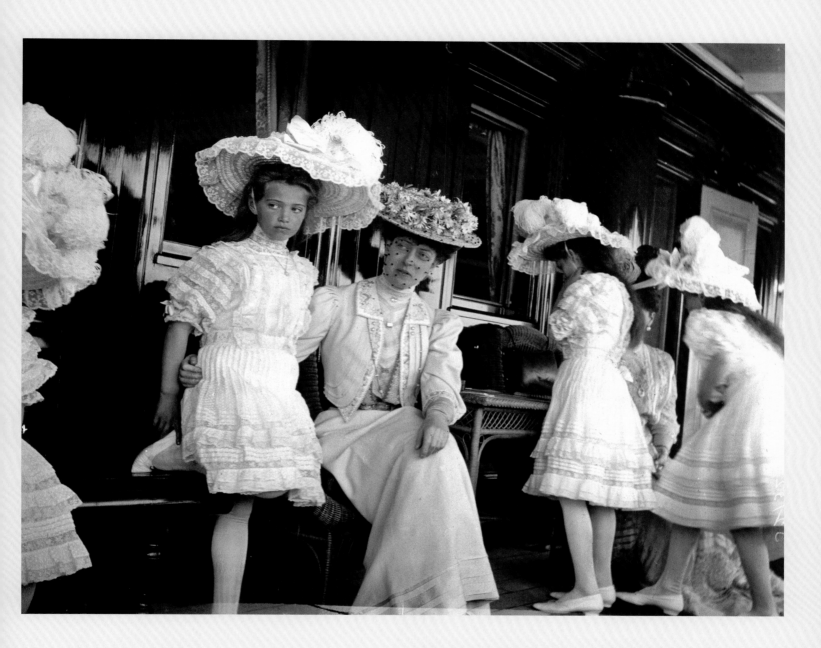

Queen Alexandra, *Princess Victoria with the daughters of the Emperor of Russia:* (left to right) *Grand Duchess Maria, Grand Duchess Tatiana and Grand Duchess Olga,* 1908
Printing-out paper, 9.4 × 11.8cm (3¹¹⁄₁₆ × 4¹¹⁄₁₆″)
RPC 03/0074/14c

Empress Alexandra of Russia is seated towards the right, and Grand Duchess Anastasia is moving out of the picture on the left. This snapshot was published in *Queen Alexandra's Christmas Gift Book.*

ABOVE: Queen Alexandra, *Two views of sea and rocks near Bygdö in Norway*
Printing-out paper,
8.8 × 8.8cm (3⁷⁄₁₆ × 3⁷⁄₁₆″); 8.5 × 9cm (3⅜ × 3½″)
RPC 03/0075/11c; 03/0075/11d

These two photographs suggest an interest in the different textures
of natural objects.

ABOVE: Queen Alexandra, *Two views of ships at sea*, 1908
Printing-out paper,
9.1 × 8.8cm (3⁹⁄₁₆ × 3⁷⁄₁₆″); 9.1 × 8.8cm (3⁹⁄₁₆ × 3⁷⁄₁₆″)
RCIN 2103334/37; 2103359/44

A ship at the centre of the horizon is a favourite feature in
the Queen's photography.

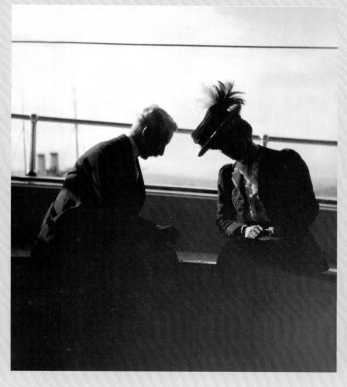

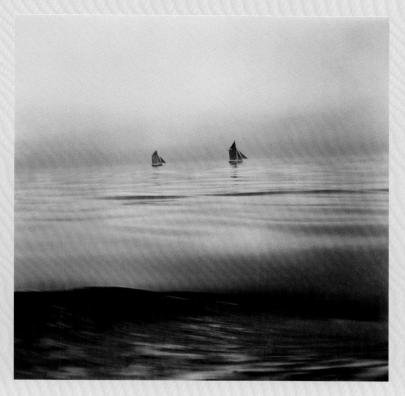

Queen Alexandra, '*Col. Legge & Victoria*', 1908
Printing-out paper, 11.6 × 9.4cm (4⅗ × 3⁷⁄₁₀″)
RPC 03/0075/8e

This is one of Queen Alexandra's 'silhouette' photographs, a style
of composition which she enjoyed. An example of this kind of work
was shown as part of the Queen's posthumous contribution to the
Kodak Exhibition of Royal Photographers in 1930.

Queen Alexandra, *Two sailing boats*, 1908
Printing-out paper, 9.3 × 8.7cm (3⅝ × 3⁷⁄₁₆″)
RCIN 2103385/50

Here the sea resembles folds of silken material while
the two little boats look as though they are stencilled.

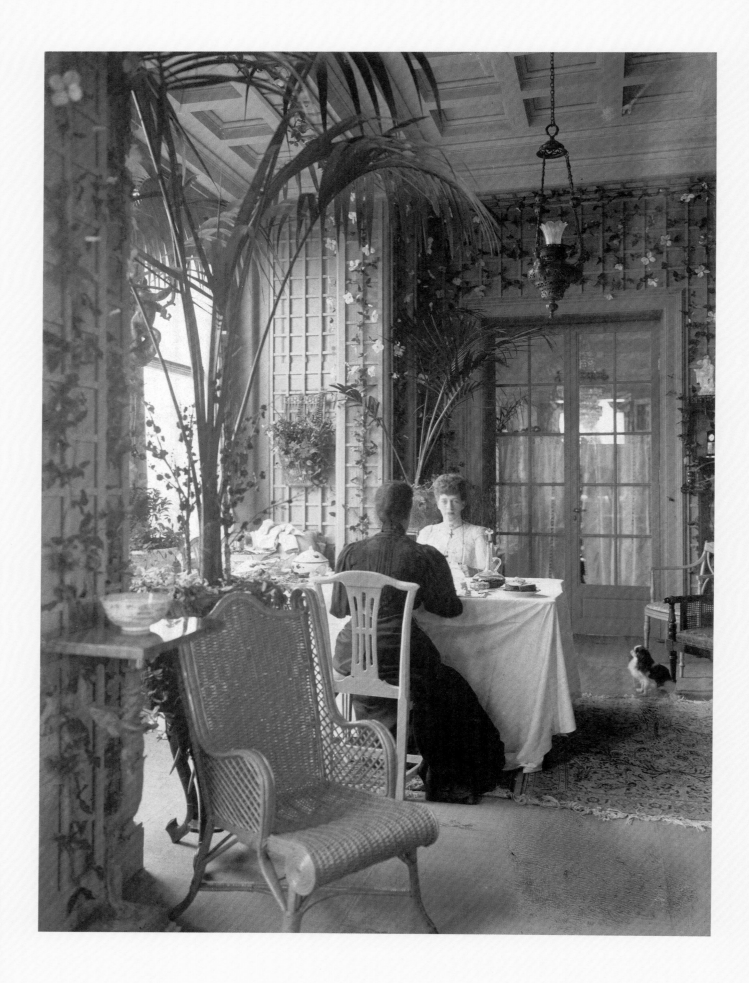

OPPOSITE: Unknown photographer, *Queen Alexandra and Dowager Empress Marie Feodorovna of Russia at table, Hvidöre, watched by one of their dogs*, 1908
Toned printing-out paper,
22.9 × 16.7cm (9 × 6⁹⁄₁₆″)
RCIN 2103177/36

RIGHT: Unknown photographer, *Queen Alexandra and Dowager Empress Marie Feodorovna of Russia at the entrance to the Grotto*, Hvidöre, 1908
Toned printing-out paper,
22.6 × 16.7cm (8¹³⁄₁₆ × 6⁹⁄₁₆″)
RCIN 2103161/24a

BELOW: Queen Alexandra, *'My sister and my dogs'*, 1908
Printing-out paper, 9.6 × 11.8cm (3¹³⁄₁₆ × 4⅞″)
RCIN 2103223/7

The Dowager Empress of Russia (the Queen's sister Dagmar) by the sea at Klampenborg, near Hvidöre, the house bought by Queen Alexandra and her sisters in Denmark after their father's death in 1906.

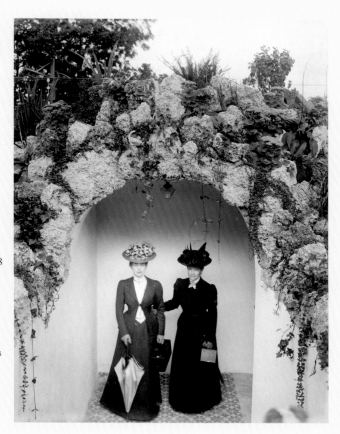

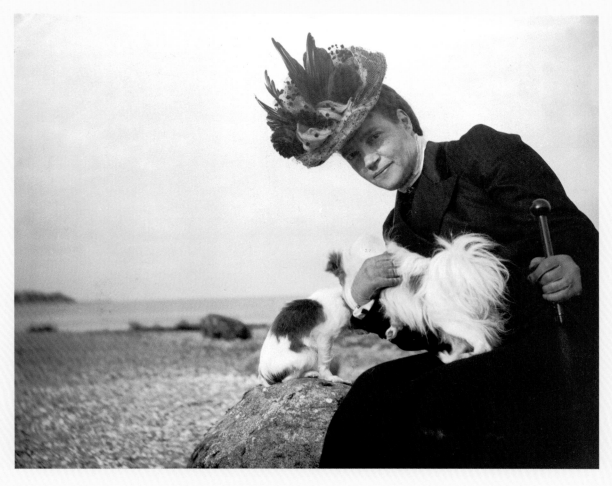

By September 1908 Queen Alexandra was staying in Denmark with her sister Dagmar, now Dowager Empress of Russia, at their villa, Hvidöre, at Klampenborg, on the outskirts of Copenhagen, purchased after their father's death in 1906 so that the sisters could keep a home of their own in their native land. As there was still much to be settled with regard to the book, Ralph Hall Caine set off for Denmark, where he stayed at the Hotel d'Angleterre in Copenhagen. One of his hopes was to persuade Alexandra to expand the number of photographs included in the book, and in this he was successful.

Ralph Hall Caine reported that in his discussions about the book with Queen Alexandra she was 'charming and delightful', but with very decided opinions. She showed him exactly what she wanted:

> … and it was easy to see that she was taking the deepest possible interest in connection with every detail of its production. In fact she said more than once to me 'As this is to be my book, it must give that impression.' In other words, the idea that she should name the photographs 'Photograph of My Father' &c. &c., immensely appealed to her. (Miss Knollys told me, afterwards, that she had never seen the Queen interest herself so much in anything).

Ralph was particularly delighted at getting thirty or forty more photographs, 'many of which are much the most interesting in the book'. They included some taken only three months earlier, during the meeting at Reval. However, Ralph failed to persuade the Queen to allow a preface to the book, or to write any long account or give any extensive descriptions of the pictures, although she had written captions on the back of each photograph.[21]

By now the forthcoming book was being 'whispered about', and it was decided that an official announcement should be made 'before it should leak out in paragraphs in the Halfpenny press'. Hall Caine had been employed as a part-time journalist by the *Daily Telegraph* for many years, and on 12 October 1908 the paper ran a feature heralding the fact that the Queen had 'prepared a delightful surprise for the people of this country and the British Empire – a real surprise, which no one would divine in a score of guesses, and one which is entirely her own'. This was a *Christmas Gift Book* containing not views, landscapes or 'set ceremonial pictures' but 'informal, unofficial, everyday, human snapshots. And it is this which will make the Royal Gift Book so intensely interesting.'[22]

With an advertisement couched in such terms as these, and coupled with the novelty of the idea, the book could hardly fail. Miss Knollys wrote from Denmark on 16 October, by which time a quarter of a million copies had been ordered, mostly by booksellers, in advance of publication, to say that Queen Alexandra was delighted at the success of the book, which was 'much greater than anything we could have hoped for'.[23] Six days later she placed orders on behalf of the Queen and Princess Victoria, adding that the Queen hoped that one copy would be ready for her to give to the King on his birthday, 9 November. With so much at stake, Hall Caine now sought to ensure sales by asking the King to issue a public expression of approval of the book on the day before

publication, as 'my long experience of the public tells me that they require to be led and the King of all men is the one to lead them'.[24] However, although the King was glad to hear that such large orders had been received, he declined to write a letter or send a message as requested.[25] Queen Alexandra's photographs should be judged by their quality, not by her social position, and the King stated that 'any work which may emanate from the Queen should stand entirely on its own merits and should not be in any way "exploited"'. By forbearing to give the book an unfair advantage, he might also be seen as tacitly expressing his opinion that his wife could hold her own as a photographer, without the recommendation of her royal status.

Although publication was not due until 12 November, half a million copies had been ordered and were being printed by 27 October. The day before, Charlotte Knollys had again written to Hall Caine, assuring him:

> how gratified H.M. is with the wonderful reception which has been accorded to the announcement of her Book & she quite recognises & is most grateful for, the able and energetic manner in which Lord Burnham [the proprietor of the *Daily Telegraph*] has so kindly taken the matter up. Nor does the Queen by any means overlook the ability, the zeal & the *tact* which your son has displayed. At the same time the Queen always remembers that to <u>your</u> initiative the Album owes its birth.[26]

An article in the *Daily Telegraph* for 29 October described how the book, which 'is being turned out complete at the rate of about 20,000 copies a day', was being produced at five different printing houses, on machines which consumed altogether 2,000lb of printing ink. In order to maintain consistently high standards, the photogravure and process blocks were regularly renewed, which required 3,000 blocks. The binding 'calls for the consumption of 125 tons of straw board and 25,000 rolls of cloth' and was done by 458 people (340 women and 118 men); the pictures were 'carefully pasted in by hand… by girls'. At one time fifty new people a day were being taken on.[27]

On 12 November the book was published,[28] at a price of half a crown (12½ p – at today's values about £7). On publication day Earl Carrington, among others, was quoted as describing the book as 'an ideal gift for the season of goodwill to all men'. It was 'most artistic in form and issued at a price that should enable thousands of Her Majesty's devoted subjects to purchase it, and so help in furthering her great works of charity'. In his regular column, 'A Literary Letter', in the *Sphere* for 14 November, Clement K. Shorter gave his opinion that 'Queen Alexandra's book is certain of an enormous sale and it serves to remind us, as all who carry a camera are aware already, how very human a series of photographs can be.' On 4 November Ralph Hall Caine had presented the Queen with £10,000 from the sales of the album,[29] the first instalment of funds which ultimately benefited thirty charities.

On 18 December, Alexandra sent a watch and chain to Ralph and 'a large framed likeness' of herself to his father as 'the originator of a scheme which has been crowned with such brilliant success'.[30] While much of this success was due to the personal nature of the book and the fact that,

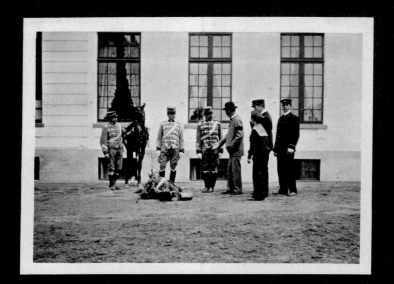

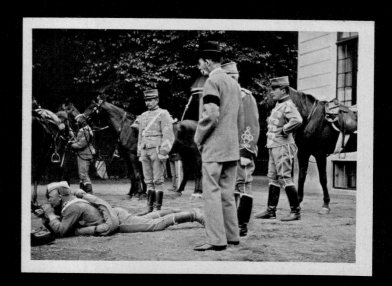

The Thames—Boulter's Lock.

The Club at Maidenhead.

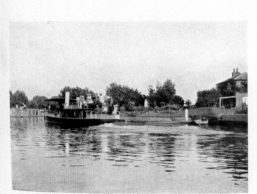

On the River.

In the Lock.

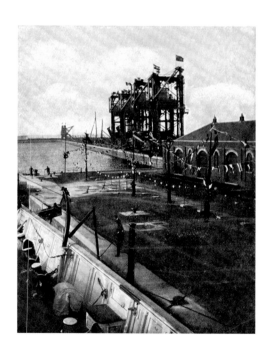

OPPOSITE: Queen Alexandra, 'My Father and Colonel Kjör – Danish Army'; 'My Father inspecting a new cavalry repeating rifle'; 'Testing the new repeating rifle'
Page size: 28.8 × 22.2cm (11³⁄₁₀ × 8⅓″)
RPC 03/0076

Facsimile prints were stuck on to some of the pages in the manner of a real photograph album…

ABOVE LEFT: Queen Alexandra, 'The Thames – Boulter's Lock'; 'The Club at Maidenhead'; 'On the River'; 'In the Lock'
Page size: 28.8 × 22.2cm (11³⁄₁₀ × 8⅓″)
RPC 03/0076

…others appeared as printed illustrations.

ABOVE RIGHT: Queen Alexandra, The Opening of the Alexandra Dock, Cardiff, 1907
9.4 × 6.8cm (3⁷⁄₁₀ × 2⁷⁄₁₀″)
RPC 03/0076

One of Alexandra's photographs of a formal engagement.

most unusually, it was by a member of the royal family, the photographs undoubtedly gave pleasure through their own merits. It is easy to understand how someone with Alexandra's love of books and photography might have felt nervous as well as excited at the thought of publishing her own work. Although proud of her photographic achievements, she disliked 'showing off', and throughout all the stages of production was careful, during negotiations with Ralph and his father, to stress Hall Caine's involvement and the fact that the book had been his idea. Modesty, and perhaps a sense of what was proper for her as Queen, would not allow her to publish any lengthy written compositions of her own, although this would certainly have added to the book's interest. It would be intriguing to know whether Hall Caine and his son were shown Queen Alexandra's holiday albums, with their vivid descriptions, dramatic shots and infectious sense of enjoyment.

In 1909, forty-six of the photographs in *Queen Alexandra's Christmas Gift Book* were reproduced as postcards by Messrs A.V.N. Jones and Company of 112 Fore Street, London E.C., by special arrangement with the Queen's Gift Fund, to which part of the profits were to go. The photographs were reproduced in photogravure, on plate-sunk mounts, and were sold at 2d each, or 7s 6d for the whole set.[31] A full-length autograph portrait of Alexandra, in photogravure, was presented with each full set.[32]

On 8 February 1909 the King and Queen left London for a four-day State Visit to Berlin.

The ensuing album contained the work of professional photographers and none of Alexandra's own photographs; however, her descriptions leave no doubt as to how she regarded the visit.[33] In many ways it was a chapter of accidents, beginning on 9 February when 'the train shook terribly during dinner – the dishes handed round caught my head & I found a <u>quail</u> suspended in my hair!' At the station, where the Emperor William II (whose late mother had been the King's sister), his family and officials were waiting to greet the King and Queen, the royal carriage stopped outside the station by mistake, 'so Their Imperial Majesties had to walk in the dirt a long way!' This was not all, as 'We had to change carriages just before reaching the Palace – as our horses jibbed, kicked & plunged at three different places & at last positively refused to go a step further. So out we bundled, Empress and all & climbed into poor Lord Granville's carriage.'

At the palace, they lunched with 'the Family' – 'after which <u>they went</u> to <u>bed</u>!!!' This German custom was too much for the Queen, who had been looking forward to sight-seeing; she accordingly took 'a delightful & amusing' drive with the Emperor's younger brother, Prince Henry, his wife and sister. On the following day King Edward, who was not in good health, nearly fainted after lunch at the British Embassy, much to the Queen's horror. However, he was well enough to accompany her to the Institute for Surgical Inventions, which had been associated with his late sister, the Empress Frederick ('poor Vicky'[34]). These were 'beautifully arranged & organised'.

OPPOSITE LEFT: *Queen Alexandra's copy of her 'Christmas Gift Book'*, 1908
28.8 × 22.2 × 2.5cm (11⅜ × 8¾ × 1")
RPC 03/0076A

This is the copy that was specially bound for the Queen; the title *Pleasant Recollections* is on the spine.

OPPOSITE RIGHT: *Queen Alexandra's Christmas Gift Book*, 1908
29 × 22.6 × 1.5cm (11½ × 8¹³⁄₁₆ × ½")
RPC 03/0076C

The version of the book that was produced for the public.

LEFT: *Queen Alexandra's Christmas Gift Book*, 1908
30.5 × 23.2 × 2.8cm (12 × 9⅛ × 1¹⁄₁₆")
RPC 03/0076B

This copy has been bound for the Queen with a wooden cover; the workmanship is typical of that produced at the Carving School at Sandringham.

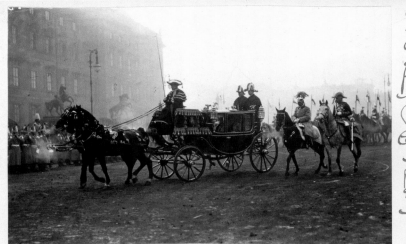

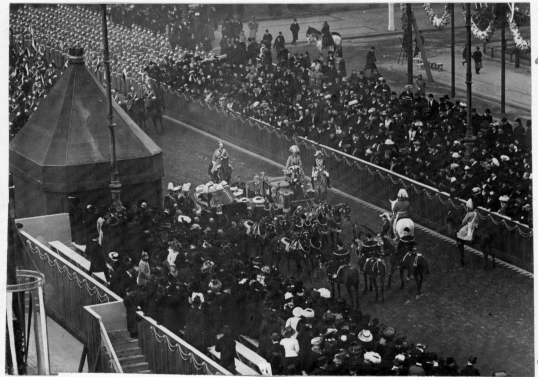

We had to change a carriage first before reaching the Palace — as our horses jibbed, kicked & pranced at three different places & positively refused to go a step further. So out we handed Empress & all & climbed into poor Lord Gran ville's carriage.

Receiving an Address from the Bürgomeister

OPPOSITE: Queen Alexandra, *Changing carriages, Berlin*, 1909
Silver print, 41 × 30cm (16⅛ × 11¹³⁄₁₆″)
RPC 03/0079/9

To the right of the photographs the Queen describes the mishap that occurred on their arrival in Berlin.

ABOVE: Unknown photographer, *Victoria of Schaumburg-Lippe leaping across her husband's dinner table*, 1909
Silver print, 9.7 × 14.2cm (3¹³⁄₁₆ × 5⅝″)
RPC 03/0079/28b

An equestrian feat performed by one of the German Emperor's sisters. Victoria of Schaumburg-Lippe was King Edward VII's niece.

ABOVE: Queen Alexandra, *Two officers walking in the garden of San Anton, Malta*, 1909
Printing-out paper, 10.1 × 12.6cm (4 × 4¹⁵⁄₁₆″)
RPC 03/0077/23g

The pattern formed by the different textures of the foliage in this picture frames the two small figures in the central distance.

OPPOSITE TOP: Queen Alexandra, *A Naval Review in Malta*, 1909
Printing-out paper, 9.7 × 8.8cm (3¹³⁄₁₆ × 3½″)
RPC 03/0077/25f

OPPOSITE BELOW: Queen Alexandra, *Officer at a Military Review in Malta*, 1909
Printing-out paper, 12.7 × 10.1cm (5 × 3¹⁵⁄₁₆″)
RPC 03/0077/27e

Queen Alexandra, *Sea view with steam, sunlight and distant ship,* 1909
Printing-out paper, 12.5 × 10.3 cm (4¹⁵⁄₁₆ × 4¹⁄₁₆″)
RPC 03/0077/77c

Queen Alexandra, *A group in the garden
of the Verdala Palace, Malta*, 1909
Printing-out paper, 8.9 × 8.8cm (3½ × 3⅞″)
RPC 03/0077/33d

The two gentlemen in conversation, Captain Myles
Ponsonby and Sir Harry Legge *(side view)*, occupy
the central ground of this photograph; they are
flanked by two ladies intent on their own thoughts
(Dowager Empress Marie Feodorovna, *right*;
unknown lady, *left*).

On their visit to Malta the King and Queen
opened the Connaught Hospital for the Maltese
on 22 April, watched a military review, and visited
two more hospitals in the next two days.
Travelling on to Italy, they had 'a most beautiful
& interesting expedition up & right round Mount
Etna in a small mountain train'. After this they

visited the Marquis Giuliano's palace in Catania,
where he gave them 'a grand tea & all the old
family servants waited upon us in red liveries'.
The next day, 27 April, they steamed through
the 'formerly so lovely Straits of Messina' which
had recently suffered terrible devastation in
an earthquake.

At Palermo, King Edward and Queen
Alexandra visited the Capuccini Catacombs,
'which looked more ghastly than ever', and met
King Victor Emmanuel and Queen Elena of
Italy, with the Duke and Duchess of Aosta,
at Baia. They all drove in motor cars up
'a tremendous mountain to the Monastery of
Camaldoli from where there is a wonderful view
of Naples – it was all most interesting to see
& the poor Monks are only allowed to speak
once a week'.[35]

Unknown photographer, *Queen Alexandra taking a photograph*, 1909
Printing-out paper, 8.7 × 30.5cm (3⅟₁₆ × 12″)
RPC 03/0078/5c

The Queen is about to photograph the group at the palace in Athens, seen opposite.

A State Ball that evening was a very grand affair, which the King and Queen watched from a dais. They witnessed a number of 'Minuets & Gavottes which were compulsory – each Regiment being told off to dance with their chosen partners, watched & scrutinised by the Emperor & the dancing mistress – who made them practise daily'.

On 11 February they visited the stables opposite the palace, where Alexandra was fascinated to see 240 horses and 400 carriages 'which are kept on the <u>first</u> <u>floor</u> & go up & down in <u>lifts</u>'. After lunch they spent several enjoyable hours at the Kaiser Friedrich Museum, followed by dinner with the Crown Prince and Princess ('William and Cecile are charming'). The day ended with a gala performance at the Opera of the ballet *Sardanapal*, 'arranged by the Emperor himself', which was 'beautifully put on the stage'.

Alexandra's animosity towards the Emperor had been tempered by good manners during the visit, but on the last day, during a tour of the Hohenzollern Museum, 'we were joined by William

Queen Alexandra, *King George I and Queen Olga of the Hellenes,*
with three granddaughters, Princess Olga (right), *Princess Elizabeth and*
Princess Marina (left) *of Greece,* 1909
Printing-out paper, 8.7 × 8.8cm (3⁷⁄₁₆ × 3½″)
RPC 03/0078/4e

The photograph the Queen is about to take in the illustration opposite.

who wished himself to explain everything to me'. To her intense irritation, this took so long that 'we could only pay a very short & hurried visit to the famous Virshow's Hospital – where we were received by the Director Ohlemüller & his Medical Staff – I regretted our very short visit as I was anxious to see all the latest Medical & Surgical discoveries'. However, departure was now imminent and, regaining her good humour, she concluded that it had been 'a very successful visit – everybody was most kind & we made the acquaintance of many interesting people – Finis.'

Two months after returning from Berlin, the King and Queen took part in another Mediterranean cruise. The two albums which recorded it were, as it happened, the last of that particular kind which Alexandra compiled. The first volume, with 77 pages, was captioned only to page 57, after which the photographs remained unlabelled; in the second volume, with 74 pages full of photographs, only the first nine pages had captions and these were fairly brief. The Queen had not lost her appetite for photography but her taste for long descriptions was waning.[37]

1 *Daily Mirror*, 11 April 1905

2 Information by courtesy of the Kodak Ltd Archive.

3 See Delia Millar, *The Victorian Watercolours and Drawings in the Collection of Her Majesty The Queen*, London 1995, cat. nos. 1670–1751.

4 The *Amateur Photographer*, 16 January 1906, p.57

5 Bodleian Library, Acland MSS d.177

6 Information by courtesy of the National Portrait Gallery.

7 Acland Papers, *loc. cit.*

8 *ibid.*

9 The books were published by Messrs Heinemann & Co., and the photographs were reproduced in gravure by a recently established London firm, the Fine Arts Publishing Company. See Sir Lionel Cust, *King Edward VII and his Court*, London 1930, pp.215–19.

10 Quotations in the next six paragraphs are from the Mediterranean Cruise albums for 1905.

11 Sir William James, *Admiral Sir William Fisher*, quoted in *Royalty Digest*, February 2000, p.239

12 The Queen had brought *The Garden of Allah* by Robert Hichens to read on this holiday: 'most interesting, beautifully written but unnaturally sad'.

13 Robert Hichens, *Yesterday*, quoted in *Royalty Digest*, October 2001, p.114

14 There are photographs of him in Frances Dimond and Roger Taylor, *Crown and Camera*, London 1987, p.76.

15 RA.GV/AA 32/39

16 On 20 February 1906, Charlotte Knollys wrote to Hall Caine assuring him that the Queen recognised that it was entirely through his efforts that so much money had been raised. She wanted to thank him personally on her return to England from Denmark, where, following the death of her father, King Christian IX, she was then staying. (Hall Caine Papers, Manx National Heritage Library, Douglas, Isle of Man)

17 *ibid.*

18 They had probably bought presents and distributed charitable donations and 'their purses [were] consequently empty'. *ibid.*

19 The *Sketch*, 1 January 1908

20 Hall Caine Papers

21 *ibid.*

22 *Daily Telegraph*, 12 October 1908

23 Hall Caine Papers

24 RA.PP/EVII/D 28119, 7 November 1908

25 RA.PP/EVII/D 28119, 8 November 1908

26 Hall Caine Papers

27 *Daily Telegraph*, 29 October 1908

28 At the last moment Queen Alexandra was dismayed to find that she had mixed up the names in two photographs taken at Balmoral, but the mistake was easily corrected. (Hall Caine Papers)

29 RA.VIC/QAD/1908: 4 Nov.

30 Hall Caine Papers

31 7s 6d was equivalent to approximately 37p; at today's values, about £21.

32 The *Amateur Photographer & Photographic News*, 1 June 1909, p.528

33 Quotations in this and the next four paragraphs are from the Berlin album for 1909.

34 She had died in 1901, the same year as her mother.

35 From the *Mediterranean Cruise* albums for 1909.

36 This tour was particularly enjoyable for the Queen because her sister, the Dowager Empress of Russia, accompanied her. The party also included her Lady-in-Waiting, Louisa, Countess of Antrim, who shared the Queen's enthusiasm for compiling albums. See Elizabeth Longford, *Louisa, Lady-in-Waiting*, London 1979.

WIDOWHOOD

Members of the royal family have long been noted for their interest in horses. Queen Alexandra was accomplished at riding and carriage driving and owned a number of books about horse-breeding and racing. One particular title, comprising four volumes, was *Portraits of Celebrated Racehorses* by Thomas Henry Taunton, published by Sampson Low, Marston, Searle and Rivington in 1887–8. This showed portraits of famous horses in chronological order from 1702 to 1870, with details of their respective pedigrees and performances in full. It may have inspired her to create *The Sandringham Stud Book*, which recorded the horses and mares associated with the Stud from its beginning in 1887. It is not clear exactly when the Princess began the book but, as Queen, she continued to add information until 1917. She wrote details about the horses, including their names, dates, parents, partners and progeny, races they had won and their ultimate fate. To this she added newspaper cuttings and other printed material, pictures, and about seventy photographs. Some of these were the work of professionals but, as time went on, she used her own prints.

Enclosed between the last pages and the back cover of the book, which finally amounted to over a hundred pages, are various cards and notes. They include Alexandra's instructions to someone unknown to write out for her more details of horses that won races between 1908 and 1912, and of the new stud mares, 'as I am going on with the book'.[1] This implies that there had been a gap when she did not work on the project, during the period around and after the death of King Edward, who had been in failing health for some time.

King Edward's determination to ignore his state of health and to continue working for as long as possible had misled people into thinking that he was not in any immediate danger. Queen Alexandra and Princess Victoria had left on 14 April 1910 for a holiday in Corfu, but on receiving word that the King had been taken ill they returned, reaching Buckingham Palace at 5.20 pm on 5 May. The following day the King collapsed. Realising that the end was near, Alexandra, with extraordinary generosity of spirit, gave permission for his close friends, including his mistress Mrs Keppel, to come and bid him goodbye. He died on 6 May. The Queen remained calm, although heartbroken at her husband's death, and Lord Esher, seeing her moving quietly about the room where the King lay, was convinced that, in a strange way, she was almost happy. She talked 'with a tenderness which betrayed all the love in her soul, and oh! so natural feeling that she had got him there altogether to herself'.[2]

The Queen allowed more of the King's friends to pay their last respects, but, dreading the moment when he must be taken away from her, she delayed his funeral until 20 May. According to the custom of the day he had been photographed after death by the Court photographers W. & D. Downey. Now the Queen, as though wishing all his subjects to have the opportunity of seeing the very last of him, allowed this private photograph to be published, in *Edward VII. His Life and Times*, edited by the Royal Librarian, Sir Richard Holmes, and published in two volumes in 1910–11.[3]

W. & D. Downey, *King Edward VII,*
photographed after death, May 1910
Platinum print, 15.8 × 22.9cm (6⅕ × 9″)
RCIN 2907551

Queen Alexandra believed that the oxygen administered to the King in his last hours had helped to preserve his body after death; this illusion of life was one reason why she found it hard to accept the inevitable and delayed his funeral until 20 May, two weeks after he had died.[4]

Following the death of the King, Alexandra apparently compiled no new photograph albums, although she continued to take photographs. By this time she had also attempted something quite different: perhaps Ralph Hall Caine's request for her to write more in the *Christmas Gift Book* had started a train of thought in her mind. The result was a twenty-five-page typescript entitled *An Eastern Journey in 1908–1909, by Alexandra*, echoing the title *Eastern Journeys* used by King Edward for one of the albums which he kept as Prince of Wales. In style and content the work is very like the written passages in the Queen's holiday albums, and the first impression is that the descriptions have been extracted from one of these and put together as a continuous narrative. One almost expects the whole album, with photographs, to come to light in a forgotten cupboard. But there were no photographs, because the Queen did not go on an 'Eastern Journey' in 1908–9.

Queen Alexandra, *The Sandringham Stud Book*, 1887–1917
34.7 × 25.3 × 5.5cm (10 × 13¾ × 2⁄₁₆″)
RCIN 1231417

The book is bound in brown calf, with onlays and gold-tooled floral decorations.

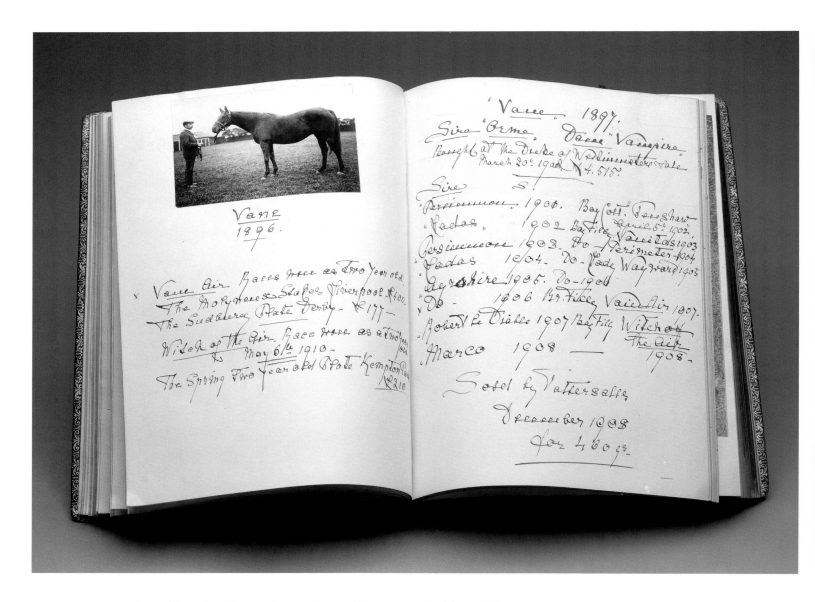

Queen Alexandra, *The page relating to the mare, Vane*
Silver print, double spread size
33.8 × 47 cm (13⅜ × 18¼″)
RCIN 1231417

Special mention is made in the book of 'Witch of the Air', a bay filly belonging to the King. As a two-year-old, she won the Spring Plate at Kempton Park on 6 May 1910, the day of the King's death. News of her success was brought to him as he lay dying and he was able to respond that 'I am very glad'.[5]

TOP: Unknown photographer, *Queen Alexandra
about to photograph a mare and foal*
Printing-out paper, 8.5 × 8.5cm (3³⁄₁₆ × 3³⁄₁₆″)
RPC 03/0075/1e

ABOVE: Queen Alexandra, *Persimmon
at Wolferton Stables*, 1907
Printing-out paper, 10.2 × 13cm (4 × 5⅛″)
RCIN 1231417

ABOVE: William H. Grove & Boulton,
Queen Alexandra's painting room at Marlborough House,
1912
Carbon print, 23.8 × 28.7cm (9⅜ × 11⁵⁄₁₆″)
RCIN 2102022/35

This room housed a number of watercolour paintings,
at least some of which were the Queen's work; it also
led into an area containing many of her books.

LEFT: William H. Grove & Boulton,
*A corner of the room formerly used as the Prince of Wales's
study in Marlborough House,* 1912
Carbon print, 19.1 × 14.6cm (7½ × 5¹³⁄₁₆″)
RCIN 2102001/14

A painting of Queen Alexandra's father,
King Christian IX, hangs over the bookcase, which
contains a collection of walking sticks and canes.
Photographic screens of the kind shown were
very popular; several remain at Sandringham.

She seems to have written an imaginative account, partly inspired by books and partly by her memories of the wonderful holiday in Egypt which she had enjoyed so much in 1869. But she chose to set it in 1908–9 instead of 1869 and not to write it in her own character as Queen.

No individuals are named in the account, but the narrator is established as an English person travelling with a party of others to Egypt in 'a great P. & O. ship, the *Marmora*'.[6] The descriptions of scenery and natural phenomena are vivid and were evidently based on personal experience. Certain details are described with great clarity. The crew and other staff of the *dahabiah* (steamer) 'all wear most picturesque and artistic dresses, the crew a sort of loose trousers with a dark blue jersey and "Cook's Nile Service" worked upon it in red. Their headgear was a tight-fitting cap with a turban wound tightly round it.'

The narrator describes how the boat was kept clean, with the deck being dusted with a feather brush, and how everyone coming on board had their boots brushed. She also includes information about the country, in the manner of a guidebook. Thus 'the people of the Nile make a fairly good profit on their sugar canes, which they take to the markets on their camels and donkeys. Of birds there are not many different species, but what are to be seen are very pretty. They are quails, snipes, hawks, wagtails, hoopoes and kingfishers. We also saw a good many storks sitting, or rather standing on one leg, along the banks of the Nile.'

It is not certain when *An Eastern Journey in 1908–1909* was written, but a clue may be found in the description of the building of an enormous dam near Philae. 'When finished it will be very fine and it is marvellous to think what a size it will be and the extraordinary power it will have over the water. They have been working at this for years, and those who know say that it will take four more years before the whole is completed.' These remarks may have been inspired by the work taking place in 1912 to increase the height of the Aswan Dam. Thus Alexandra's comment, that it 'will take four more years before the whole is completed' (that is, four years after 1908–9), is accurate if it refers to the works of 1912. She had already mentioned, in another part of the manuscript, an existing dam, perhaps the first Aswan Dam, built between 1898 and 1902.

It is clear that the manuscript was written after 1902; and in or after 1912 becomes the most likely date. Queen Alexandra's eldest daughter, Louise, Princess Royal, with her husband, the Duke of Fife, and their two daughters, visited Egypt in 1911–12 (the Duke in fact died there, shortly after the whole family had been involved in a shipwreck). Perhaps this reawakened the Queen's memories of Egypt and prompted her to write about it. The manuscript also ends with the observation that 'although all nations are at this time in a bad state, the English have ever been known to fight on bravely. Let us hope and pray that England may stand firm for ever and be liberal and true to all, and as the waves of trial and temptation beat upon her she may stand firm as a rock at sea.' This could easily have been written during the two years leading up to the start of World War I.

The manuscript gives a number of insights into Alexandra's character and views. One of these was the position of women in society. She writes that 'the women [in Egypt] are much more hard-working than the men. I do not remember ever having seen any really lazy women. The men treat the poor women very badly, they look upon them more as beasts of burden, and indeed they

treat them as such, and all they like to do themselves is sitting or squatting on the ground and chattering to each other.' Such sentiments recall her comments about the Norwegian girl scrubbing the floor in 1893 while the boy lay on the bed. Again, when writing about two temples built by Rameses II at Abu Simbel, she comments on the 'smaller temple, dedicated to his wife... and it is curious that the figures at the entrance were four of himself and only two of her, by this one could see how much he thought of himself and that he wished to be remembered'.

Loyal and loving wife though she was, Queen Alexandra (as her father had stated many years earlier) had 'a will of her own',[7] and this was, after all, a time when the rights of women were actively being discussed. Although she would never have approved of the most extreme methods of campaigning used by the Suffragettes, that did not mean that she was unaffected by the spirit of the age.[8]

Several other anecdotes in *An Eastern Journey* are almost certainly based on the Queen's experiences in 1869. Thus, when writing about the 'splendid' Egyptian donkeys, she mentions that 'when they have got the bit between their teeth they set off at full speed, as one did with me, and it takes some time to slow down again'. On another occasion she mentions picking some figs (a favourite fruit of hers) to eat in a garden: 'There were some tiny green ones which were delicious, and the little purple ones were even sweeter and nicer.'[9] Again, after describing the great difficulty of climbing a sand hill, she adds that 'we got a most glorious view of the country and had a delightful run down, the deep sand seemed to support our feet'. These descriptions have a ring of real experiences about them.

With her religious convictions and moral values, it was natural to Alexandra to write occasionally in a serious and thoughtful manner. Thus she notes that 'it is always the ones who do things quietly... who do the real good things in the world' and 'those who do their best to work and help others, raise themselves to higher position and gain a truer end'. As the narrative draws to a close, the Queen reflects that 'the last day at a place is always a sad one, and especially at a place where one has found peace and happiness as one did when steaming up the Nile, reading, writing, or drawing, or gazing upon the beauties and wonders of the country surrounding us'.

If the dating of the manuscript to just before World War I is correct, then it was written at a time when Alexandra's photographic activities were drawing to a close. It may be relevant at this point to examine her surviving accounts,[10] which are incomplete, but in which the earliest reference to the processing of photographs was on 28 January 1898. This refers to 'Developing Negatives etc.' during the period July–November 1897 by the Eastman Photographic Materials Company Ltd. Further bills from them are noted on 6 May, 1 September and 7 and 26 October 1898. From 1899 onwards until 19 November 1914, the names Kodak Ltd, Eastman Company and Eastman Kodak appear some twenty-four times. On 27 March 1899 George Eastman wrote to a colleague that 'Our Oxford Street manager was called to attend at Marlborough House to explain the working of the special Bulls'-Eyes and other Kodaks. They are going to take the new apparatus with them on their proposed journey to Greece and Crete [the Mediterranean cruise of 1899]. They have been working with the old model cameras in many instances, and I am very glad that they have now taken to the daylight-loading system.... He elicited the fact that no one shares

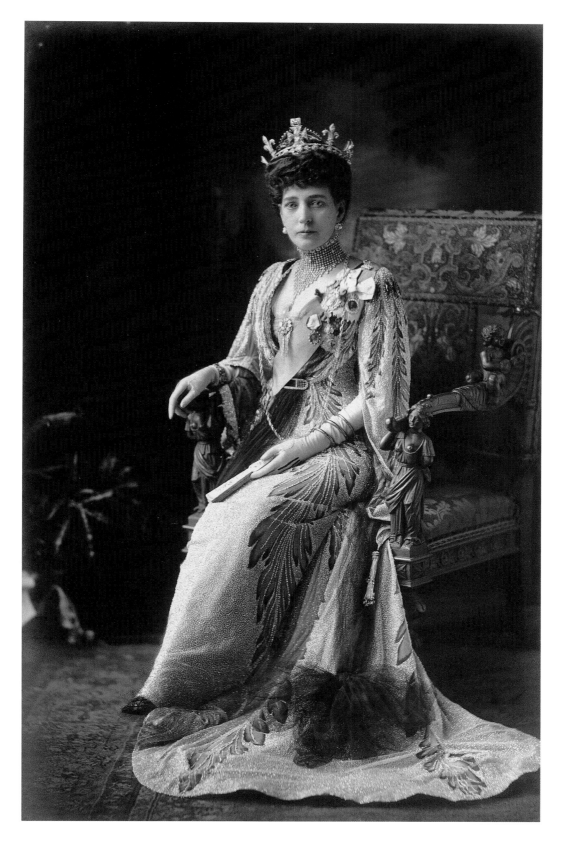

W. & D. Downey, *Queen Alexandra*, 1913
Silver print, 28.5 × 17.8cm (11¼ × 7″)
RPC 01/0236/74

royalty orders with us for cameras, and states that... the Princess of Wales thanked us for the trouble we always took with her orders.'[11] Funds to pay for these orders were drawn from 'Miscellaneous Expenses' and the 'Wardrobe Account'.[12]

Alexandra's later photographs, or those which have survived, were mostly taken in this country. They include a set of five photographs taken at Mr Alfred Lewis's Stud Farm at Heacham in Norfolk on Saturday 10 August 1911. They are all of horses, and are accompanied by a letter dated 26 August 1912 from Mr Lewis to Sir Dighton Probyn which makes it clear that, in her impulsive way, Queen Alexandra had paid him an unexpected visit and had later sent him the photographs which she had taken so that he could identify the horses for her. 'I have very great pleasure in returning photographs with their names & no. ... it is very gratifying to hear that Her Majesty was pleased with my Stud.... I trust should I have the honour of seeing Her Majesty Queen Alexandra again, you will be able to give me a little longer notice.'[13]

Twelve more photographs were taken by Queen Alexandra and Princess Victoria in May 1913; these showed more horses, some sea views and various other subjects. The Queen's last bill from Kodak was dated 19 November 1914 but there is some doubt as to whether she ceased taking her own pictures after that time. No albums attributed to her have been found; on the other hand, Princess Victoria continued taking photographs and compiling albums, and may sometimes have included work by her mother. There is a reference in the engagement diaries kept for the Queen by Charlotte Knollys which may be significant; this occurs on 26 October 1918 and reads 'Margaret Grant & Children came to be photographed'.[14] Mrs Grant was the wife of the Rector of Sandringham. Some photographs of this date, which could be the ones referred to, are in Princess Victoria's album, but there seems little likelihood that Miss Knollys would record Princess Victoria's activities in a diary intended for Queen Alexandra's. It may also be significant that the entry for 14 November 1918 mentions 'Called at Ralph's'.[15] This might have been a social call, but it is possible that it refers to the delivery or collection of a film. Whatever the case, the photographs taken on 26 October appear to have been Alexandra's last recorded work.

Even when she was no longer so active with her camera, Alexandra retained her interest in photography. One aspect of the subject was stereoscopic photography, about which she had known for many years but with which she became more involved in later life. This branch of the art had

Harald Cohen, *A stereoscopic view in Denmark: Erindring fra Kjöbenhavn*
Albumen print, 7.3 × 14cm (2⁹⁄₁₀ × 5½")
RCIN 2980276

This photograph was found in one of the Princess of Wales's sketchbooks.

Unknown photographer, *Glass stereoscopic slides:*
Miss Charlotte Knollys; The Nest; The Dairy; and
*Inside a greenhouse in the grounds at Sandringham c.*1914
each double image approximately
5.2 × 10.5cm (2¹⁄₁₆ × 4⅛″)
RCIN 7084 (viewer and slides)

A considerable collection of glass slides exists at
Sandringham which were intended to be used with the
Vérascope Richard stereoscopic viewer. Thirty-seven
small slides show scenes during the procession on Garter
Day at Windsor Castle in *c.*1911–14; three others show
what appears to be Edinburgh Castle by night. The large
Vérascope Richard machines enabled larger, hand-
coloured glass slides to be inspected; the examples
illustrated here show views in the grounds at
Sandringham in about 1914.

existed for almost as long as mainstream photography: the earliest stereo views were
daguerreotypes, produced experimentally in the 1840s and commercially in the 1850s. As these
were superseded by prints on paper, so stereo views began to be produced as double pictures
mounted on card. They became increasingly popular in many countries; the three-dimensional
effect, produced when they were inspected through a viewer, gave more depth and a greater
illusion of reality than conventional photographs.

According to William C. Darrah's *The World of Stereographs*, Britain was 'more completely and
beautifully stereographed than any other country in the world' and two of the greatest stereo
photographers, George Washington Wilson and Francis Bedford, were well known to the royal
family. However, Denmark was also well served in this respect. The best stereos were published
by Vilhelm Tryder in Copenhagen; other photographers operating there between 1860 and 1880
were Vilhelm Tillge, J.C. Farrer and the firm of Muller Budtz & Company. Publishers of stereo
views included P. Fangel and the more prolific Peter Elfelt who, between the late 1880s and early
1900s, issued more than 4,000 Danish views.[16]

Some stereo cards of early photographic views in Copenhagen have been found in one of Alexandra's sketchbooks and in the 1860s she had become aware of the work of the London Stereoscopic and Photographic Company (which had been set up in 1854). By the beginning of the twentieth century a number of stereoscopic viewers in varying sizes had found their way into royal possession. Five hand-held viewers with long handles have survived at Sandringham and at least two of them may have belonged to Queen Alexandra. In addition, two larger viewers, intended to stand on tables, and a smaller instrument were supplied by Vérascope Richard. The surviving stereo cards include six cards by Peter Elfelt and Peter L. Petersen, both of Copenhagen, showing Alexandra and members of the Danish Royal Family in the early 1900s.

There is a record of a hand-held viewer having been given to Queen Alexandra as a birthday present on 1 December 1914 by Polly (Mrs Lionel) Sartoris and her family. Another was accompanied by a note from Colonel Sir Henry Streatfield, Queen Alexandra's Equerry and Private Secretary. Written on 18 July 1916, this informs the Queen that 'Mr H. Girdwood, a photographer employed by the India Office, sends Your Majesty a stereoscope and photographs taken by him at the Front. They are extraordinarily interesting.' Sir Henry then went on to explain how the stereoscope should be used: 'The little rest slips on to the thin bit of wood and one looks through the glasses. The wooden handle pulls down. The right focus has to be obtained.'[17] The war photographs in question are no longer kept with the viewer and have not yet been traced.

During the latter years of her photographic career Alexandra's practice of keeping albums of newspaper cuttings increased. She had started her collection at least in 1901; before this she also kept volumes on particular topics, such as speeches made by her eldest son, Prince Albert Victor. From 1901 to 1910 she amassed twenty-one albums; these, or some of them, were apparently put together with the help of members of her Household. For instance, in the volume for

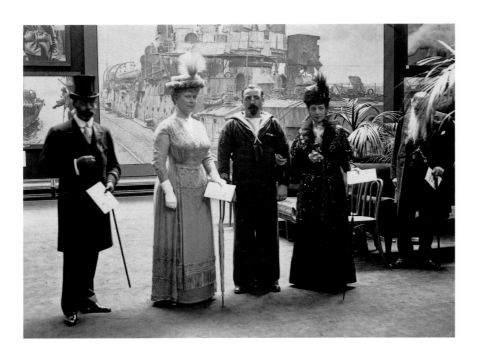
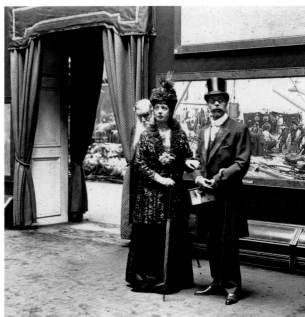

January–March 1908 there is a typed sheet on Sandringham paper, dated 1 December 1908 (the Queen's 64th birthday). It bears the note 'Five volumes of Newspaper Cuttings recording events relating to Her Majesty The Queen from July 1st 1907 to September 30th 1908, with the humble duty of [a list of names follows].'

During the war, Queen Alexandra resumed this pastime, eventually compiling sixty-six volumes. Her niece Marie, Grand Duchess George of Russia, who had been stranded in England when war started, frequently visited her at Marlborough House at this time, and in her memoirs she explains that while the Queen was very fond of playing the game of Patience, she 'only kept a tiny space for this on the table, as the rest was piled up with quantities of newspapers and illustrated reviews. She always read them holding a magnifying glass, as she said she saw better that way than with spectacles. She read everything and cut out either articles or pictures of interest, which were pasted in special albums. She possessed thousands of these, kept in various boxes or drawers.'[18]

Queen Alexandra was, clearly, keenly interested in the war, which she saw as the realisation of all her worst fears about Emperor William II's ambitions. Like other royal figures she was caught by the dilemma of living in, and loyally supporting, one country, while having close relatives who lived in enemy territory. Many of her relatives were German, or lived in Germany (such as her younger sister, Thyra, Duchess of Cumberland) and she must have worried considerably about them. In addition, by 1917 the fate of her sister and other relatives in Russia was causing her great anxiety. Altogether, according to Charlotte Knollys, 'Her Majesty takes this dreadful war terribly to heart and is almost tiring herself out in her efforts to help and comfort all the many sufferers – both in body and mind'.[19] Between August 1914 and December 1918 the Queen visited at least 130 hospitals and supply depots.[20]

Alexandra also visited several photographic exhibitions during the First World War. One of

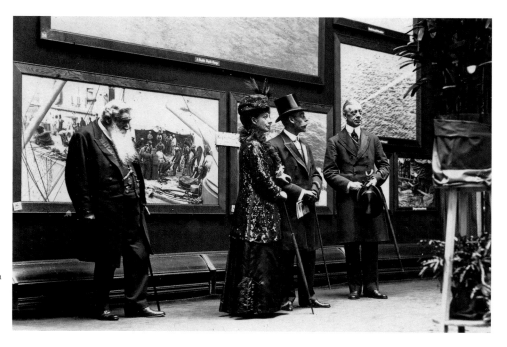

Princess Victoria, *The royal visit to the exhibition of Naval War Pictures at the Prince's Galleries*, 21 July 1918
Snapshots, printing-out paper,
7.4 × 9.9cm (2¹⁵⁄₁₆ × 3⅞″)
7.9 × 7.4cm (3⅛ × 2⅞″)
6.8 × 9.9cm (2¹¹⁄₁₆ × 3⅞″)
RPC 03/0113/47f; 03/0113/47h; 03/0113/47i

These pictures show: *Left to right*: Queen Alexandra *(right)* with King George V, Queen Mary, a naval attendant and General Sir Dighton Probyn *(far right)*; Queen Alexandra and King George V and General Sir Dighton Probyn; Queen Alexandra and King George V, with General Sir Dighton Probyn *(left)* and Admiral Sir Henry Campbell *(right)*.

these was held at the Grafton Galleries, where she saw Canadian war photographs on 5 December 1916. The next was at the Fine Art Society's gallery, where she saw material from the Photographic Section of the French Army on 13 April 1917. In 1918 the Queen paid two visits to the Grafton Galleries, on 2 and 26 March, to see some 'large War Photographs' and 'War Pictures taken by Lieut. Brookes' respectively.[21] On 21 July 1918 she, with King George V, Queen Mary, Princess Mary and Princess Victoria, visited the Prince's Galleries, where there was an exhibition of large naval war photographs. Princess Victoria took her camera with her, and her album for this date contains many snapshots of the royal visit. In the Queen's engagement diary, by the entry recording her attendance at the exhibition, is an envelope with a note in Princess Victoria's hand: '<u>Naval War pictures, Prince's Galleries, July 21 1918</u>, could you beg for two of BB341, a <u>little larger</u>.'[22]

1 Note, RCIN 1231417b in *The Sandringham Stud Book*

2 Georgina Battiscombe, *Queen Alexandra*, London 1969, p.272

3 Writing on 23 August 1910 to thank Miss Acland for her 'kind letter', Miss Knollys told her that 'I have not only shown the Queen what you say about the Photograph but have also put your name down on the list of those asking for them, so that I may remind Her Majesty from time to time. At present she is still too crushed by her sorrow to have energy for <u>anything</u>.' Bodleian Library, Acland MSS d.177. This implies that copies of a photograph, arguably of King Edward, were being made available to friends; it is even possible that the image in question was the death-bed portrait.

4 Helmut and Alison Gernsheim, *Edward VII and Queen Alexandra: a Biography in Word and Picture*, London 1962, p.151

5 See Philip Magnus, *King Edward VII*, London 1964, p.456.

6 Quotations in this and the next seven paragraphs are from the manuscript; Private collection.

7 RA.VIC/QVJ/1862: 3 Sep.

8 The entry for 21 May 1914 in the Queen's engagement diary is accompanied by a leaflet announcing that a women's deputation, led by Mrs Pankhurst, would attempt to seek redress for their grievances from the King at Buckingham Palace on that day. The Queen certainly supported women's education and became the first royal patron of Bedford College, London University, in 1905, remaining a good friend to the college until her death, and visiting it on several occasions. On one of these visits, on 26 June 1916, she took the college entirely by surprise and, unattended, 'made her way to the Hall where an examination was in progress. The invigilator, not recognising the Queen, was on the point of asking her to leave when, happily, Professor Spurgeon [a senior member of staff] appeared, explained the situation, and escorted her on a tour of the building.' See Margaret J. Tuke, *A History of Bedford College for Women, 1849–1937*, Oxford 1939, pp.208–209.

9 RA.VIC/Add C 07/1/0259

10 RA.VIC/Add A 21/220A-D

11 Carl W. Ackerman, *George Eastman*, Houghton Mifflin Company, New York 1930, p.146

12 Although Alexandra had a separate heading for 'Photographs' in her accounts, the developing and printing of her own negatives were not generally paid for from this section, which was normally used for purchasing the work of other photographers. On one occasion she received an advance from her husband to enable her to pay W. & D. Downey's bill for the March quarter in 1898.

13 Private collection

14 RA.VIC/QAD/1918: 26 Oct.

15 RA.VIC/QAD/1918: 14 Nov.

16 Darrah, reprinted 1997, pp.102, 104, 126

17 Private collection

18 *A Romanov Diary*, p.165. At the end of the war she continued to collect newspaper cuttings from *The Times* relating to it; these were kept in thirteen volumes for the year 1919.

19 Acland MSS d.154, 17 June 1917

20 RA.VIC/QAD/1914–18. List of Hospital Visits

21 RA.VIC/QAD/1918: 2, 26 Mar.

22 RA.VIC/QAD/1918: 21 July

THE LURE OF THE CINEMATOGRAPH

During this period in her life, Queen Alexandra's connection with photography took yet another turn; she developed a liking for films, or, as they were known, cinematographs. In this she may again have been influenced by her husband, who as early as 13 March 1882 had attended 'Mr Muybridge's Lecture & illustrations of photographs of animals in motion' at the Royal Institution in London. On 27 June 1896, during a visit to Cardiff,[1] where the Prince and Princess visited the Fine Art and Industrial Exhibition, they met one of the participants in the exhibition, Birt Acres, a pioneer maker of films. He filmed the royal visit – thereby probably making the Prince and Princess of Wales the first members of the royal family to appear in a moving picture – and later sought permission to show his film in public. As a result, he was requested to go to Marlborough House (accompanied by his assistant, Cecil Hepworth), to demonstrate some of his work to the guests assembled for the marriage of Princess Maud of Wales to her cousin Prince Charles of Denmark on 21 July 1896.[2] This may have been the first Royal Command film performance.

In September 1896 the Prince and Princess visited Balmoral, where Queen Victoria was entertaining Tsar Nicholas II of Russia, his wife, Empress Alexandra Feodorovna (Alix of Hesse, the Queen's granddaughter), and their baby daughter, Grand Duchess Olga. In her Journal for 3 October, the Queen described how they 'at 12 went down to below the Terrace, near the Ball Room, & were all photographed by Downey by the new cinematograph process, which makes moving pictures by winding off a reel of films. We were walking up & down & the children jumping about.'[3] Cinematography was being taken up in other countries too; while staying in Denmark during October in 1899 and 1900, the Princess of Wales saw 'moving pictures' and a 'performance of the cinematograph' as part of the royal family's evening entertainment.

After the death of Queen Victoria in 1901, Cecil Hepworth, by now a rising film-maker, decided to film her funeral from a position inside the railings of Grosvenor Gardens. As he began to work his camera, a noisy and 'coffin-like' construction, the sound shattered the 'great silence and hush' of the funeral procession. In vain Hepworth longed for the ground to open and swallow him up with his 'beastly machine'. Not surprisingly, the noise attracted the attention of King Edward. He held up his hand, halted the procession and waited for a moment before moving on. Hepworth believed that the King had heard the noise of his camera and had caused the procession to stop so that the cameraman could get a good picture.[4] If this was the case, it showed the King's willingness to co-operate with photographers and his support for the new and growing film industry. This did not mean that he was prepared to allow the filming of the Coronation inside Westminster Abbey, but it did mean that he and Queen Alexandra began to appear in 'cinematograph news' themselves as well as watching films at home or at public venues for their own amusement.

During the autumn of 1901 the Queen saw four such performances. Two, on 9 and 17 September, were in Denmark and were put on by the English Biograph Company and the Danish Biograph Company respectively. Later, on 14 October, Fraser & Elrick put on a show at Balmoral (see page 170 for the programme), and on 9 November, King Edward's birthday, a cinematograph performance took place at Sandringham. Films were becoming a more regular part of royal entertainment in Britain and abroad.[5]

On 4 April 1907, during a visit to England by her sister, the Dowager Empress of Russia, a show was put on at Alexandra's special request in the Green Drawing Room at Buckingham Palace. Gaumont's chronomegaphone apparatus from the Hippodrome, under the direction of Fred Trussell, the acting manager, was brought to the palace so that members of the royal family could see the 'singing pictures'. These were produced by 'a combination of the principles of the cinematograph and the gramophone', enabling 'realistic-looking artists' to 'act and sing in a natural manner. The pictures were thrown on to a screen over a bank of palms.' The Queen, the Empress, the Prince and Princess of Wales, their children, and Princess Victoria, with members of the Royal Household, were all present. 'The display was greatly appreciated and Alexandra showed her pleasure by commanding the putting on of extra pictures after the ordinary programme had been completed. The entertainment lasted about an hour.'[6] This performance was perhaps unusual in including mechanically produced music as well as pictures, at a time when the music accompanying films was often presented by a live pianist playing offstage. In the Queen's engagement diary for 2 September 1908 there is a note to say that she 'assisted at a performance of the "Kinematograf"' while in Norway.[7] In what capacity it is not recorded, but it should be remembered that she was a good amateur pianist.

In 1909 Alexandra had at least two opportunities to see the cinematograph, the first during the royal visit to Manchester on 6 July. On 23 August a performance, to which 100 people were invited, was put on in the Ballroom at Balmoral.[8] The Queen was growing accustomed to watching films as part of a large audience, as well as seeing them privately at home. At some point during this period she seems to have acquired a Kinora Viewer, which had been on show at the Exposition in Paris in 1900 and was becoming popular, although it did not appear on the British market until 1902.[9] It consisted of a box with a viewer on the top. Inside was a detachable reel of many tiny photographs (of which the image size was 25 × 20 mm, 1 × ¾") mounted on a core and placed on a spindle. It was worked by a clockwork motor, which allowed a lip to hold each photograph still for an instant before letting it go to make way for the next one. The effect was to give the illusion of motion in a manner almost as good as projected film.

It was soon possible to buy Kinora reels showing a variety of different subjects, a number of which featured Queen Alexandra herself.[10] These included *London's Welcome to Their Majesties*, *Queen Alexandra Presenting Medals* (in either general or close-up views), *Queen Alexandra in Carriage*, and *Royal Group*, with the King, Queen and Prince of Wales. Several including King Edward were still available after his death, such as *The late King and Queen Mother walking* and *The late King and Queen Mother in Carriage*; even his funeral procession could be viewed through the Kinora.[11]

During 1911, the year after the King's death, Alexandra seems to have found some consolation

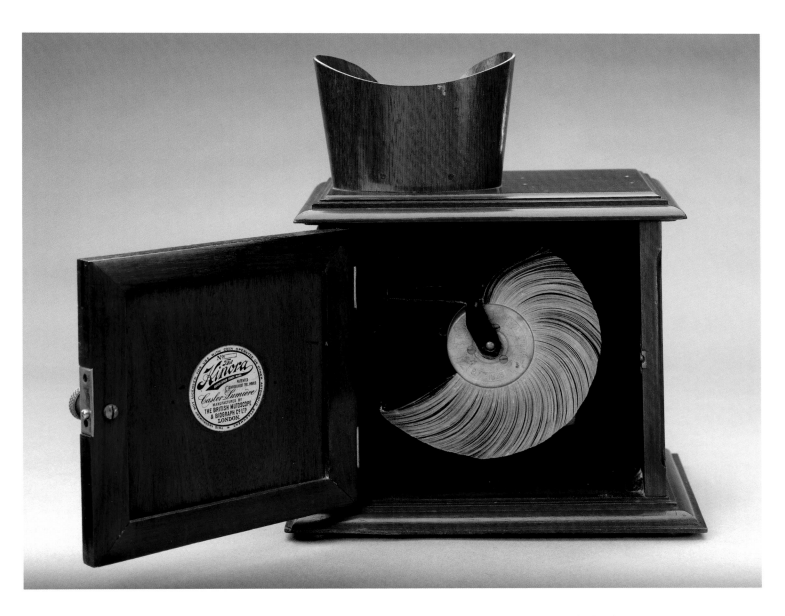

Casler Lumière, manufactured by The British
Mutoscope & Biograph Co. Ltd., London
*The 'Kinora' viewer, c.*1900
Wood and metal
26.8 × 22.3 × 15cm (10⁹⁄₁₆ × 8¾ × 5¹⁵⁄₁₆″)
RCIN 7102

The viewer was operated by clockwork; the tiny
photographs that can be seen attached to the spool were
exposed individually and consecutively, and the whole
series, watched through the viewer on the top of the
instrument, gave the impression of moving film. This
model, shown open to display the working parts, is the
same design as the one exhibited at the Paris Exposition
in 1900, where the Princess of Wales may have seen it.

in watching films. Some were put on in the Ballroom at Sandringham on the evening of 29 July. Charles Urban (who had petitioned unsuccessfully for permission to film the Coronation service in 1902) was invited to show a varied programme of examples of his 'Kinemacolor' (see page 173). In September and October, when the Queen, with Princess Victoria, visited Denmark, she saw 'wax figures and Cinematograph' on 29 September, while Princess Victoria, with her cousin Prince Christopher of Greece, went to public cinematograph performances on the 28th and 30th. On 12 October Prince Chervadchidze, a member of the Dowager Empress of Russia's Household, gave a cinematograph entertainment in Copenhagen for the Queen, Dowager Empress and Princess. Inspired by her enjoyment of these occasions, Alexandra, on returning home, invited cinematograph performances at Sandringham on 30 November and 1 December, her 67th birthday.[12]

Sorrowful and depressed as she was after the King's death, the Queen did not appear in public for some time. Her first public engagement, on 11 May 1912,[13] was to visit the Scala Theatre in London to see a Kinemacolor performance of scenes from the Delhi Durbar of 1911, at which her son and daughter-in-law, now King George V and Queen Mary, were crowned as Emperor and Empress of India. This film would have appealed particularly to her, as it showed the India she had longed to see. It is easy to understand Alexandra's enjoyment of films; they enabled her to witness current events without having to make any effort at conversation or feel at a disadvantage because of her deafness. Films at that time were generally silent (apart from the musical accompaniment) and the story could be followed by means of captions or titles, making them an ideal recreation for a deaf person. As she grew older and her sight began to deteriorate, it would also have been more comfortable to look at pictures projected on a large screen than to examine small snapshots in albums. By now she was travelling abroad less frequently and would soon, on account of the war, have to stop entirely. Films obviously helped to stimulate her imagination and went some way towards satisfying her appetite for seeing new places and being kept abreast of events.

In 1913 Queen Alexandra saw three cinematograph shows, the last of which, given at Sandringham on her birthday, was called *The British Soldier*. On 12 May 1914 she saw a film of Captain Scott's Antarctic Expedition, shown in the Ballroom at Buckingham Palace, and on 30 January 1915 she went again to the Scala, this time to see a 'Kinematograph of War Pictures'.[14]

When Alexandra visited Millbank Hospital on 7 July 1917, she found herself 'photographed to be published for the Cinema'.[15] Two further film performances, on 10 October and 16 November, were given in the Ballroom at Sandringham; the first was a 'cinema & lecture' by Sir Ernest Shackleton on his expedition to the South Pole. The second was put on to entertain the soldiers who were then billeted at Sandringham.[16]

Alexandra's interest in films and film-going continued both during[17] and well after the war.[18] Very possibly the last film performance she attended was on 1 December 1924, when she saw the first version of *Monsieur Beaucaire*, featuring Valentino and Bebe Daniels, at Sandringham.[19]

In May 1920, while suffering from a severe attack of bronchitis, the Queen burst a small blood vessel in her eye after a fit of coughing, and her sight was affected for some time.[20] She was unable

Unknown photographer,
Queen Alexandra on Alexandra Rose Day, c.1916
Silver print, 15.9 × 12.9cm (6¼ × 5⅟₁₆″)
RPC 01/0236/82

Alexandra Rose Day was inaugurated in 1912 to celebrate the fiftieth anniversary of the Queen's first visit to England. Money for charity was raised by the sale of small pink fabric flowers, fixed by a pin. The highlight of the occasion, in June every year, was a drive by the Queen through London, when she was presented with numerous bunches of flowers. By now she would have preferred to curtail her public life, so grew to dread this event, but always appeared to enjoy it. Her niece, Grand Duchess George of Russia, remembered that the Queen was 'wonderful in public; the way she bowed and smiled to everyone was quite unique…. She always gracefully waved her hands in a way which was very personal to her.'[21]

J. Russell & Sons, *Queen Alexandra and General Sir Dighton Probyn*, *c*.1923
Toned silver print,
29.2 × 21.8cm (11⁹⁄₁₆ × 8⁹⁄₁₆")
RPC 01/0236/91

The Queen with her faithful old servant, who died in 1924 at the age of 91.

to read comfortably which, as Princess Victoria wrote to a friend, was 'a terrible deprivation to her'.[22] Gradually she recovered and in 1921 was reading *The True Story of the Empress Eugénie* by the Comte de Soissons. This was 'not a nice story of the poor Empress – & many false statements at the end'.[23]

For her birthday in 1921 Alexandra received an album from the President of the Children's Libraries Movement, J. Brett Langstaff, on behalf of 'the Englishmen and Women of Arts and Letters'; it contained nine photographs of actors in the piece *Not as Bad as We Seem*, and many signatures. On 24 December 1922 she received a book from one J.C.C. Rye: *The Pageant of Peking*, containing sixty-six photographs of Peking and its environs, taken by Donald Mennie.

The last of the Queen's engagement diaries to be completed was that for 1923. On 27 July she posed in a 'Four Generations' group with her son, King George V, her granddaughter, Princess Mary, Viscountess Lascelles, and her great-grandson, the Hon. George Lascelles (now the

Earl of Harewood).[23] This may have been the last formal photograph taken of her.

On 8 May 1924 Miss Knollys wrote to Miss Acland to reassure her that 'in spite of all the Newspaper reports the Queen is <u>not</u> ill…. Her Majesty however greatly prefers Sandringham to London, as when in London she is overwhelmed with requests to attend Charitable Functions – Hospitals, Opera etc., and as she is now very deaf, she cannot derive much pleasure from the association of her friends, and greatly prefers the peace and quiet of the Country.'[25] The Queen's niece Marie, Grand Duchess George, was very conscious of her aunt's difficulties. 'Her great drawback was her lifelong deafness; she was terribly sensitive about this and absolutely refused, even *en famille*, to use any kind of instrument. She only spoke about this defect in her later years, never even mentioning it before. It was a terrible torture to her, as she was so full of life and interest, and she always felt she was missing something.'[26] This disability was frustrating for others too; even her much-loved sister, the Dowager Empress of Russia, found it hard to bear, especially as, by now, Queen Alexandra tended more and more to live in the past while the Empress was still alert to present-day matters. The two elderly sisters, reunited in 1919 after years of torturing anxiety, had once looked forward to spending their last years together in England; sadly, the Empress elected to live in Denmark instead.[27]

Alexandra's life at Sandringham was quiet and uneventful, with regular attendance at church, Sunday afternoon visits to feed her various beloved animals, and long motor-car drives every day. Her niece frequently stayed with her and described in her memoirs how, after the day's drive, tea would be taken in the hall. After this the Queen, with help from her companions, would 'put together jigsaw puzzles, her one amusement'.[28] Dinner was taken privately upstairs, when the Queen would appear dressed in a black velvet tea gown, wearing pearls and other jewellery, with a corsage of flowers. She remained fairly well but at 80 'was beginning to lose her wonderful energy and had moments of great lassitude'.[29] Her deafness was by now almost impenetrable, and she was unable to hear the wireless programme broadcast on 3 June 1925 to celebrate the 60th birthday of her beloved son, King George V. However, Miss Acland asked the British Broadcasting Company to have a transcript made, so that the Queen could read it. She was delighted and, as Miss Knollys reported on 6 October 1925, declared that 'she shall always value and treasure it as long as she lives'.[30]

This remark was prescient; Alexandra insisted on continuing as usual, but she was losing weight and growing weaker. On 19 November 1925 she had a heart attack and, although she was conscious and could recognise members of her family, it was evident that she would not survive for long. She died very quietly in the early evening of 20 November 1925. Her niece wrote that 'a short time after, all her wonderful beauty returned, and she lay on her deathbed with a happy smile, the picture of peace'.[31]

In May 1930 a Kodak exhibition of royal photographers was held in London; it was later sent on a world tour to raise money for King Edward's Hospital Fund for London and the Voluntary Hospitals. Ten of Queen Alexandra's photographs were exhibited.[32] This venture embraced several issues dear to the Queen: her support of her husband; her interest in hospitals; her generosity, and her love of travel. It seems entirely appropriate that, even after her death, her favourite hobby contributed to a cause that had been so close to her heart.

1 Dates of exhibitions are from RA.VIC/EVIID/1882: 13 Mar.

2 Alan Birt Acres, 'Birt Acres: Pioneer Film Maker', published in *The Photohistorian*, No. 127, August 1999

3 RA.VIC/QVJ/1896: 3 Oct.

4 Cecil Hepworth, *Came the Dawn: Memoirs of a Film Pioneer*, London 1951, p.56

5 Queen Alexandra saw films in Denmark on 20 October 1903 and 19 October 1904, and on 30 August 1905 was present at a performance in Norway. RA Queen Alexandra's Engagement Diaries.

6 The *Daily Graphic*, 4 April 1907

7 RA.VIC/QAD/1908: 2 Sep.

8 RA.VIC/QAD/1909: 23 Aug.

9 It had been patented in England in 1896 and the rights in the Lumière Kinora had been purchased in June 1898 by the British Mutoscope & Biograph Company, an offshoot of the American Mutoscope & Biograph Company, which owned the patent of the Mutoscope, a device invented by Herman Casler.

10 Short 'animated portraits', consisting of sixty pictures, could be taken at the Biograph Studio in Regent Street, London. In 1908 the Kinora amateur camera was marketed after winning a silver medal at the Franco-British Exhibition (which Queen Alexandra visited) at the White City. The Kinora underwent several changes in design between 1896 and 1914, but the one still in royal possession is the 1900 design, which makes it probable that the Princess of Wales saw it in Paris and later purchased or was given one.

11 Barry Anthony, *The Kinora. Motion Pictures for the Home, 1896–1914*, East Sussex 2001, pp.3–10

12 RA.VIC/QAD/1911: 30 Nov.; 1 Dec.

13 RA.VIC/QAD/1912: 11 May

14 *ibid.* Coincidentally, at about this time, her eye had been caught by a report in a newspaper which informed her that 'The Kaiser has presented to the Turkish Museum at Constantinople a number of films, representing the manoeuvres and military operations of German troops. The Kaiser's films will be exhibited in a Turkish cinema theatre' (*Central News*, 13 January 1915). This report the Queen cut out and pasted in her album.

15 RA.VIC/QAD/1917: 7 July

16 On 11 February 1918, an entertainment in aid of Queen Alexandra's Field Force Fund was given at the New Gallery in Regent Street. Charlotte Knollys noted that 'the war in Africa was represented on the Cinema (<u>excellent</u>)'. *ibid.*

17 In 1916 there was a showing at Marlborough House on 2 December of *Ellen Terry's Finest Performance*; the actress and her daughter were both invited. In the same year the Queen also saw Cecil Hepworth's film *Comin' thro' the Rye*, based on a popular novel by Helen Mathers (see Hepworth, *op. cit.*, p.131). In 1917 she saw *Tom Brown's School Days* at Buckingham Palace on 24 February, and D.W. Griffith's *Intolerance*, starring Lillian Gish, shown at Drury Lane Theatre for the benefit of the blind on 10 May. In March 1918 she saw the Italian film *Cristus*, representing the life of Christ, at the Philharmonic Hall in London.

18 *ibid.* In July 1919 a 'Cinema and Thought reading performance' was given at Marlborough House. According to her engagement diary, the last occasion when Queen Alexandra visited a cinema was on 30 May 1921. At the Alhambra Theatre she saw 'Mark Twain's film' about a man who dreams himself back to the Middle Ages: *A Connecticut Yankee at the Court of King Arthur*, starring Harry Myers. A film performance was given at Sandringham on 2 January 1922, when an audience of 400 people saw *Fresh Air*, Charlie Chaplin's *The Kid*, and *The Runaway Train*.

19 RA.GV/QMD/1924: 1 Dec.

20 RA Queen Alexandra's Engagement Diaries

21 Marie, Grand Duchess George, *A Romanov Diary. The Autobiography of Her Imperial and Royal Highness Grand Duchess George*, New York 1988, p.166

22 RA.GV/BB 14/1175/122, 2 June 1920

23 Georgina Battiscombe, *Queen Alexandra*, London 1969, p.299

24 RA.VIC/QAD/1923: 27 July.

25 Acland MSS d.177, 8 May 1924

26 Grand Duchess George, *op. cit.*, p.166

27 Private information

28 Grand Duchess George, *op. cit.*, p.258. A number of puzzles were bought from J.C. Vickery (RA.VIC/Add A 21/220).

29 *ibid.*

30 Acland MSS d.177, 6 October 1925

31 Grand Duchess George, *op. cit.*, p.260

32 Information by courtesy of the Kodak Ltd Archive.

WORKS SHOWN BY QUEEN ALEXANDRA
AT KODAK EXHIBITIONS AND ELSEWHERE

The numbers given to the photographs are the exhibition numbers

1. **The Eastman Kodak Picture Exhibition, the New Gallery, Regent Street, London, 27 October to 16 November 1897**

The exhibition was also shown in New York in 1898. The photographs listed here were illustrated in the catalogue and may not comprise the Princess's total contribution

1. The Britannia
2. Wellington Barracks
3. Photograph [of a lady, possibly Princess Victoria, seated on a yacht]
4. Photograph [of Prince Edward and Prince Albert of York with small carriage and pony, attended by a groom and nanny]
5. Their Royal Highnesses Prince and Princess Charles of Denmark
6. Their Royal Highnesses Prince and Princess Charles of Denmark

2. **Kodak Exhibition at the Kodak Gallery, 40 West Strand, London, 1902**

26. On the Royal Yacht
29. Haarlem
30. Gunboat Escort
31. A Loyal Crowd
33. In the Grounds, Sandringham
34. H.M. King Edward and Lord Suffield
35. Procession Passing Buckingham Palace
36. A Royal Fishing Party
37. Potsdam
38. Off the Coast of Scotland

3. **Grand Kodak Exhibition, 57–61 Clerkenwell Road, London, 1904–5**

Screen 30. Enlargements upon Royal Bromide Paper (toned) from Kodak Negatives
118. Isle of Wight
119. Changing the Guard
120. Sandringham

121. Heaving the Lead on the Royal Yacht
122. On the Royal Yacht off Arran
123. Eventide
124. On a Canal in Holland
125. Dawn
126. An Escort
127. H.M. The King and a Guest
128. A Salute

4. Exhibition of Royal Kodak Photographs at the Kodak Gallery, 115 Oxford Street, London, 1906

1. A Quiet Evening
2. H.M.S. *Camperdown*
3. Heaving the Lead
4. In the Grounds at Sandringham
5. Evening in the Highlands
6. Loyal Crowd outside the Palace, Copenhagen
7. A Destroyer
8. On the Kiel Canal
9. In the Highlands
10. Gathering Storm Clouds
11. H.M.S. *Ganges*
12. A Royal Fishing Party
13. Torpedo Destroyer
14. H.M.S. *Ganges*
15. On Board the Royal Yacht *Victoria and Albert*
16. In the Quadrangle, Windsor Castle
18. A Royal Salute
19. H.M. King Edward and Lord Suffield
20. Viewing the Royal Yacht
21. H.M.S. *Ganges* from the Royal Yacht
22. A Dutch Wherry
23. In the Highlands
24. The First Sight of Home

5. Kodak Exhibition of Royal Photographers, held on behalf of King Edward VII's Hospital Fund for London and the Voluntary Hospitals, 1930

The exhibition went on a World Tour, on behalf of the Hospitals, on 23 May 1930

1. H.M. King George V
2. His Late Majesty King Edward VII
3. His Late Majesty King Edward VII
4. H.M. King George V, H.R.H. The Prince of Wales, H.R.H. The Duke of York and His Late Majesty King Edward VII
5. H.R.H. The Prince of Wales as a Midshipman
6. Victory
7. The Late Lord Charles Beresford
8. Seascape
9. Silhouette
10. Landscape

6. Photographs by Queen Alexandra reproduced in the *Graphic*, August–September 1905

1. The King and Lord Suffield in the Garden at Marlborough House
2. Sandringham House. The Prince of Wales's Children in the Garden
3. Warships off the Coast of Scotland
4. Evening off the Coast of Scotland
5. To Catch a Glimpse of Her Majesty: Small Craft Cruising round the Royal Yacht off the Coast of Scotland
6. The Forecastle of the Royal Yacht *Victoria and Albert*
7. A Loyal Crowd: a View Taken from the Amalienborg Palace, Copenhagen, on the King of Denmark's Birthday
8. Warships Saluting Her Majesty's Arrival off the Coast of Scotland
9. Sunset off the Coast of Scotland

7. Photographs by Queen Alexandra reproduced in the royal edition of *The Flag: The Book of the Union Jack Club*, published in May 1908

1. His Majesty the King in the grounds of Buckingham Palace
2. The old *Victory* saluting as we pass
3. The Fleet off Cowes, 1907

'PROGRAMME OF CINEMATOGRAPH ENTERTAINMENT'

Programme of Cinematograph Entertainment to be given by command and in presence of Their Gracious Majesties The King and Queen, Her Royal Highness Princess Victoria and other Members of the Royal Family at Balmoral Castle on Monday Evening, 14th October 1901, by Fraser & Elrick, Opticians and Photographic Dealers, Edinburgh

Part I – South Africa and the Return of our Troops from the War

1. South African Railway Scene – 'To the Front'
2. Royal Engineers' Construction Train
3. Balloon Section Crossing a River
4. Crossing a Drift with a 4.7 Gun
5. Lord Roberts' Triumphal Entry into Kroonstadt
6. An Ostrich Farm
7. Arrival home of the Naval Brigade from Ladysmith
8. Naval Brigade at Gosport
9. Reception of Captain Percy Scott and the Men of H.M.S. *Powerful*, with the Guns they used in Ladysmith
10. Return of the C.I.V.'s and their March through the Streets of London
11. Patriotic Tableau – Britain's Welcome to her Sons
12. Union Jack Ensign

Part II – Incidents in the Cruise of the *Ophir*

13. King Edward, The Duke of York, and Members of the Royal Family passing along the Jetty, between the *Victoria and Albert* and H.M.S. *Ophir*
14. The Royal Travellers proceeding on board
15. His Majesty the King bidding farewell to and shaking hands with Officers of H.M.S. *Ophir*, previous to their departure
16. H.M.S. *Ophir* steaming out of Portsmouth Harbour conveying the Duke and Duchess of York to the Australian Colonies, being preceded by the Royal Yacht *Alberta*, with Their Majesties The King and Queen aboard
17. The Royal Yacht and Escort
18. The Arrival of the Duke and Duchess of Cornwall and York at Melbourne, Australia, on the 6th of May 1901

19. The Governor-General (Lord Hopetoun) and the Duke and Duchess of Cornwall and Staff going to open Parliament at Melbourne, 9th May 1901

20. Parade of Trades and Friendly Societies before the Duke and Duchess of Cornwall and York, at Melbourne, 11th May 1901

21. Arrival of the Duke and Duchess of Cornwall at Sydney, 27th May 1901
 – Leaving the Domain and passing into College Street

22. The Great Review of Australian Field forces before T.R.H. The Duke and Duchess of York at Centennial Park, Sydney, Australia, 28th May 1901

23. Laying Foundation Stone at Ballarat of the Monument to the Soldiers who have fallen in South Africa

24. Panorama of Sydney Harbour, showing Crowds waving farewell

Part III – Opening of Parliament and Miscellaneous Subjects

25. Panorama of Windsor Castle

26. Opening of the First Parliament of King Edward VII – Procession along Whitehall

27. The Scene at the Houses of Parliament

28. The Royal Visit to Netley Hospital

29. Arrival of His Majesty the King at Ballater

30. His Majesty's Inspection of Highlanders composing the Guard of Honour

31. Departure of the King from Ballater *en route* for Balmoral

32. His Majesty the King in Edinburgh

33. Their Imperial Majesties the Czar and Czarina of Russia at the review at Betheny, France

34. Launching of Santos Dumas' Navigable Balloon at Paris

35. Launch of the *Celtic*

36. *Brighton Queen* passenger ship embarking passengers and steaming full speed ahead

Part IV – Various Subjects

37. The Village Blacksmith

38. A Laughable Street Incident

39. Brickbuilding

40. Children at Play

41. The Maypole Dance

42. Gossip over the Tea Cups

43. Skating in Switzerland

44. *Shamrock* Becalmed and being Towed by the *Erin*

45. Mysterious and Marvellous Fishing

46. Masks and Faces

47. Love in a Tub
48. Miller and Sweep
49. Stop Thief!
50. Indian Jugglers
51. The Magic Extinguisher
52. The Clown Barber
53. The Little Chinese Girl
54. Britannia

Four programmes, giving details of films performed at
Fredensborg Slot, 9 September 1901, 8.8 × 13cm (3¹⁵⁄₁₆ × 5⅛″);
Balmoral, 14 October 1901, 22.8 × 12.6cm (9 × 5″)
– see page 170 for the full programme details;
Sandringham, 29 July 1911, 22.9 × 18cm (9¹⁄₁₆ × 7¹⁄₁₆″);
Sandringham, 30 November 1911, 19.5 × 12cm (7⅞ × 4¹⁵⁄₁₆″).
RA.VIC/QAD/1901: 9 Sep.; 14 Oct.; RA.VIC/QAD/1911: 29 July; 30 Nov.

KINEMACOLOR
LIFE IN NATURAL COLOURS

Under the Direction of the Inventor, Mr. CHARLES URBAN

PROGRAMME.

1. **'Floral Friends'.** Sixteen Studies, including Nasturtiums, Heath, Scarlet Wind Flowers, Fuchsias, Dahlias, Corn Flowers, Pansies, Mimosa, Chrysanthemums, Poppies, Tiger Lilies, Tulips, Carnations, Lilies of the Valley, and Roses. Showing the accurate reproduction of all gradations of colour, with wonderful Stereoscopic effects.

2. **H.M. King George and H.I.M. Emperor William Viewing the March Past of Troops** on the occasion of the Unveiling of the Queen Victoria Memorial, May 16th 1911

3. **'Farmyard Friends'.** A Series of Familiar Scenes

4. **Scenes in the Indian Camp at Hampton Court,** June 18th

5. (a) **The Coronation Procession** (June 22nd). Proceeding through the Mall

 (b) **Their Majesties Crowned.** Return from Westminster Abbey, passing through Parliament Square

6. **Animal and Bird Studies**

7. **'The Birth of Flowers'.** Showing the Evolution of the Flower from Bud to Blossom. Crocuses, Daffodils, Turban Ranunculus, Tulips, Anemones, Pink Gypsy Grass, Nasturtiums, Roses, Butterfly Flowers, Japanese Tiger Lilies. The actual growth of the flower is shown by means of speed magnifications, so that they expand before our very eyes. The effect is no less startling than beautiful.

8. **The Investiture of H.R.H. The Prince of Wales, K.G., at Carnarvon Castle**, July 13th. General views of Carnarvon Castle. The day before the Ceremony. The Water-Gate. Hoisting the Royal Standard. Bluejackets Signalling from the Tower. Arrival of the Welsh Choir in

National Dress. Sir Schomberg McDonnell, Chief of H.M. Board of Works, under whose direction the Castle arrangements were carried out. Arrival of the Mayor and Corporation of Carnarvon in Castle Square. Arrival of the Prince, and Presentation of Address by the Municipality. Arrival of the Prince at the Castle. Sounding the Fanfare. Hoisting the Standard of the Prince of Wales. The Prince's Procession to the Chamberlain's Tower in the Castle. Presentation of an Address to Their Majesties the King and Queen in Castle Square. The Royal Procession to the Castle. The King's Procession through the Castle. The Ceremony of the Investiture on the Dais in the Castle. Presentation of the Prince to the People from Queen Elinor's Gate. Presentation to the People from the King's Gate. Leaving the Castle. The Royal Standard on the Tower.

EXTRA (if required)-

a) **His Majesty Receiving the City Sword** at Temple Bar, June 3rd, 1911

b) **Lord Kitchener Reviewing Troops** at Khartoum, February 1911

A Trip on Lake Garda – Northern Italy

CONTEMPORARY NEWSREELS
FEATURING QUEEN ALEXANDRA

A selection of films from the British Film Institute's National Film and Television Archive

1.	1901	The Opening of the First Parliament of King Edward VII's Reign, 14 February 1901
2.	1902	Royal Remembrances: the Coronation of King Edward VII and Queen Alexandra (released 1929)
3.	1902	Coronation of King Edward VII (Hepworth)
4.	1902	Queen Alexandra's Review of Colonial Troops
5.	1903	Through Three Reigns (Hepworth)
6.	1903	Hepworth Personal Collection (Hepworth)
7.	1903	King Edward VII lays a Foundation Stone
8.	1903	Twenty Years Ago (released 1928)
9.	1903	King Edward VII Visits Belfast
10.	1905	King Edward VII Opens Sheffield University
11.	1908	King Edward VII Opens the Royal Edward Dock at Avonmouth
12.	1908	King Edward VII Visits Bristol Art Gallery
13.	1909	King Edward VII at Sandringham
14.	1910	Funeral of King Edward VII (Gaumont)
15.	1910	Funeral of King Edward VII (Hepworth)
16.	1910	Funeral of King Edward VII (Hepworth)
17.	*c.*1910–1915	King George V and Queen Mary at the Races (includes Queen Alexandra inspecting 10,000 Scouts on Horse Guards Parade) (Warwick Bioscope)
18.	1911	Hepworth Personal Collection, No. 2 (Hepworth)
19.	1911	Queen Alexandra on her Way to Italy (Pathe)
20.	1913	Alexandra Day: Queen Mary and Queen Alexandra drive through London to see the Flower Sellers (Topical Budget)
21.	1913	The Smallest Car in the Largest City in the World
22.	1914	Alexandra Day: The Queen's Emblem Being Sold in London (Pathe Gazette)
23.	?1914	Queen Alexandra's Rose Day
24.	1915	Queen Alexandra at Westminster: Observing the Giving of Maundy Money (Topical Budget)
25.	1915	Queen Alexandra Unveils Statue of King Edward VII at Southwark Cathedral (Topical Budget)

26.	1915	Royal Garden Party (Topical Budget)
27.	1915	Pekinese Dog Show at the Botanical Gardens (Topical Budget)
28.	1915	The Queen and the Children: 3,000 Children of Troops Fighting at the Front (Topical Budget)
29.	?1915	Unveiling of Memorial to Nurse Cavell by Queen Alexandra
30.	1916	Queen Alexandra's Help: Queen Alexandra, Princess Victoria and Princess Arthur of Connaught Received by the Mayor of Streatham (Topical Budget)
31.	1916	Two Queens at Drury Lane (Topical Budget)
32.	1916	Queen Alexandra's Drive Through London (Topical Budget)
33.	1916	Maundy Money: Queen Alexandra at Westminster Abbey (Topical Budget)
34.	1917	Roses for the Rose Queen: West End Tour amongst Rose Sellers (Topical Budget)
35.	1917	Queen Alexandra and the Prime Minister (Topical Budget)
36.	1917	Queen Alexandra Watching Volunteers: March Past of National Guard (Topical Budget)
37.	1918	What the King and London Saw: March of U.S. Soldiers (Topical Budget)
38.	1920	Royalty at the Advertising Exhibition (Gaumont)
39.	1922	Princess Mary Wedded to Viscount Lascelles at Westminster Abbey (Topical Budget)
40.	1923	A Double Distinction: Sir Dighton Probyn, V.C.
41.	1925	Queen Alexandra: The Nation's Tribute of Tears, Passing of the 'Gentle Lady' (Topical Budget)
42.	1925	Death of Queen Alexandra (Gaumont Graphic)
43.	1937	Crown and Glory, Part 1 (Paramount)

Undated

44.	Queen Alexandra

A 'Topical Budget Compilation' reel includes Nos. 20, 24, 26, 27, 30, 32, 33, 34, 36

QUEEN ALEXANDRA'S PHOTOGRAPH COLLECTION

Queen Alexandra's collection dates from the 1850s to the 1920s; it includes thousands of photographs in albums and a considerable number of loose prints. Many images were also mounted in frames or jewellery, on screens and elsewhere. Some, such as portraits and views of royal residences, were commissioned; others were acquired as gifts from family members, friends and acquaintances, or purchased from suppliers. A significant number, probably at least 4,000, were taken by Alexandra herself.

Between two and three hundred photograph albums, portfolios and boxes, which once belonged to King Edward VII and Queen Alexandra, are now kept in the Royal Photograph Collection at Windsor Castle and at Sandringham House. Some sixteen of these can be identified as having been the Queen's property because they contain her book-plate, cypher, signature or a dedicatory inscription; others may also have been hers but this is not indicated. It is known that she personally compiled about twenty other albums; additional albums and unmounted snapshots may have been given away or otherwise disposed of. The incomplete *Sandringham Album* is now kept at Frederiksborg Castle in Denmark. Photographs taken during the Norwegian cruise of 1904 were published in the *Christmas Gift Book* but no album or collection of prints relating to the cruise has been found.

This list gives details of the compilations in which photographs illustrated in this book were assembled. Almost all are now part of the Royal Photograph Collection, which is in the process of being catalogued under the Royal Collection Computerised Inventory System. Catalogue numbers are given in the captions to the illustrations, using the following abbreviations:

RA Royal Archives
RC Royal Collection
RCIN Royal Collection Inventory Number
RL Royal Library
RPC Royal Photograph Collection

The suppliers and binders of albums are unknown unless otherwise stated.

Albums in the Royal Photograph Collection which were personally arranged by Queen Alexandra, or which contain work by her:

Monarchs of the world, *c*.1866
This includes studio portraits by professional photographers, and painted decorations which are typical of the Princess of Wales's work.
15 × 23.3 × 6cm (6 × 9⅕ × 2⅖″); RPC 01/0116
p.31 (both), p.32

Collage album with photographs and painting, *c*.1866–9
Images by professional photographers in combination with Alexandra's own painted designs.
Album supplied by Bumpus Ltd., Oxford Street, London W1.
28 × 38.5 × 5.5cm (11 × 15⅕ × 2⅕″); RCIN 2300089
pp.36, 37, 38, 39

Kodak, *c*.1889–90
Photographs taken with the Princess's No. 1 Kodak camera. Album supplied by Albert Barker, New Bond Street, London W1.
37.2 × 40.1 × 9.7cm (14½ × 15⅓ × 3⅓″); RPC 03/0063
pp.64 (all), 65 (both), 66 (all)

Norwegian cruise, 1893
An album combining postcards, documents, and photographs by professionals with snapshots, paintings and a handwritten diary by the Princess of Wales. Album supplied by Houghton & Gunn, 162 New Bond Street, London W1.
29.5 × 41.5 × 3.2cm (11⅗ × 16⅓ × 1¼″); RPC 03/0064
pp.71–4 (all)

Bernstorff, August–September 1898
Snapshots commemorating Queen Louise of Denmark's 81st birthday celebrations.
24.5 × 34.4 × 4cm (9⅗ × 13½ × 1½″); RPC 03/0066
p.77

Mediterranean cruise, March–May 1899
This contains snapshots, one painting and a handwritten diary by the Princess of Wales, combined with postcards, professional photographs and documents.
Album supplied by Houghton & Gunn, 162 New Bond Street, London W1.
32 × 42.5 × 6cm (12½ × 16¾ × 2⅓″); RPC 03/0065
pp.78, 80–85 (all)

Queen Alexandra's album, *c*.1890s–early 1900s
This was given to the then Princess of Wales by Helen Faudel-Phillips in the 1890s. It contains nearly 500 snapshots, possibly by more than one photographer.
Album supplied by J.C. Vickery, Regent Street, London W1.
28 × 39 × 5.8cm (11 × 15⅓ × 2¼″); RPC 03/0067
pp.87, 95, 118–19 (all)

Mediterranean cruise, 1905: Volume 1
A compilation of Queen Alexandra's own photographs and a handwritten diary, with other photographs, postcards and documents.
Album supplied by Bumpus Ltd., Oxford Street, London W1.
37.5 × 50 × 8cm (14¾ × 19⅔ × 3⅓″); RPC 03/0069
pp.93 (bottom), 107 (both), 109–11 (all), 112 (top left, bottom)

Mediterranean cruise, 1905: Volume 2
Album supplied by Bumpus Ltd., Oxford Street, London W1.
37.2 × 49.2 × 6cm (14½ × 19⅓ × 2⅓″); RPC 03/0070
pp.112 (top right), 113, 114–16, 117 (top left), back cover

Mediterranean cruise, 2 April–23 May 1906
A compilation similar to the 1905 cruise albums, but with fewer descriptions by the Queen.
37 × 46.3 × 6cm (14¼ × 18⅓ × 2⅓″); RPC 03/0071
p.117 (bottom left, right)

Sea views, *c*. early 1900s
Thirteen large-format photographs by the Queen.
32 × 42.2 × 4.8cm (12½ × 16⅗ × 1⅗″); RPC 03/0188
Half-title, pp.103, 104

Various views, *c*. early 1900s
Thirteen large-format photographs by the Queen.
32 × 42 × 4.7cm (12½ × 16½ × 1⁷⁄₁₀″); RPC 03/0189
pp.105–6 (all)

State visits to Denmark, Sweden and Norway, 20 April–4 May 1908
A compilation similar to the 1905 cruise albums, but with fewer snapshots and captions by the Queen. Album supplied by Bumpus Ltd., Oxford Street, London W1.
37.3 × 49.2 × 7.5cm (14⅔ × 19⅓ × 3″); RPC 03/0073
pp.121–3

State visit to Russia, Reval, 5–14 June 1908
A compilation of the Queen's own snapshots, other photographs, postcards and documents. Supplier unknown, but album contains a trademark stamp showing a seated woman.
27.8 × 37.5 × 5.2cm (10⁹⁄₁₀ × 14¾ × 2″); RPC 03/0074
pp.124 (all), 125

Album, August–September 1908
This contains approximately 379 photographs, of which 65 are by professional photographers, and some postcards. Queen Alexandra captioned many of the snapshots.
32.7 × 45 × 5.5cm (12⅘ × 17¾ × 2⅛″); RPC 03/0075
pp.126 (left, top and bottom), 127 (left), 149 (top)

Hvidöre, 1908
An album recording life at the Queen's villa in Denmark, including a watercolour sketch, snapshots and other photographs, and some captions.
24.3 × 35 × 5.2cm (9½ × 13¾ × 2″); RCIN 2103204
pp.126 (right, top and bottom), 127 (right), 129 (bottom)

Hvidöre, *c.*1908–1911

Album bound in brown leather with decorative lines in gold and black. It contains 70 photographs by an unnamed photographer (possibly Mary Steen), recording Queen Alexandra's life at the villa.

Supplier/binder unknown

38.3 × 28 × 5.5cm (15¼ × 11 × 2¼"); RCIN 2103133

pp.128, 129 (top)

State visit to Berlin, 1909

A compilation of photographs and documents which does not include any work by Queen Alexandra except a brief handwritten diary of the visit.

Album supplied by J. Macmichael, 42 South Audley Street, London W1.

42.7 × 34 × 6.5cm (16¾ × 13⅖ × 2½"); RPC 03/0077

pp.136–7 (all)

Mediterranean cruise, 1909: Volume 1

This contains snapshots, other photographs, postcards and documents, and has a handwritten partial diary of the cruise.

37.5 × 46.2 × 5.3cm (14¾ × 18⅓ × 2"); RPC 03/0077

pp.138–41 (all)

Mediterranean cruise, 1909: Volume 2

The second volume has some captions by the Queen.

37.5 × 46.2 × 5cm (14¾ × 18⅓ × 1⁹⁄₁₀"); RPC 03/0078

pp.142–3 (both)

The Sandringham Stud Book, 1887–1917

Details the horses and mares associated with the Stud, including 70 photographs, some of which are by Queen Alexandra.

34.7 × 28 × 6.5cm (13⅖ × 11 × 2½"); RCIN 1231417

pp.147, 148, 149 (bottom)

Other albums and boxes in the Royal Photograph Collection, mentioned in the text, which also belonged to King Edward VII and Queen Alexandra:

**Albert Edward, Prince of Wales.
Photographs. 1848–1862**

Album bound in dark burgundy coloured cloth, with leather corners and spine, and decorative lines in gold. The base of the spine is also tooled with the Prince of Wales's crest and library mark. It contains 114 photographs collected by the Prince, including some placed loosely in the back of the album. They are mostly portraits, of the Prince's relatives, Royal Household and friends; and a significant number are of works of art. Bound by W.F. Taylor, High Street, Windsor, Berkshire

33.7 × 27.2 × 2.7cm (13¼ × 10¾ × 1⅛"); RPC 03/0055

p.26

**Photographic views and portraits
of the Crimean Campaign**

A set of 350 photographs taken in 1855, during the Crimean War, by Roger Fenton. Originally kept at Sandringham, in three blue cloth portfolios with black leather spines and corners, with the title tooled in gold, these are now housed in four boxes.

Modern casing

Box measurements 61.2 × 51.5 × 6.3cm (24⅛ × 20¼ × 2½"); RCINs 2500229–578

p.43

Princess Alexandra's album, 1859–1866

Album bound in dark green velvet, with gilt clasps. It has carved wooden panels on the front and back covers, the front panel bearing a design of oak leaves and acorns, and a vine; while the back has a design of a gate. It contains eighty-six *carte-de-visite* portrait photographs of the Princess and other members of the royal family.

16 × 24 × 6cm (6¼ × 9⅜ × 2½"); RPC 01/0184

pp.17–18 (all); p.21 (both)

HRH The Prince of Wales's tour in the East, 1862

A set of 180 photographs recording the Prince's tour, taken by Francis Bedford. Originally kept at Sandringham in four dark green leather bound portfolios, with the title and line decoration tooled in gold, these are now housed in six boxes.

Modern casing

Box measurements 61.2 × 51.5 × 6.3cm (24⅛ × 20¼ × 2½"); RCINs 2700849–1028

p.27

Sandringham, 24 May 1864

Album bound in very dark green leather, with overlaid gilt metal decorations in the corners of the front cover, surrounded by a gilt metal border round both covers, with clasp. The title and Queen Victoria's cypher and crown are also overlaid in gilt metal on the front cover. It contains some printed matter including four engravings of Sandringham Hall and Sandringham Church, and twenty-two photographs by Vernon Heath, the majority of which show exterior views of the house, and of the grounds and estate.

35 × 46.2 × 3.3cm (13¾ × 18¼ × 1¼"); RCIN 2102229

p.30 (top)

Eastern Journeys

Album bound in green cloth with very dark green leather spine and corners, with the title and decorative lines tooled in gold. It contains seventy-three photographs by various photographers, showing views in Egypt, Turkey, Greece and the Crimea, which were acquired as a result of the Prince and Princess of Wales's tour in 1868–9.
Bound by Rivière
46.5 × 37 × 7.5cm (18¼ × 14¾ × 3″); RCIN 2700775
p.44

Bolshoi Imperatorskiy Kremlevskiy Dvorets v Moskve

A portfolio bound in purple velvet, with the title (in Russian script) and decorative lines in gold. It contains twenty-one photographs of the Grand Imperial Palace of the Kremlin in Moscow, probably taken in the 1870s. Supplier/binder may have been the photographer I. Dyagovchenko, whose name also appears on the cover.
64.5 × 49 × 3.8cm (25½ × 19⅜ × 1½″); RCIN 2103398
p.47

Paris, 1871

Album bound in dull red cloth, with leather corners and spine, and decorative lines and the title in gold. It contains nineteen photographs, some of which are by Bruno Braquehais, showing Paris and St.Cloud at the time of the Siege.
26.5 × 36.2 × 2.5cm (10½ × 14¼ × 1″); RPC 09/0050
p.46

Captain Oliver Montagu's album, 1874

Album bound in black leather, with gold line decoration. It contains a hand-written diary of the events and celebrations taking place in St Petersburg and Moscow at the time of the wedding of Prince Alfred, Duke of Edinburgh, and Grand Duchess Marie Alexandrovna of Russia. This is accompanied by photographs, newspaper cuttings, menus, programmes, invitations and other souvenirs.
35.8 × 51.8 × 6.3cm (14 × 20¼ × 2½″); RPC 04/0004
p.70

Princess Victoria's album, 1887–1888

Album bound in black cloth with black leather spine and corners and decorative lines in gold. It contains 179 photographs, many of which may be Princess Victoria's own work.
28 × 24 × 4.4cm (11 × 9½ × 1¾″); RPC 03/0085
p.62

Prince George's album, Christmas 1889

Album bound in red leather, with decorative lines in gold. It was given to the Prince as a Christmas present by his sister, Princess Victoria, in 1889; the current binding is of a later date. It contains a large quantity of photographs of multiple but unattributed authorship; many were taken or acquired during Prince George's travels.
Bound by Zaehnsdorf, 1903
37 × 48 × 6.1cm (14¼ × 19 × 2½″); RPC 03/0121
Front cover

Queen Alexandra as Princess of Wales

Box of 191 photographs, by professional photographers, of Queen Alexandra before her marriage and as Princess of Wales.
Modern casing
47 × 36.8 × 8.2cm (18½ × 14¼ × 3¼″); RPC 01/0235
Frontispiece, p.97

Wales family photographs.
Volume 7. Princess of Wales

One of a series of boxes of photographs recording the life of the Prince of Wales and his family from 1848 to 1873. This one contains photographs of the Princess from June 1864 to October 1866, taken by professional photographers.
Modern casing
30.3 × 36 × 6.3cm (12 × 14¼ × 2½″); RPC 01/0176
pp.8, 30 (bottom)

Wales family photographs.
Volume 8. Princess of Wales

Photographs of the Princess from November 1866 to August 1870, taken by professional photographers.
Modern casing
30.3 × 36 × 6.3cm (12 × 14¼ × 2½″); RPC 01/0177
pp.34 (left), 42 (bottom)

King Edward VII and Queen Alexandra
with their descendants

Two boxes containing a total of 105 photographs of the King and Queen, with their children and grandchildren, taken by professional photographers.
Modern casing
47 × 36.8 × 8.2cm (18½ × 14¼ × 3¼″); RPCs 01/0238, 01/0239
p.34 (right)

The Province of Munster

Album bound in red leather, with the title, ERVII, crown and decorations tooled in gold. On the front cover is a black leather inlay in the shape of a shield, within which

are three crowns inlaid in tan leather with gold tooling. This is one of four volumes presented to King Edward VII in remembrance of his visit to Ireland in 1903. It contains fifty views taken in Munster.
Bound by Hegan & M'Ferran, Belfast
40.2 × 35 × 8.3cm (15¾ × 13¾ × 3¼″); RCIN 2600102
p.90 (left)

The Province of Leinster
Album bound in red leather, with the title, ERVII, crown and decorations tooled in gold. On the front cover is a green leather inlay in the shape of a shield, within which is a design of a harp inlaid in tan leather with gold tooling. One of four volumes presented to King Edward VII in remembrance of his visit to Ireland in 1903. It contains fifty views taken in Leinster.
Bound by Hegan & M'Ferran, Belfast
40.2 × 35 × 8.3cm (15¾ × 13¾ × 3¼″); RCIN 2600000
p.90 (right)

The Province of Ulster
Album bound in red leather, with the title, ERVII, crown and decorations tooled in gold. On the front cover is a tan leather inlay in the shape of a shield, onlaid in red leather with a cross and with a smaller shield in cream leather, upon which is a hand in red leather. The design also includes gold tooling. One of four volumes presented to King Edward VII in remembrance of his visit to Ireland in 1903. It contains fifty views taken in Ulster.
Bound by Hegan & M'Ferran, Belfast
40.2 × 35 × 8.3cm (15¾ × 13¾ × 3¼″); RCIN 2600051
p.91 (top)

The Province of Connaught
Album bound in red leather, with the title, ERVII, crown and decorations tooled in gold. On the front cover is an inlay in the shape of a shield, half in cream and half in black leather, upon which is an eagle onlaid in profile, in black on the cream leather. On the black leather is an arm in a red sleeve, its hand grasping a short sword, onlaid. These designs also have gold tooling. One of four volumes presented to King Edward VII in remembrance of his visit to Ireland in 1903. It contains fifty views taken in Connaught.
Bound by Hegan & M'Ferran, Belfast
40.2 × 35 × 8.3cm (15¾ × 13¾ × 3¼″); RCIN 2600153
p.91 (bottom)

Windsor Castle Photographs
Album bound in burgundy leather, with a black leather panel on the front cover, bearing the title, and profuse gold tooled decorations overall, including the title on the spine. It contains 126 photographs of the Private and State Apartments as they were during the residence at the Castle of King Edward VII, Queen Alexandra and Princess Victoria; and twenty-four exterior views of the Castle and precincts, including St George's Chapel. There are also six aerial views of the Castle, probably taken at a later date.
Supplier/binder Larner & Stokes, inscribed 'To the Queen'
33.5 × 45.3 × 8.5cm (13¼ × 17¾ × 3½″); RCIN 2100737
p.92

Marlborough House, 1912
Album bound in red leather, with Queen Alexandra's cypher in gold and black and the title tooled in gold across the top left-hand corner of the front cover. It contains thirty-seven platinum prints showing interior views of Marlborough House, taken by Grove & Boulton.
Supplied by the photographers
32.3 × 43.7 × 5.3cm (12¾ × 17¼ × 2″); RCIN 2101986
pp.79, 150 (both)

Princess Victoria's album, August 1916 – May 1919
Album bound in dark burgundy leather, with gold tooled line decorations and the dates typed on a paper label at the top of the spine. It contains quantities of snapshots taken by Princess Victoria as well as some prints by other photographers.
44 × 32.3 × 5cm (17¼ × 12¾ × 2″); RPC 03/0113
pp.156–7

Queen Alexandra
Box of ninety-four photographs by professional photographers, showing Queen Alexandra as Queen and Queen Mother.
Modern casing
47 × 36.8 × 8.2cm (18½ × 14¼ × 3¼″); RPC 01/0236
pp.89, 153, 163, 165

Peter Elfelt (1866–1931), *The Princess of Wales*
*in a photographer's studio, c.*1890–91
Modern print from original glass-plate negative,
18 × 24cm (7 × 9½")
The Royal Library, Copenhagen

A preliminary shot before an official sitting.
The photographer's assistant holds up a backdrop
behind the sitter.

PROFESSIONAL PHOTOGRAPHERS
WHO PHOTOGRAPHED QUEEN ALEXANDRA

This list is based on information from the records of the Copyright Office of the Stationers' Company, now held at the National Archives in Kew.

GREAT BRITAIN

England

Greater London: William Atkins; Albert P. Baker; Henry Barraud; Arthur George Barrett; Basebe & Son; Alexander Bassano; Franz Baum; Thomas Henry Bolland *(Hanwell)*; Francis Byrne & Company *(Richmond)*; William Joseph Byrne *(Richmond)*; Arthur William Child; Alexander Corbett; *Daily Sketch*; Arthur Debenham; A. Debenham & Company; A. Debenham & Son; Baron De Meyer; Adolphe Disdéri; Arthur James Hope Downey; William Downey; William Edward Downey; William & Daniel Downey; Walter James Edwards; James Edward Ellam; Elliott & Fry; Mary Catherine Ellis; William Ellis; Thomas Fall; Claude Charles Fenton *(Barnes)*; Louis Ghémar; William Andrew Gowing; Charles James Gunn *(Richmond)*; Gunn & Stuart; R. Vernon Heath; Henry Hering; Hills & Saunders; Charles John Hinxmann; Frederic George Hodsoll; Joseph Hubert; Alice Hughes; Lafayette; James Stack Lauder; Lock & Whitfield; London News Agency Photographs Ltd; London Stereoscopic & Photographic Company Ltd; Paul Martin; Maull & Company; John Jabez Edwin Mayall; Arthur J. Melhuish; Harold Moyse; Ladislas Niewsky; William George Plowright; Victor A. Prout; Frederick William Ralph; Oscar Remandas; Augustin Rischgitz; Robert Roberts; James Russell & Sons Ltd; John Lemmon Russell; Ernest Schwartz; David Shackleton; Southwell Brothers; The Sport & General Press Agency; W.S. Stuart; A. & G. Taylor; George Taylor; Stephen Thompson; John Thomson; Thomas Charles Turner & William Drinkwater; United Association of Photography Limited; Henry Van der Weyde; G. Vandyk Ltd; Stanislas Julian Walery *(Count Ostrorog)*; F.R. Window; Window & Bridge

Aldershot: Charles Edward Wyrall
Barnsley: George Henry Denton; Warner Gothard, jnr.

Birmingham: Frederick Harry Andrews; Edmund Smith Baker, jnr.; Henry Joseph Whitlock
Bolton: Nathan Smedley Kay
Bradford: Appleton & Company; John Mitchel Dowling Worsnop
Brighton: Charles Hawkins
Bristol (and Clifton): Harvey Barton, jnr.; David Hamilton; Lewis Raphael Protheroe
Burton-on-Trent: Ernest Abrahams; J.F. Sutcliffe
Calne: Henry George Summers
Chester: James Hampson Spencer; George Watmough Webster
Chichester: James Russell & Sons Ltd
Chorlton-cum-Hardy: Leonard Renaud
Cromer: Stanley Hay Wrightson
Dersingham: Frederick Ralph; Frederick William Ralph; Thomas Ralph
Easebourne: Francis William Marc de la Coze
East Stonehouse: William Rose
Eton: Hills & Saunders
Failsworth: Ernest Stephenson Wood
Hull: George Cooper; Thomas Charles Turner & William Drinkwater; W.J. Wellsted
Hunstanton (and St. Edmunds): Augustus Mace
Huntingdon: Arthur Madisson
Isle of Wight: Arthur William Debenham *(Cowes)*; A. Debenham & Company, A. Debenham & Son *(Ryde, Cowes, Sandown)*; Arthur Debenham *(Ryde)*; Cornelius Jabez Hughes and Gustav Mullins *(Ryde)*
King's Lynn: Mr Pridgeon
Leeds: Hatley Bacon
Leicester: Frank Brown
Liverpool: Brown, Barnes & Bell; Julius Alfred Kay; John Millward (c/o Medrington's Ltd)
Manchester: Robert Banks; James Bradford Brown; Hamilton Griffie McBurney
Middleton: Harry Entwistle; Thirza Fothergill; William Herbert Thorpe

Newcastle under Lyme: Edwin Harrison

Newcastle upon Tyne: William & Daniel Downey;
Peter Maitland Laws

Newmarket: Henry Robert Sherborn

Norwich: William Lewis Shrubsole; Edgar Wilkinson;
Wilkinson & Company

Penzance: Robert Preston & Samuel Poole

Portsmouth: Francis James Baxter (H.M. Yacht *Victoria
and Albert*); Symonds & Company

Ripon: Austin Clarke

Salford: John White

Salisbury: John Edward Jarvis

Scarborough: Sarony & Company

Sevenoaks: Charles Essenhigh Corke; Henry
Essenhigh Corke

Sheffield: Frank Mottershaw (trading as Sheffield Photo.
Company); Edwin Taylor; Ernest Thompson

Sheringham: Wilkinson & Company

Southport: Julius Alfred Kay

Southsea: A. Debenham & Company; A. Debenham
& Son; Cass Cole Fleming

Sunderland: Paul Stabler

Sutton: David Knights-Whittome

Swindon: John Rowland King

Tunbridge Wells: G. Glanville

Wallington: Harry John Kempsell (trading as French
& Company)

Watford: Frederick Downer

Weymouth: Arthur Harry Davis; H. Wheeler

Worcester: Thomas John Bennett

Worksop: Amos Emblin

Worthing: James Russell & Sons Ltd

Ireland

Belfast: Herbert Allison; Alexander Robert Hogg;
John Malcomson

Cork: William Griffith Honey

Dublin: Charles William Burnside; Chancellor & Son;
George Lafayette; Lafayette; James Stack

Lauder (and Dalkey): Herbert Edward Haffield (*Co. Dublin*)

Londonderry: George Ayton; Frank Coghlan

Omagh: John Joseph Thompson

Waterford: George Day Crocker; Arthur Henri Poole

Scotland

Aberdeen: James Ewing; George Wilson Morgan
(George William Morgan)

Aberdeen, Aboyne & Ballater: G. & W. Morgan

Ballater: Robert Milne

Blackdales: Harold Mackenzie

Edinburgh: James Charles Halyburton Balmain;
Frank Pelham Moffat; Ian Smith; Marshall Wane

Glasgow: Joseph Brandelbourg; Joseph Fowler;
Maclure, Macdonald & Company (Richard Hughes
was associated with this firm and Joseph Brandelbourg
with this address)

Kelso: James Mackintosh

Wales

Bangor: Thomas Mills

Cardiff: Andrew Lawrence; Eustace Henry Simon

Llandrindod Wells: Roger Francis Ross Swettenham

Swansea: James Lambert

Upper Bangor: John Wickens

AUSTRIA

Gmunden: C. Jagerspacher

BELGIUM

Brussels: F. Deron; Ghémar Frères

DENMARK

Copenhagen: F. Danielsen; J. Danielsen; Peter Elfelt;
C. Ferslew & Company; Georg E. Hansen;
Messrs. Hansen & Weller; E. Hohlenberg; Kirchhoff
& Henschel; E. Lange; C. Michelsen; Jewis Michelsen;
J. Petersen & Company; J. Petersen & Søn;
Peter L. Petersen; Søstrene Schiøtz; Mary Steen;
Rudolph Striegler

Kongens Lyngby: A. Th. Collin

FRANCE

Paris: Robert Bingham; Emile Desmaisons;
Adolphe Disdéri; Le Jeune; Levitsky

GERMANY

Darmstadt: Carl Backofen

Frankfurt-am-Main: Erwin Hanfstaengl

GREECE

Athens: C. Merlin; P. Moraïtes & Company

ITALY

Milan: Leonida Pagliano

Venice: Fratelli Vianelli

RUSSIA

St Petersburg: Charles Bergamasco; V. Jasvoin

TURKEY

Constantinople: Abdullah Frères

The following photographers held the Royal Warrant to Queen Alexandra (i.e. they were photographers By Appointment to H.M. The Queen or The Queen Mother):

(as Queen)

England: W. & D. Downey; Eastman (or Kodak Ltd); William Edward Gray; Lafayette Ltd; W.S. Stuart
Naples: Carlo La Barbera

(as Queen Mother)

England: W. & D. Downey Ltd; William Edward Gray; Walter Jones; Kodak Ltd; Lafayette Ltd; F. Ralph, senior; J. Russell & Sons; W.S. Stuart; C. Vandyk Ltd
Naples: Carlo La Barbera

PICTURE CREDITS

All works reproduced are in the Royal Collection, © 2004 HM Queen Elizabeth II, unless indicated otherwise below.

pp. 12, 14 (top), 63 (top) The Danish Royal Collection, Christian VIII's Palace, Amalienborg, Copenhagen, Denmark; pp. 13, 16, 33, 63 (bottom), 69 Frederiksborg Castle, Denmark; pp. 14 (bottom), 182 The Royal Library, Copenhagen, Denmark; p. 60 (both) National Museum of Photography, Film & Television/SSPL; p. 120 Devonshire Collection, Chatsworth, Derbyshire.

Every effort has been made to contact copyright holders; any omissions are inadvertent and will be corrected in future editions if notification of the amended credit is sent to the publisher in writing.

BIBLIOGRAPHY

Published Sources

Vernon Heath, *Recollections*, London 1892

Mrs C.N. Williamson, *Queen Alexandra, the Nation's Pride*, London 1902

Charles Urban, *The Cinematograph in Science, Education and Matters of State* (pamphlet in British Library), London *c*.1910

The Kinora Library. A Descriptive List of Moving Pictures that You May See in Your Own Home, The Projection Box, London 2001, reprinted from a catalogue of *c*.1911

Alice Hughes, *My Father and I*, London 1923

Elizabeth Villiers, *Queen Alexandra the Well-Beloved*, London 1925

Carl W. Ackerman, *George Eastman*, New York 1930

Sir Lionel Cust, *King Edward VII and his Court*, London 1930

Margaret J. Tuke, *A History of Bedford College for Women, 1849–1937*, Oxford 1939

Baroness de Stoeckl, *Not All Vanity*, ed. George Kinnaird, London 1950

Cecil Hepworth, *Came the Dawn: Memoirs of a Film Pioneer*, London 1951

Sir Frederick Ponsonby, first Lord Sysonby, *Recollections of Three Reigns*, London 1951

James Pope-Hennessy, *Queen Mary*, London 1960

Helmut and Alison Gernsheim, *Edward VII and Queen Alexandra: a Biography in Word and Picture*, London 1962

Philip Magnus, *King Edward VII*, London 1964

Dearest Mama: Private Correspondence of Queen Victoria and the Crown Princess of Prussia, 1861–1864, ed. Roger Fulford, London 1968

Georgina Battiscombe, *Queen Alexandra*, London 1969

William C. Darrah, *The World of Stereographs*, Land Yacht Press, 1977, reprinted Nashville, Tennessee, 1997

Jeremy Maas, *The Prince of Wales's Wedding. The Story of a Picture*, London 1977

Elizabeth Longford, *Louisa, Lady-in-Waiting*, London 1979

Pamla J. Eisenberg, *Alexandra, First Lady of Royal Photography*, History of Photography Monograph Series No. 5, November 1983, © Arizona State University, Phoenix 1983

Frances Dimond and Roger Taylor, *Crown and Camera. The Royal Family and Photography, 1842–1910*, London 1987

Jane Roberts, *Royal Artists, from Mary Queen of Scots to the Present Day*, London 1987

Marie, Grand Duchess George of Russia, *A Romanov Diary. The Autobiography of Her Imperial and Royal Highness Grand Duchess George*, New York 1988

Brian North Lee, *British Royal Bookplates*, Scolar Press, London 1992

Delia Millar, *The Victorian Watercolours and Drawings in the Collection of Her Majesty The Queen*, London 1995

Barry Anthony, *The Kinora. Motion Pictures for the Home, 1896–1914*, London 1996

Norman E. Oxley, *Alfred Young Nutt. In Service to Three Monarchs at Windsor*, Windsor 1996

Marianne Tidman, *Women Bookbinders, 1880–1920*, London 1996

Alan Birt Acres, 'Birt Acres: Pioneer Film Maker', *The Photohistorian*, No. 127, August 1999

Jørgen Hein and Gerda Petri, trans. Marianne Nerving and Paulette Møller, *The Royal Danish Collection. Christian VIII's Palace, Amalienborg*, Copenhagen, 1999

Palle Lauring, trans. David Hohnen, *A History of Denmark* (third edition), Copenhagen 1999

Robert Rosenblum, MaryAnne Stevens and Ann Dumas, *1900. Art at the Crossroads*, London 2000 (exh. cat., Royal Academy, London)

Roufina Samsonova, *Russkiy Farfor v Sobranii Gatchinskogo Dvortsa (Russian Porcelain in the Collection at Gatchina Palace)*, St Petersburg 2000

The Fine Art Society, *Complete List of Exhibitions, The Fine Art Society plc, 1876–2001*, London 2001

Richard N. Speaight, *Memoirs of a Court Photographer*, London n.d.

Newspapers and Periodicals

British Journal of Photography, 8 October 1875

British Journal Almanac Advertisements, c.1894

The Times, 26 April 1898

The *Lancet*, 5 July 1902

Photography, 21 August 1902

The *Sphere*, 7, 14 and 28 November 1903

The *Daily Mirror*, 11 April 1905

The *Amateur Photographer*, 5 June 1885; 13 March 1891; 16 January 1906

Illustrated London News (New York edition), 19 January 1907

The *Graphic*, 4 April 1907

The *Sketch*, 1 January 1908

The *Daily Telegraph*, 12 and 29 October 1908

The *Amateur Photographer & Photographic News*, 1 June 1909; 17 May 1910

Central News, 13 January 1915

Royalty Digest, October 2001

The Court Historian, July 2003

Unpublished Sources

Royal Archives, Windsor Castle, Berkshire

Acland MSS, The Bodleian Library, Oxford

Hall Caine Papers, Manx National Heritage Library, Douglas, Isle of Man

Draft Listing of Sitters, Royal or connected with Royalty, from Photographic Copyright Records in the Public Record Office, 1996. National Archives, Kew

Kodak Ltd Archive

National Portrait Gallery, London

INDEX

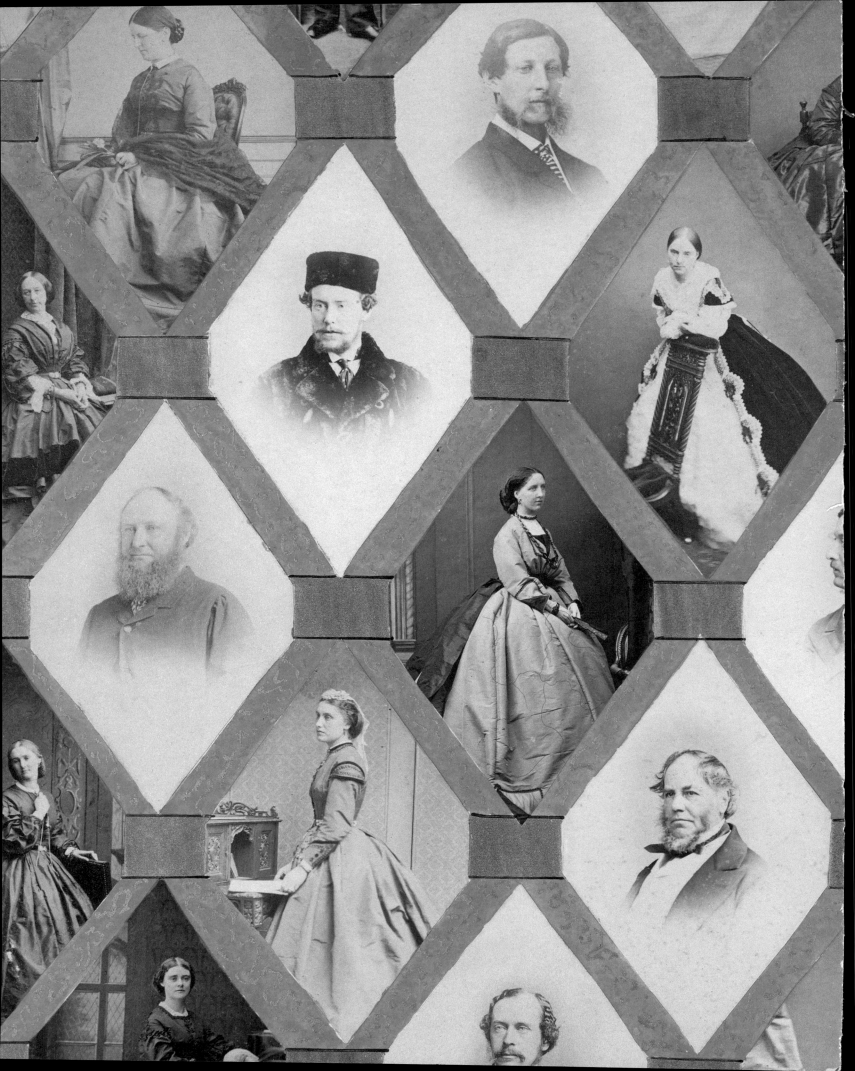